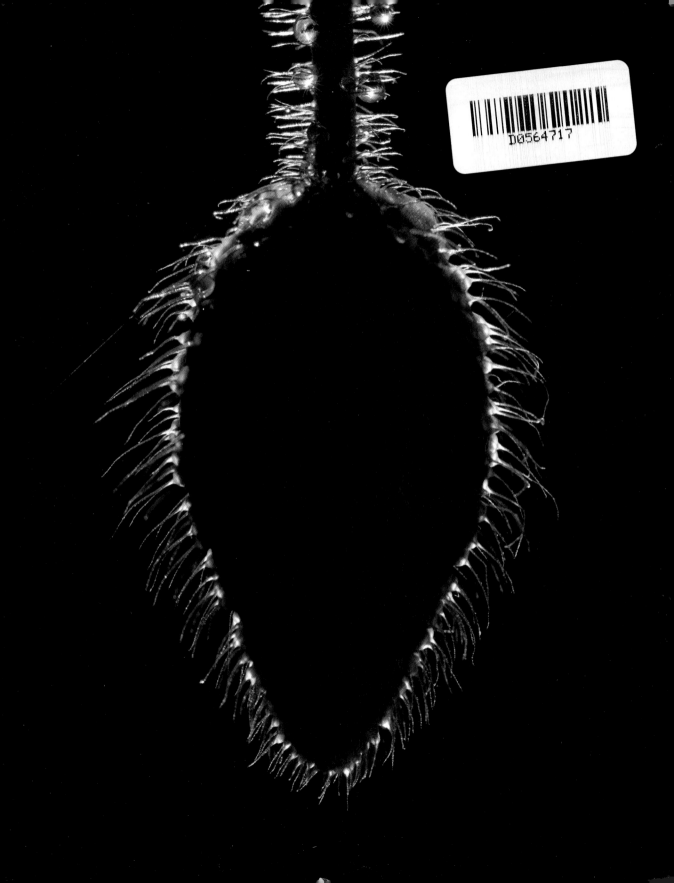

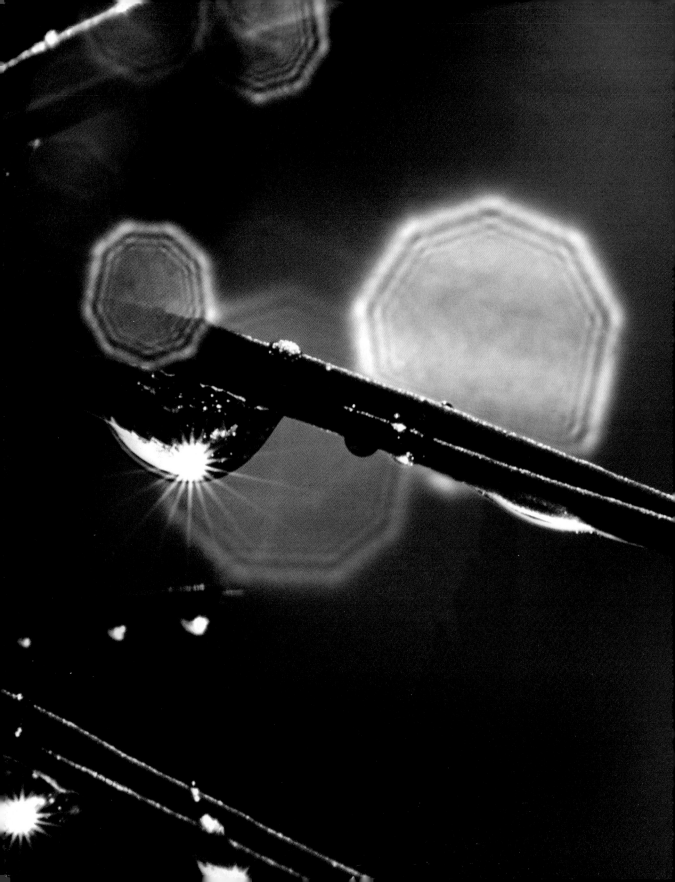

Creative Close-Ups

Digital Photography Tips & Techniques

Harold Davis

WILEY

Creative Close-Ups: Digital Photography Tips & Techniques
by Harold Davis

Published by
Wiley Publishing, Inc.
10475 Crosspoint Boulevard
Indianapolis, IN 46256
www.wiley.com

Published simultaneously in Canada

ISBN: 978-0-470-52712-2

Manufactured in the United States of America

10 9 8 7 6 5 4 3 2 1

For general information on our other products and services or to obtain technical support, please contact our Customer Care Department within the U.S. at (800) 762-2974, outside the U.S. at (317) 572-3993 or fax (317) 572-4002.

Wiley also publishes its books in a variety of electronic formats. Some content that appears in print may not be available in electronic books.

Library of Congress Control Number: 2009935224

Acknowledgements

Special thanks to Courtney Allen, Mark Brokering, Jenny Brown, Gary Cornell, Katie Gordon, Barry Pruett, Sandy Smith and Matt Wagner.

Credits

Acquisitions Editor: Courtney Allen

Project Editor: Jenny Brown

Technical Editor: Haje Jan Kamps

Copy Editor: Jenny Brown

Editorial Manager: Robyn Siesky

Business Manager: Amy Knies

Senior Marketing Manager: Sandy Smith

Vice President and Executive Group Publisher: Richard Swadley

Vice President and Publisher: Barry Pruett

Book Designer: Phyllis Davis

Media Development Project Manager: Laura Moss

Media Development Assistant Project Manager: Jenny Swisher

▲ Front piece: I intentionally underexposed this photo of a poppy bud to create an abstract image that reminds me a bit of a viper's head.
200mm macro, 1/400 of a second at f/11 and ISO 100, tripod mounted

▲ Title page: As clouds floated by, making the morning sun go in and out of shadow, I waited for the right moment to press the shutter. My patience paid off and I got this shot of sunlight on a water drop.
200mm macro, 1/15 of a second at f/40 and ISO 100, tripod mounted

▲ Above: I used a wide open aperture to create a watercolor-like effect with this hand-held close-up of a poppy.
100mm macro, 1/800 of a second at f/2 and ISO 200, hand held

▼ Page 6: Getting out early one morning, I found this dew-covered dandelion glistening in a field; many of the individual water drops can almost be seen as fractal-like representations of the whole flower.
105mm macro, 36mm extension tube, +4 close-up filter, 1/3 of a second at f/32 and ISO 100, tripod mounted

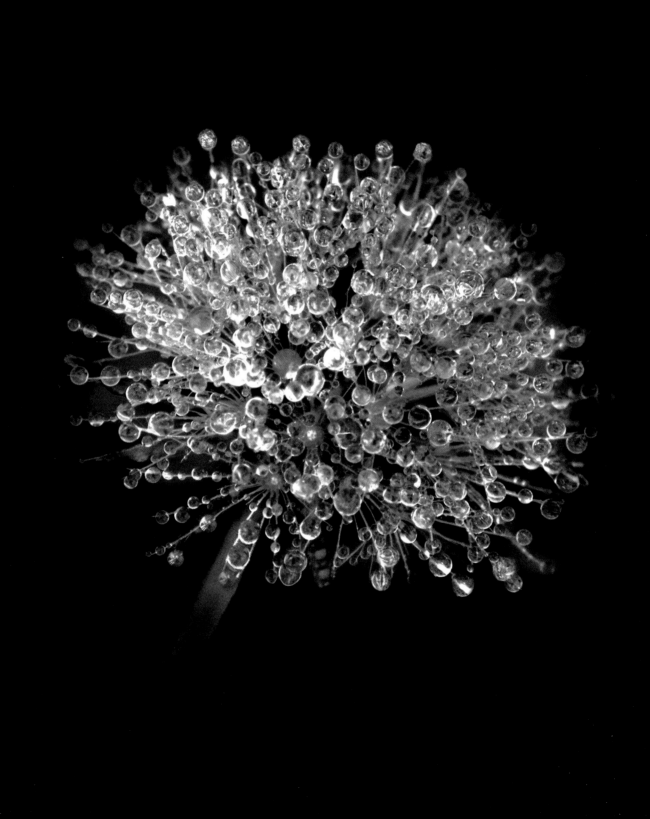

Contents

Introduction

"The unbelievably small and the unbelievably vast eventually meet, like the closing of a gigantic circle," observes the ever-smaller hero of the 1950s movie *The Incredible Shrinking Man*. What I love most about close-up photography is the way size, scale and orientation gets lost as you photograph things that are smaller and closer.

If your subject gets small enough, you might as well be photographing the cosmos. To photograph close-up with this in mind is to show a fractal part of the universe that is whole and complete by itself. Close-up photography allows you to reveal small worlds of wonder to those who look at your photos.

Best of all, close-up worlds are right where you are. You don't have to wander long distances through time and space to find great subjects for close-up photography. Wherever you go, there you are; and there will certainly be something to train your macro lens on.

Speaking of macro lenses, I use the term "close-up" and "macro" more or less interchangeably, although some close-ups are not true macros. All macros are close-ups, but close-ups from two or three feet away

probably cannot be considered true macros, as they show more of the context of the photo.

This book is primarily about how to make *creative* close-ups. You'll find all you need to know to create technically accomplished close-ups, along with the stories and exposure data behind the photos shown. I've focused on visualizing and making close-up photos, rather than on magnification charts and ratios (which are usually not helpful for actual picture-taking in the field). Taking close-up photos does not have to be complicated. I've tried to keep things simple.

Two of my own close-up loves are flowers and water drops. So it won't surprise you to find that many of the photos in this book are botanical images and photos of water drops. I hope you enjoy my photos and use the illustrated techniques to capture your favorite close-up subjects.

The more close-up photography you do, the more you'll realize that the circle does indeed close. Please enjoy!

Harold Davis

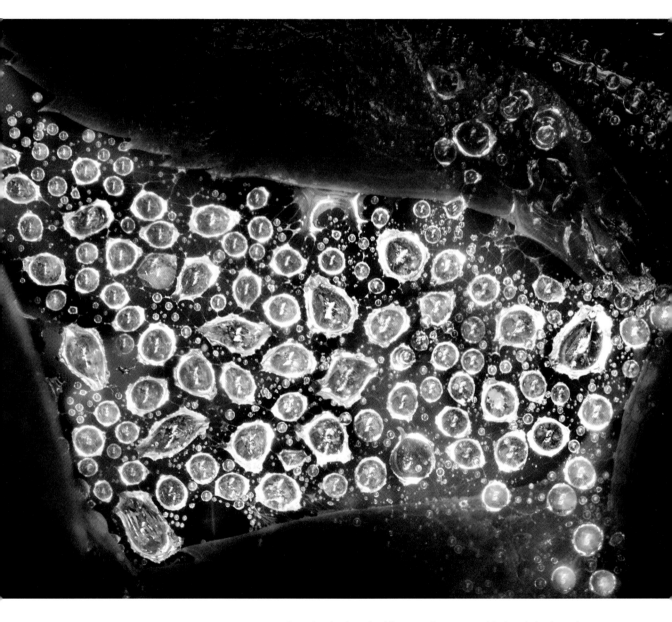

▲ The colors in these backlit water drops on a spider's web fascinated me, so I used a telephoto macro lens to get a magnified macro of this jewel-like effect.

200mm macro, 66mm combined extension tubes, 2 seconds at f/32 and ISO 100, tripod mounted

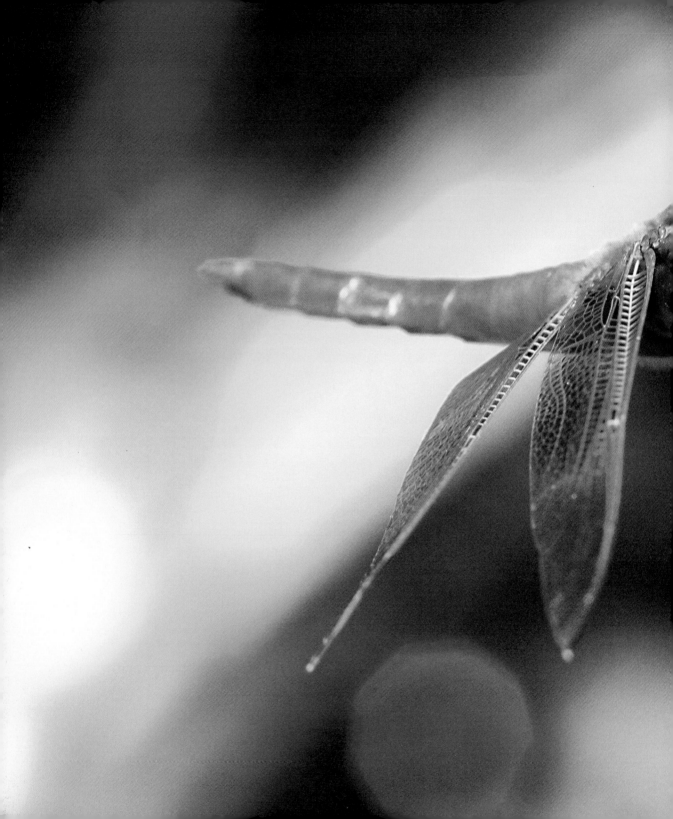

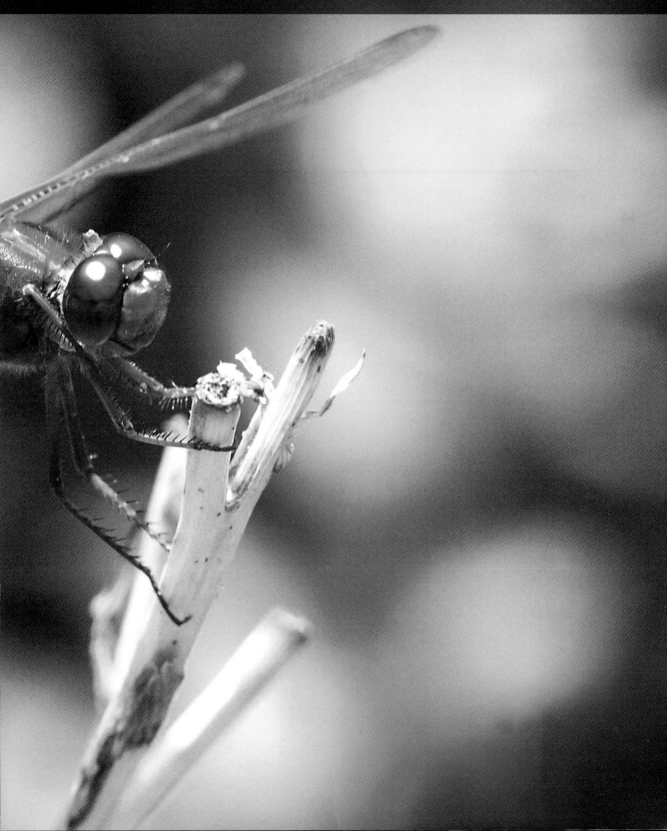

Close and Closer

How close can you go? That is the macro question. Or maybe a better question is, how close do you want to go? Close, but not quite so close, lets you show the context of your photo. *Very* close means zeroing in on individual features of your subject.

The *magnification ratio* describes the correspondence between an object and its actual size on the sensor. At 1:5, a capture renders an object as 1/5 of the corresponding dimensions of the object itself. At 1:1 the sensor rendering is exactly life size, and at 2:1 the digital image is twice as large as life.

When photographers go beyond very close—to magnification ratios greater than 1:1—they enter a completely new universe of the microcosm.

A key issue is *depth-of-field*, the field in front of and behind a subject that is in focus. The closer you get to a subject, the shallower the depth-of-field, even with the lens stopped down to its smallest aperture. This means that as you get to a magnification ratio of 1:2 and closer,

▼ At a magnification ratio of 1:5, it's a close-up, but not that close. You can barely see the water drop at the edge of the dahlia petal.

50mm macro, 10 seconds at f/32 and ISO 100, tripod mounted

Ratio 1:5

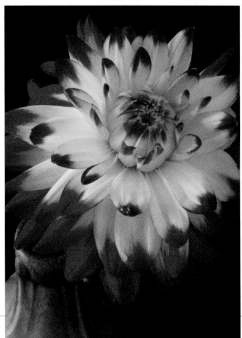

▼ At a magnification ratio of 1:2, it's getting closer. There's not much visible outside of the context of the flower, and the water drop can be seen easily.

50mm macro, 10 seconds at f/32 and ISO 100, tripod mounted

Ratio 1:2

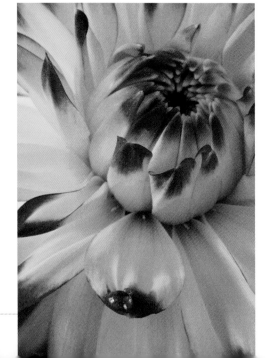

you need to use the shallow focus to your advantage by isolating particular aspects of your subject.

For more apparent sharpness, you should also attempt to position the camera so that it is as parallel as possible to the subject. This will maximize apparent focus, even though the field that is in focus is not deep. As you get very close to a subject, minute adjustments of camera position become very important because small changes in camera position have a big impact on focus.

I shot this sequence of photos of a water drop on a Dahlia petal, starting from furthest away and moving closer, to show what the magnification ratio means in the real world.

▲ Pages 10–11: Using a telephoto macro lens let me snap this photo of a dragonfly without getting close enough to disturb the critter.

Usually a telephoto macro will take you out of the range that is noticed by insects. In addition, using this kind of lens allowed me to isolate the dragonfly from its background.

200mm macro, 1/320 of a second at f/9 and ISO 640, hand held

▼ True macro lenses focus to a magnification ratio of 1:1. You can see the water drop…and a smaller water drop that wasn't visible before.

50mm macro, 13 seconds at f/32 and ISO 100, tripod mounted

▼ This 2:1 magnification shows a completely different macro world, centered on the water drop and its satellite smaller drop.

200mm macro, 36mm extension tube, +4 close-up filter, 13 seconds at f/40, tripod mounted

Ratio 1:1

Ratio 2:1

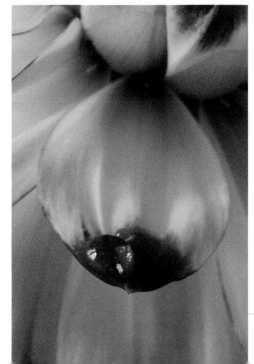

Worlds of Close-Up Photography

There are as many worlds of close-up photography as there are objects to get close to. Almost anything you can think of looks different at different magnifications. Getting closer is a way to investigate.

What do you want to investigate?

Besides my favorite subjects of water drops and flowers, some great things to explore with your camera and macro lens include insects, reflections, metallic surfaces, small marine animals in tide pools and much, much more.

Along with your choice of subject matter, consider the impact of magnification on your composition. At 1:2 or less magnification, you can fully capture an insect such as the wasp shown below or show the context of your subject.

In contrast, at 2:1 or greater, viewers lose the sense of a coherent whole. In compensation, the tiny details of your subject are now huge (like the pistils in the flower shown to the right). These details are seen as never before and can be the basis for startling photos.

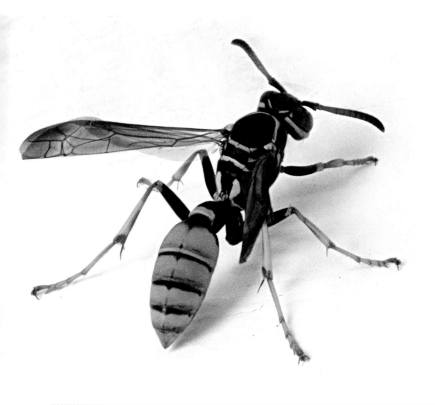

◄ The wasp shown in this photo landed near the ceiling in my living room. To photograph the insect, I propped my tripod up on some old cartons and climbed on top of a coffee table. Sometimes to get into position for a close-up shot, you just have to improvise!

105mm macro, 0.6 of a second at f/32 and ISO 200, tripod mounted

▶ I used a Low Pod Mount from Kirk Enterprises to get low enough to the ground to get this head-on view of the pistils of the Fuchsia bud. I think the photo makes the flower look like a jet engine!

200mm macro, 36mm extension tube, 8 seconds at f/32 and ISO 100, Low Pod mounted

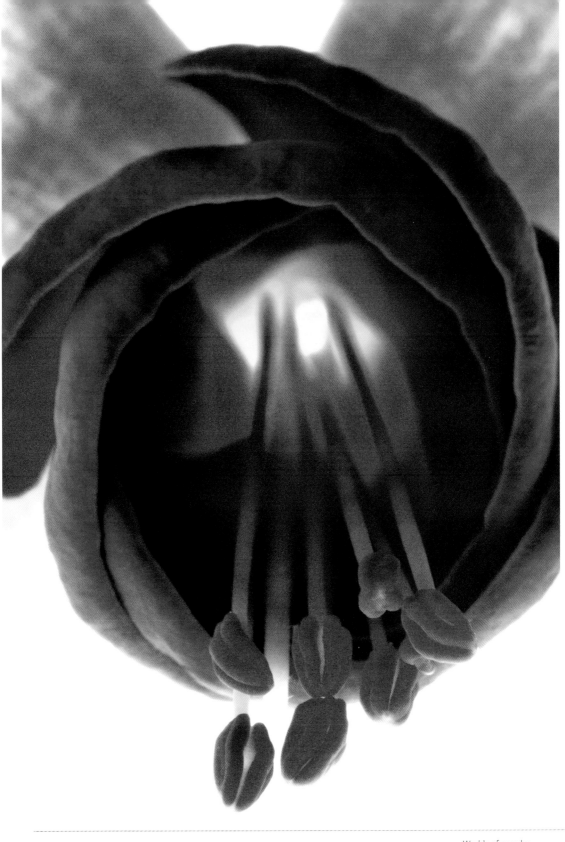

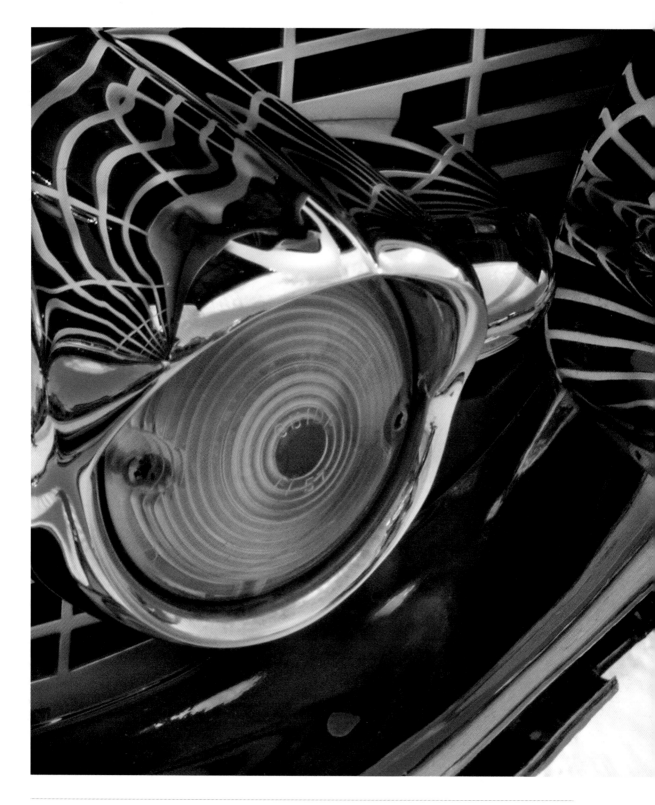

Saturday, September 6, 2014

FROM: **Goodwill Industries of**
Southern Arizona
1940 E. Silverlake Ste. 405
Tucson, AZ 85713

Your Order From:

Amazon

Customer Name: Wes D Bevans
Order Date: 09/05/2014

||||||||||||||||||
2 3 6 3 4 6 ★

Shipping Method: **STANDARD**

Number of Items: **1**

SKU	Title
09-003-002-0374	Creative Close-Ups: Digital Photography Tips

Ship To: Wes D Bevans
57751 Alder Creek Road
Scappoose, OR 97056
USA

For Customer Service Inquiries about your order, please contact us at: booksales@goodwilltucson.org

*Our Guarantee: We appreciate your business and are committed to providing the best possible service. If you are
unhappy with your purchase, please contact us immediately at booksales@goodwilltucson.org. If we are unable to
correct the problem to your satisfaction, we will refund your purchase. Thank you for your order!*

Amazon Order Number: 112-5973056-8753840

TITLE: Creative Close-Ups: Digital Photography Tips and Techniques

ISBN/UPC No.: 9780470527122 INTERNAL SKU No.: 09-003-002-0374

Description: Used - Acceptable. Binding in good condition, light wear around edges. Minor scuffs and scratches. No apparent writing/highlighting. --Please read our Seller Info and Policies prior to placing your order.

Amazon's Shipping and Handling	**3.99**
ITEM TOTAL - Amount Collected by Amazon	**13.96**

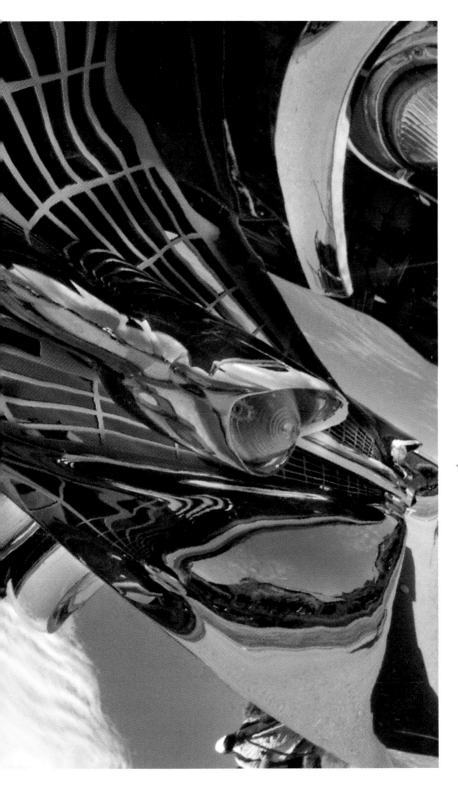

◀ At a classic car show, I got out my macro lens to photograph reflections in the polished chrome.

With this kind of close-up photo, even slight movements of the camera position have a huge impact on the final composition.

I usually try to be careful to position myself so that reflected photographer, camera, and tripod don't appear as part of the composition. This can be surprisingly difficult! Witness my small self-portrait in the lower right of the photo.

Macros that involve reflections begin to become visually spectacular when the reflection is iterated: The reflection is itself and so on.

200mm macro, 1/8 of a second at f/36 and ISO 100, tripod mounted

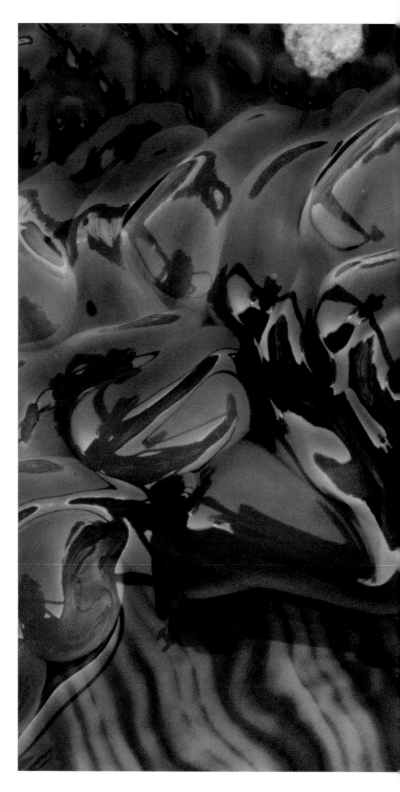

► This is a close-up of an anemone taken in a California marine preserve at low tide. If you look closely, you can see me and my tripod reflected in the tentacles.

At a normal magnification, this anemone is a sea creature. Up close at roughly 1:1, as in this photo, the anemone becomes an abstraction like a work of blown glass. Several people have commented to me that this photo reminds them of the work of the great glass artist Dale Chihuly.

105mm macro lens, 36mm extension tube, 2.5 seconds at f/40 and ISO 100, tripod mounted

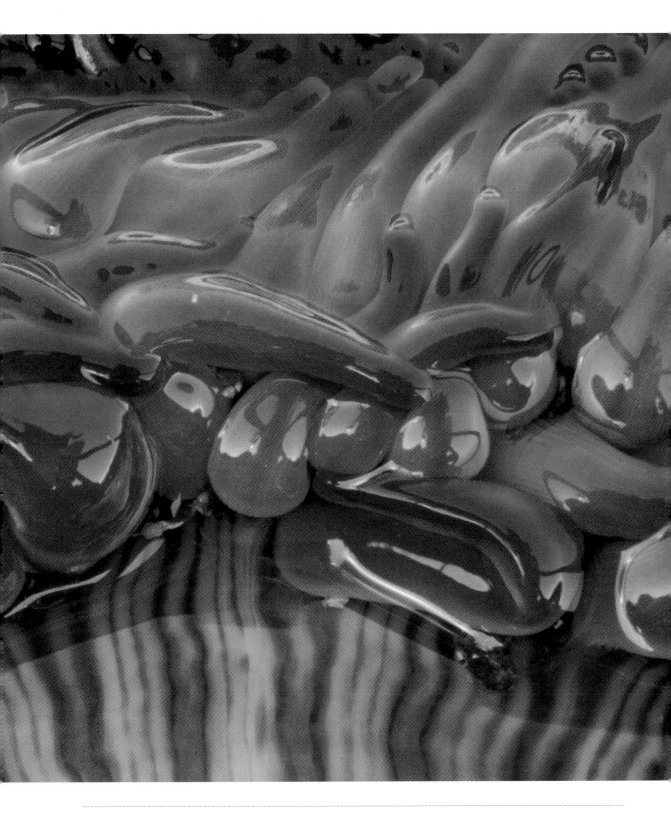

Photographing Artifacts

ar·ti·fact (är-ti-fakt) n. 1. Something created by humans usually for a practical purpose; especially: an object remaining from a particular period.

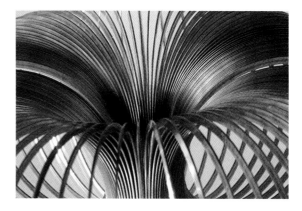

Close-up photographers spend most of their time taking pictures of objects, or portions of objects, in isolation. The subject that is photographed close-up needs to be mysterious, to tell the story of its context or to show something commonplace in a new way. The best close-ups do all of these. I consider these subjects in isolation *artifacts*: artifacts of culture, artifacts of time, and—despite the dictionary definition, which says that an artifact is something created by humans—artifacts of nature.

For me, an artifact is an isolated object that has been left behind.

Look for this sense of being remnant, where the thing that remains says something about the whole that it once was part of. Objects that convey this sense make great close-up subject matter.

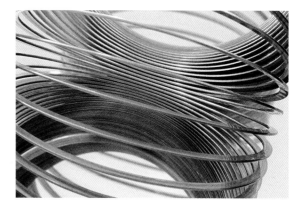

To make the photos of a common child's toy shown to the right, I used colored board to reflect colors into the Slinkies. Had I wanted a more natural effect, I could have reflected neutral colors onto the metal. One thing is for sure: a reflective surface will reflect. To get good photos of something with reflections, you need to observe them carefully and sometimes construct the reflections yourself. (See "Close-Ups in the Studio" starting on page 166 for more information.)

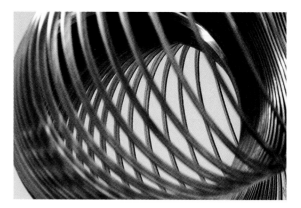

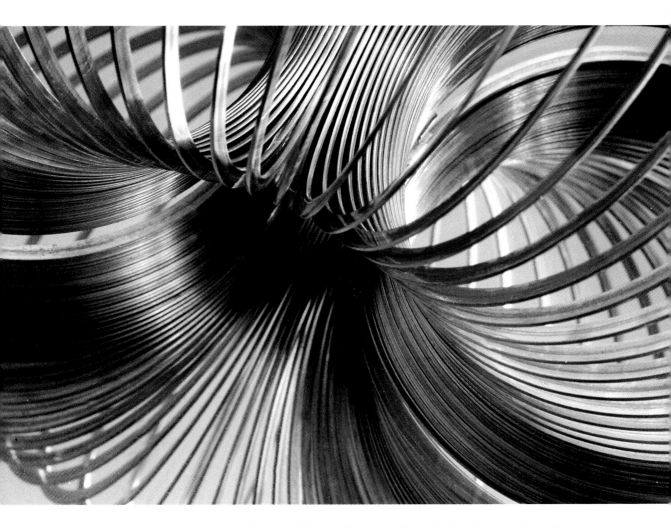

▲ Slinkies: I used bits of cardboard to reflect colors into this set of photos of a common children's toy.

Page 20, top: 105mm macro, 2.5 seconds at f/40 and ISO 200, tripod mounted

Page 20, middle: 105mm macro, 4 seconds at f/40 and ISO 200, tripod mounted

Page 20, bottom: 105mm macro, 2.5 seconds at f/40 and ISO 200, tripod mounted

Above: 105mm macro, 2 seconds at f/32 and ISO 200, tripod mounted

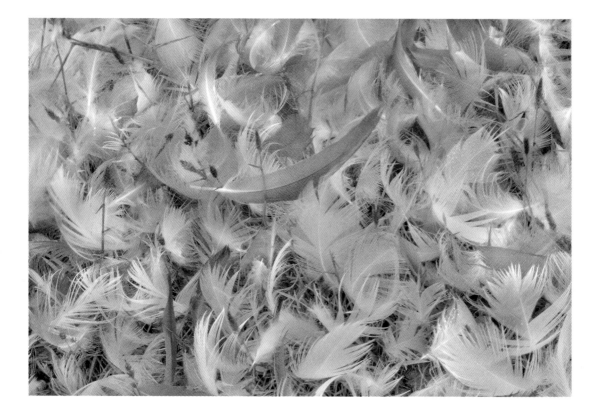

Both: On a deserted beach, a strong prevailing wind had gradually blown seagull feathers into a wind trap. I loved the way these feathers looked as a mass, creating an overall pattern on the grassy background and conveying a sense of mystery. Closer in, the individual feathers made a great macro subject with an ethereal ambience.

Above: 105mm macro, 1/6 of a second at f/36 and ISO 100, tripod mounted

Right: 105mm macro, 1/5 of a second at f/36 and ISO 100, tripod mounted

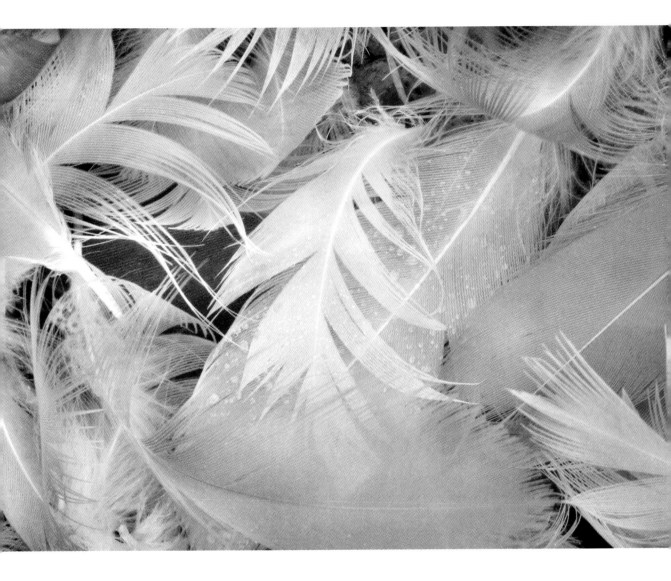

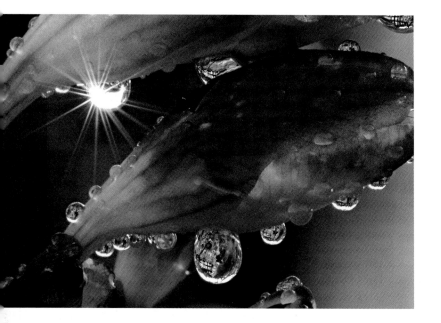

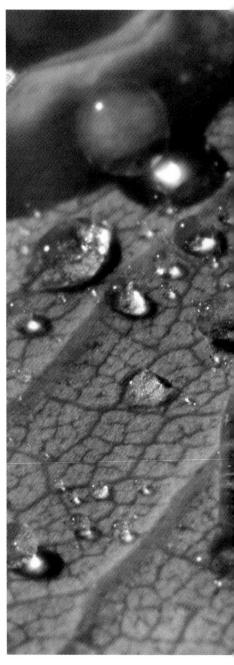

▲ When taking an extreme close-up, high depth-of-field water drop image, it's difficult to see what the photo will look like from the camera viewfinder. Even the depth-of-field preview doesn't tell me much, because at small apertures like f/40 with a bright sun, I can't see much. The effects of sunlight on the water drops are unpredictable and the smallest amount of motion can ruin the photo.

I can see—but not much more—from the LCD viewer after I've taken the photo. Part of the problem here is that in bright sunlight it is hard to see it. Another issue is that at the LCD size, the difference between almost sharp and *laser sharp* isn't readily apparent if the subject has moved slightly.

To combat these problems, I look at close-up subjects directly—not through the viewfinder—and try to time my exposures when the subject is absolutely still.

200mm macro lens, 1/3 of a second at f/40 and ISO 200, tripod mounted

▶ As the overnight rain evaporated in the morning sunshine, I noticed these water drops on a peony leaf. The sky and clouds in the reflections in the drops reminded me of entire little worlds, or alien artifacts dropped from space.

200mm macro lens, 36mm extension tube, +4 close-up filter, 1/13 of a second at f/36 and ISO 100, tripod mounted

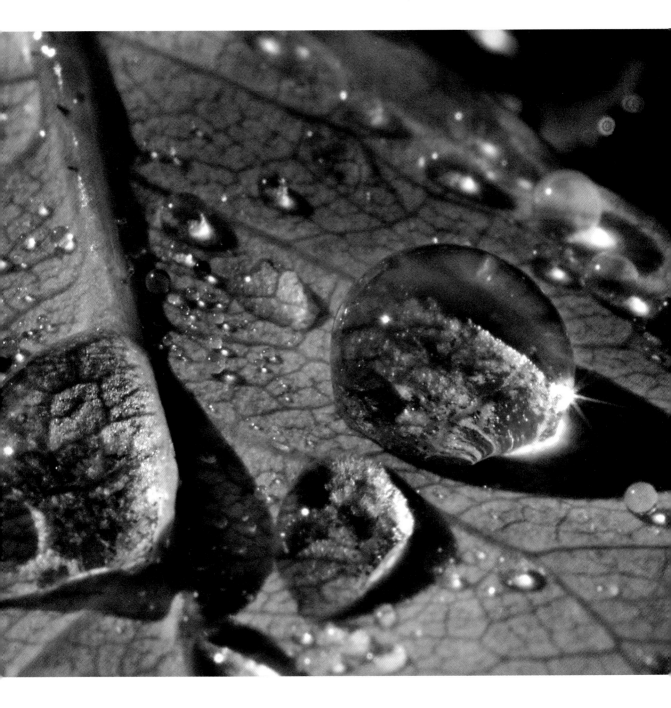

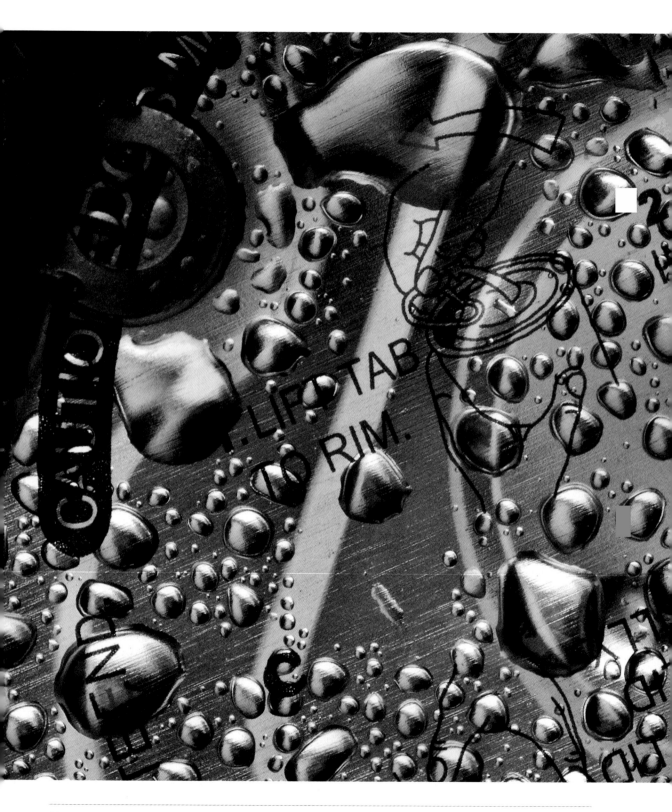

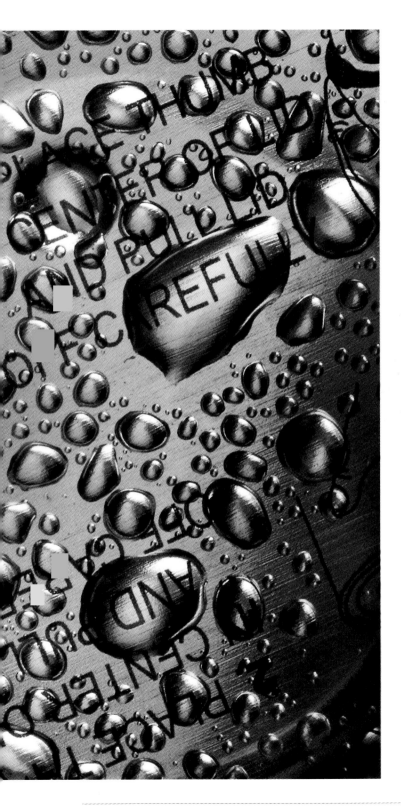

The defined pattern of water drops on this tin can lid struck me as an interesting contrast to the printed directions on the lid. To me, it represents an interesting artifact of a society that seems to regard everything as disposable. I converted this close-up image to black and white in the digital darkroom when I post-processed it.

I was particularly struck by the apparent sharpness of this image. I was drawn to the way some of the lettering, such as the upsidedown "and," appears to be magnified in the water drops.

200mm macro, 3 seconds at f/22 and ISO 100, tripod mounted

¶ncipit epistola beati ¶ieronymi ad ¶aulinum presbyterum de omnibus di/ uine historie libris. Capitulū I

¶abuit illa et celebrandūcz ingressi·aliud loni²· siue ille ue phs·vt pyth persas·ptrāsiu tas·massageta gna penetraui physon amne chmanas·vt h aureo ꝛ de tan cos disciplos curfu diez ꝛ s de p elamitas dos·assyrios arabes·palesti am·prexit ad stas ꝛ famosi in fabulo. ¶n sceret·ꝛ semp oz fieret ¶c cto volumin

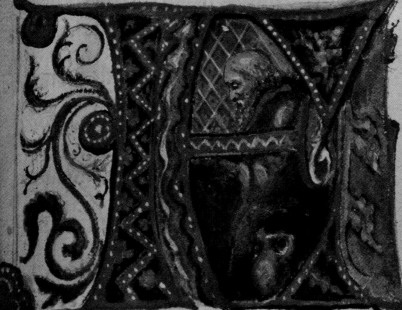

¶ater ¶mbrosius tua mihi munuscula per ferens·detulit simul et suauissimas lit/

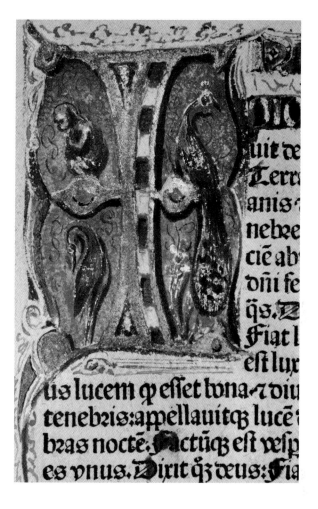

In my studio, I photographed one of the first Bibles ever printed for a collector. This Textus Biblie was printed by Preuss of Strassborg in 1486, twenty years after the Gutenberg Bible. It is the first printed book with a date on the title page.

Back in the fifteenth century, books were printed in one color (black). The decorations and illuminated paintings were added on a one-off basis. So there are some versions of this Bible that were never finished by an artist; otherwise each copy is different.

I felt very lucky to handle and photograph such an early and special book—one that is connected to the history of printing and the religious history of Western civilization.

◀ Left: The photo shows the first page of the Textus Biblie; the painting is probably of Saint Jerome at work on an edition of the Bible.

85mm Perspective Correcting macro, 3 seconds at f/36 and ISO 100, tripod mounted

▲ Above: The illustration shows the Garden of Eden, starting off the Book of Genesis.

200mm macro, 2.5 seconds at f/16 and ISO 100, tripod mounted

Finding Macro Subjects

Following my toddler around, I watched him stop, pick up something and scrutinize it carefully. He'd repeat the process over and over again, and would happily spend hours covering very little ground. The objects of scrutiny were commonplace: leaves of grass, pebbles, sticks and cracks in the pavement.

This childlike sense of wonder in the everyday—scrutiny of everything as though seeing it for the first time—is the best mindset for finding close-up subjects. Forget the way you normally see, look for details and try to see patterns and beauty in the apparently mundane.

I carry a macro lens and some other close-up gear in my everyday camera bag. (See "Getting Close," starting on page 44, for suggestions about close-up equipment.) That way, if I encounter a great macro subject when I'm in the field, I'm ready for it. But I know that many of the best close-up photos are taken at home, in familiar surroundings, and not abroad. It's one of the great things about close-ups: you don't have to go far to see whole new worlds!

Take a look at the things on your desk. Many objects you look at everyday would make good close-up subjects. Pencils, paper clips and bits of paper are all grist for the macro mill.

Wander around your house. There are tons of subjects for close-ups just sitting there, waiting for their moment in the photographic sun.

Feel like eating? Among the most interesting subjects for close-ups are a bowl of fruit, a berry or even melting ice cream.

Want a breath of fresh air? There are sure to be good close-up subjects in your yard and on the nearby sidewalk. I love having a nice garden, but sometimes the best close-up subject matter is in stark environments.

So don't think you need to find special close-up subjects in special places: good macro subjects abound everywhere!

▶ At first glance, this looks more like a head of lettuce than a close-up of mint chocolate chip ice cream in a bowl.

105mm macro, 5 seconds at f/36 and ISO 200, tripod mounted

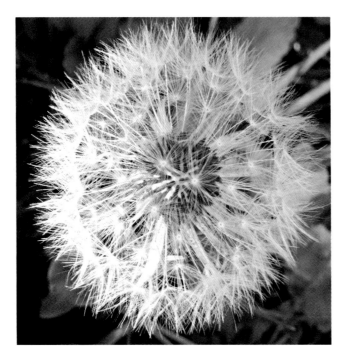

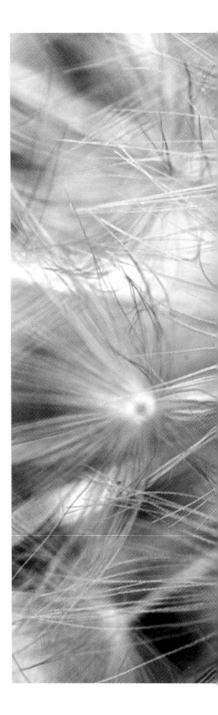

Both: Dandelions are considered weeds, and the subject of intense eradication efforts on the part of lawn fanciers. However, kids love dandelions in all the phases of their life cycle—from flower to blowing seeds. And the delicate, intricate patterns of the plant make a great subject for close-up photography.

Above: 105mm macro, 1/3 of a second at f/40 and ISO 200, tripod mounted

Right: 105mm macro, 1/10 of a second at f/16 and ISO 200, tripod mounted

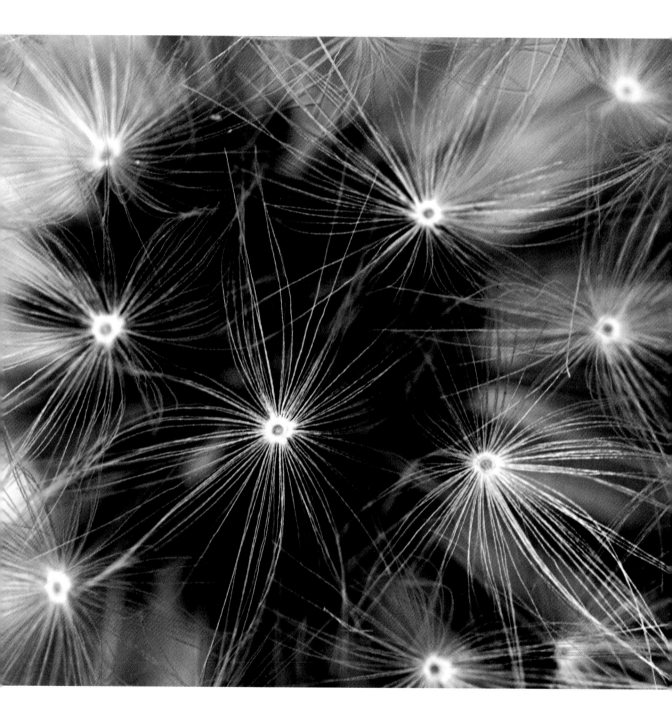

Macros and the Digital Darkroom

I do not believe that a photographer's work is done after the shutter has been released. For me, at least half the fun starts after the photo has been taken, and when the RAW file has been copied to my computer. I have no shame when it comes to the use of Photoshop, which is what I tell people when they ask if one of my images has been "Photoshopped." I tell them that I work on all of my photos in Photoshop. This is a bit of an exaggeration, but it gets my point across.

In my work, close-ups have been among the most fertile ground for work in the digital darkroom. Moving from a photograph to a composition that is one part digital photo and one part digital painting has enabled me to add magic to the realities of insects, household objects, textures and much more.

So when you shoot close-ups, stop to think about what you could do with the photo after it is taken. The possibilities are amazing!

▼ Below: I shot this pinned butterfly straight down on a lightbox for transparency.

▶ Right: My final image was created from the macro photo using digital painting on duplicate layers in Photoshop.

200mm macro, 1/60 of a second at f/6.3 and ISO 100, tripod mounted

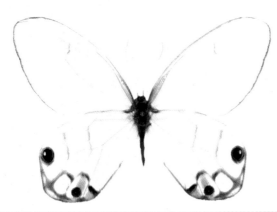

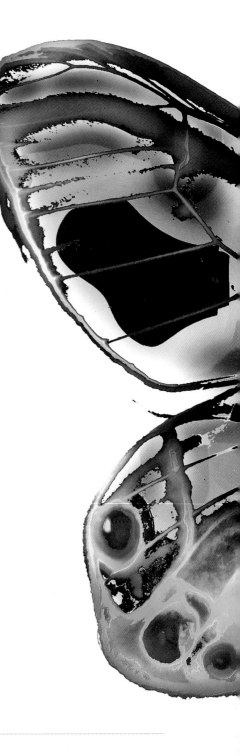

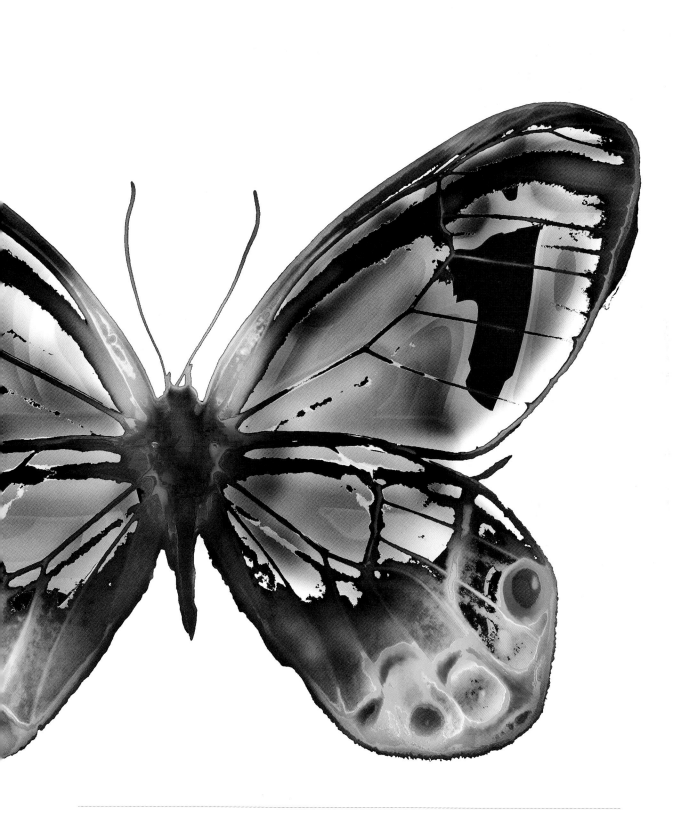

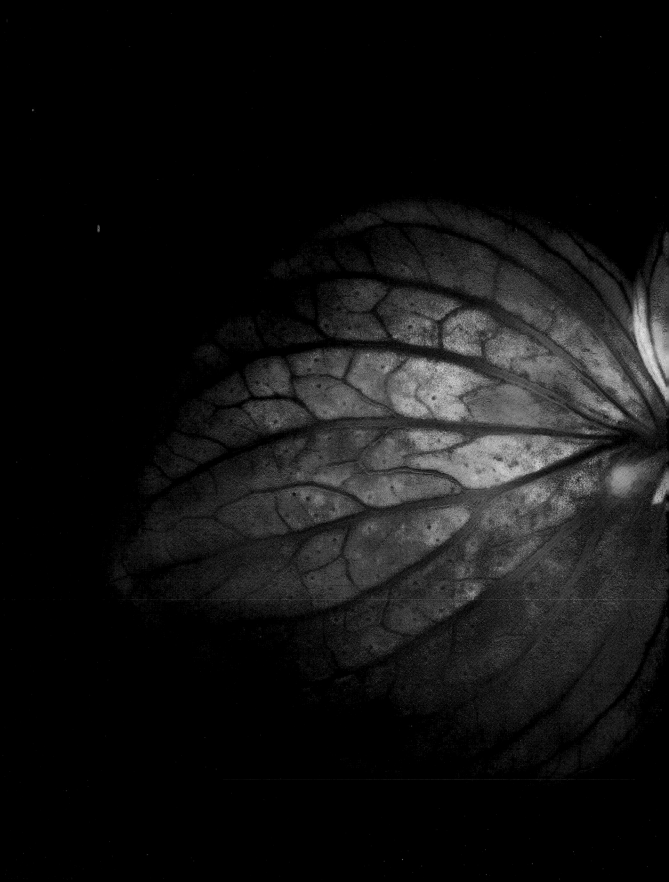

▲ I photographed these oregano leaves, and then added color in Photoshop using LAB color, inversion and equalization adjustments, and a variety of blending modes. (To find out more about these post-processing techniques, see the suggested reading on page 234.)

200mm macro, 1/4 of a second at f/32 and ISO 100, tripod mounted

Creating Close-Up Abstractions

One thing I love to do is take a fairly commonplace close-up photo and use the digital darkroom to transform it into a compelling abstraction. Viewers are often unable to tell what the original subject matter was. Hopefully, they'll be intrigued by the composition, colors and patterns of the abstraction.

If this approach appeals to you, start looking for close-up subjects with abstractions in mind. Separating content from form and leaving the subject matter aside, what is it about the composition of the object…up close and personal…that you like? How can you visualize shifting it to become an exciting abstraction?

Both: I photographed this pattern in seaweed on the Edward Weston Beach in Point Lobos Preserve, California. The original photo is already pretty abstract; but if you look closely, you can see small insects crawling on the kelp.

I felt that this photo was a good candidate for further abstraction because of the intriguing, and somewhat sinister, patterns in the composition. These patterns are an interesting contrast with the bright colors I added. By completely divorcing the image from its subject matter, the viewer is compelled to respond to the colors and composition of the abstraction.

105mm macro, 0.6 of a second at f/36 and ISO 100, tripod mounted

Both: I photographed a shadow pattern on a Persian rug close-up, and then rotated and abstracted the image to create a magical image that reminds me of a carpet that could provide magic rides.

52mm, 1/200 of a second at f/8 and ISO 200, hand held

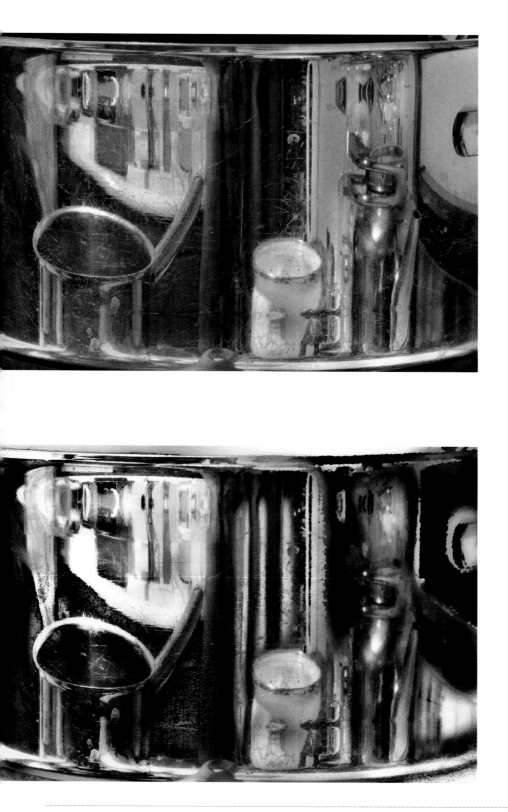

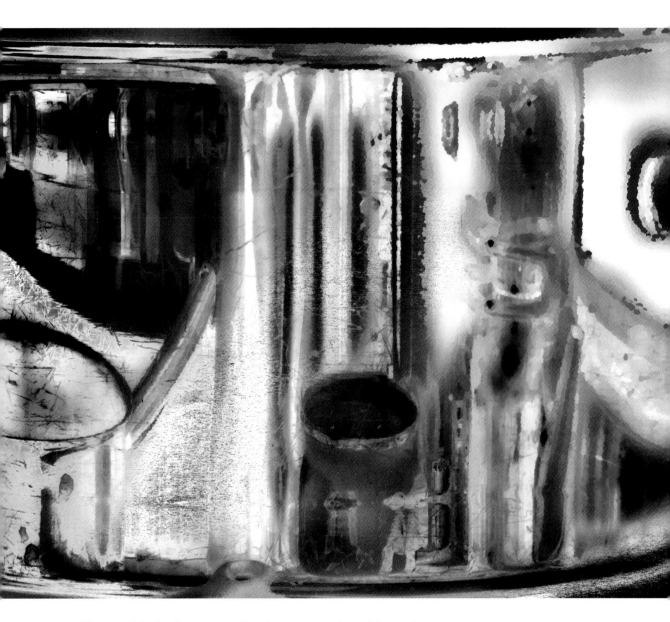

All: I created the first image (page 42, top) as a common domestic image that shows kitchen reflections in a large pot. If you look carefully at the reflections, you can see me and my tripod hidden in the center of the reflections.

The image called out to me for more work. So, I abstracted it in Photoshop using LAB colors, channel adjustments, layers and a variety of blending modes (page 42, bottom and above). To find out more about these post-processing techniques, see the suggested reading on page 234.

105mm macro, 20 seconds at f/36 and ISO 100, tripod mounted

Seeing Up Close and Personal

Cameras don't take pictures; people do. So the most important thing you can do to learn to take good close-up photos is to learn to observe carefully...up close. What is it that intrigues you about a macro subject? How close do you need to be? When you pre-visualize a close-up photo, is it in color or black and white? Where is it focused?

You may notice that I shot most of the photos in this book with a DSLR and a macro lens, or other specialized close-up equipment. However, you don't need fancy equipment to shoot macros. I encourage you to go out and shoot close-ups with almost any gear.

Oddly enough, a compact fixed-lens digital camera even has some advantages for close-ups, provided it has a macro mode. This is because the smaller the sensor size,

the more depth-of-field you get. In other words, you can fairly easily get close-ups with a compact digital camera, and you'll see that you can capture the whole subject in focus because the camera uses a small sensor. This small-size sensor is a disadvantage in terms of noise, but that's another story.

So if you have a yen to take photos close-up, don't feel you need fancy equipment to get started. The camera I used to take the close-ups on this page and page 47 is a basic several-generations-old point-and-shoot, and you can see it performs fine in macro mode.

The camera doesn't matter. Learning to see close-up, so you can pre-visualize how very small things will look when they are revealed on a large scale, does.

◀ If you don't need to blow up a photo to a huge size or worry about critical reproduction, then almost any point-and-shoot with a macro mode will work well for close-ups. When I took this photo of rose petals and their reflections, I wasn't worrying about camera hardware. Instead I could concentrate on the composition.

Canon Powershot G3 fixed-lens camera, sensor with a 4.5X crop factor, 28.8mm (140mm in 35mm terms), macro mode, 3/10 of a second at f/8 and ISO 50, tripod mounted

▲ Pages 44–45: I used a waterproof point-and-shoot camera to make this interesting close-up composition on a very wet, rainy day. I wouldn't have wanted to take my "real" cameras out and expose them to the elements.

Pentax Optio WPi fixed-lens camera, sensor with a 6X crop factor, 13.8mm (112mm in 35mm terms), macro mode, 1/25 of a second at f/3.9 and ISO 160, hand held

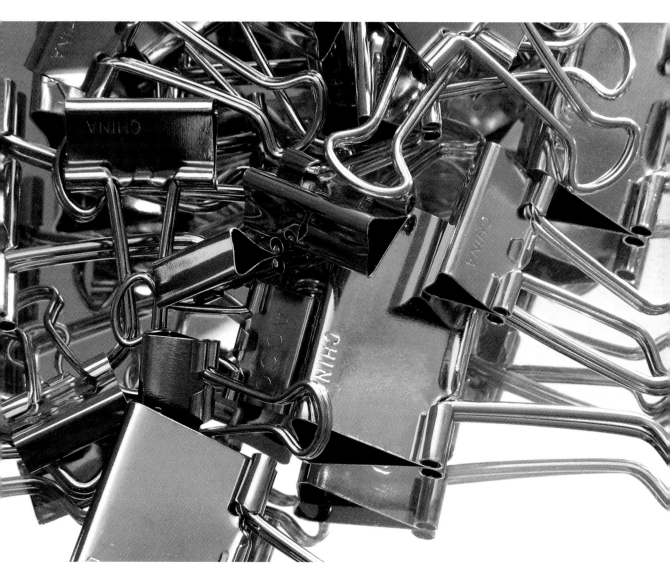

▲ I photographed these paper clips in my studio with a small camera I had at hand. I used colored boards to reflect color onto the reflective surfaces.

Canon Powershot G3 fixed-lens camera, sensor with a 4.5X crop factor, 28.8mm (140mm in 35mm terms), macro mode, 1/2 of a second at f/7.1 and ISO 50, tripod mounted

Macro Lenses

I collect macro lenses the way some people collect shoes. Actually, I'm no Imelda Marcos; but when it comes to macro lenses, I wish I were.

Macro lenses are the one kind of equipment for my DSLR that I truly obsess over. If I had hundreds of macro lenses in my closet, I would be in heaven! I hope my actual macro lens closet doesn't bore you, because I'm going to tell you what's in it in a moment.

My obsessions aside, you don't need a macro lens to make close-ups. Extension tubes and close-up filters are two much less expensive alternatives (see page 52). But having a macro lens makes taking close-ups easy, gracious and fun.

By definition, a macro lens focuses close—often so you can achieve a 1:1 magnification ratio. (See pages 12–13 for an explanation of magnification ratios.) However, most macro lenses also focus to infinity and theoretically can be used as fixed-focal length general purpose lenses. With some exceptions, zoom lenses with macro settings tend not to offer true macro magnification levels.

There are macro lenses in a wide range of focal lengths—from the normal angle of view (roughly 50mm) toward longer telephoto macros. (True wide angle macros are rare and optically difficult to create.) The longer in focal length a lens is, the closer it brings the photographer to the subject. At the same time, telephoto lenses provide lower depth-of-field. This is great for isolating subjects when they are in focus and the background is not, but not so good for achieving an image that is in focus in its entirety.

A special consideration in macro photography is that getting too close with your lens can block light, create shadows and disturb living subjects. Using a telephoto macro lens helps to avoid these pitfalls. (See the photo on pages 44–45 for an example of a telephoto macro used in this way.)

A downside of a telephoto macro is that it is unlikely to achieve quite as close a magnification ratio as a shorter lens. There's no one-size-fits-all solution when it comes to photo gear; you just have to pay your money and take your chances, which may help to explain my macro lens collection.

As with any lens, when considering the focal length of a macro lens, you need to factor in the sensor size of the camera with which it will be used. With a few exceptions (each is duly noted in the technical captions), the photos in this book were shot with Nikon DSLRs with a 1:1.5 ratio of sensor size compared to a 35mm film frame. This means that to calculate the equivalent focal lengths in 35mm terms for the lenses I've used, you need to multiply

▶ I used a "normal" focal-length macro lens to make this moderate close-up of a bouquet of Asiatic lilies. The normal perspective enhanced the natural look of this still life composition.

50mm macro, 1/2 of a second at f/32 and ISO 100, tripod mounted

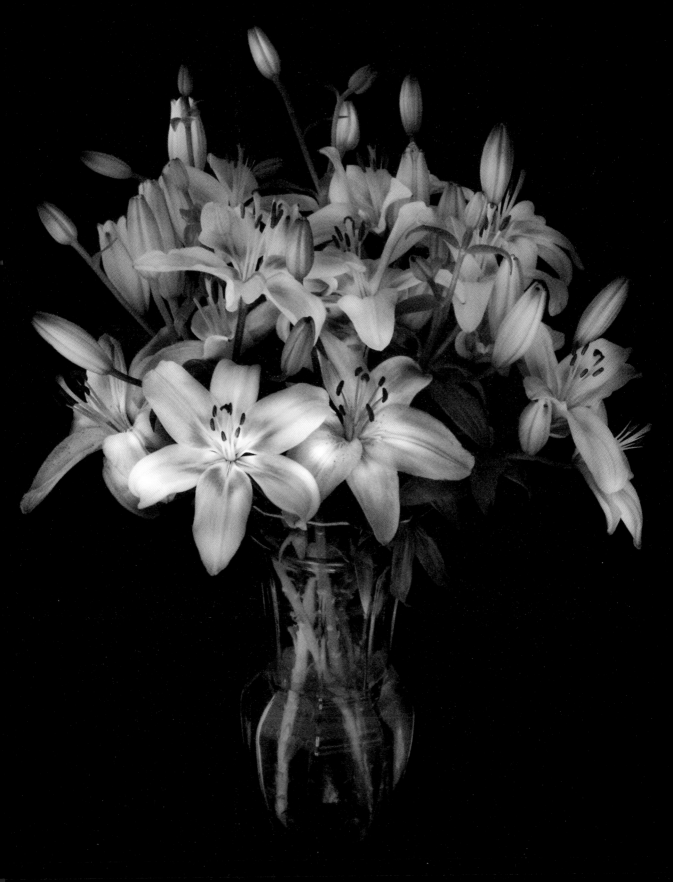

the focal lengths by 1.5. This is important not because I'm suggesting that you go back to film, but because 35mm film equivalency has become the standard for comparing focal lengths of lenses across different camera brands and models with different sensor sizes.

Here are some of the macro lenses I use, with notes about what I like and don't like about them. Even if you are not interested in any of these specific lenses, my notes may help you understand what may be important to you when shopping for a particular type of macro lens.

Focal Length	Brand	Notes
50mm f/2.8 DG macro D	Sigma	This is the shortest focal length macro lens I use; a neat feature about this lens is that the magnification ratio is clearly printed on the lens barrel so you can see it when you focus.
PC Micro-Nikkor 85mm f/2.8 D	Nikon	This is a macro lens that allows some tilts and swings, so you can correct lines of perspective—much as you would with an old-fashioned view camera. It's a completely manual lens, meaning that you first compose your photo and then manually use a button to close the diaphragm when you are ready to actually shoot your photo.
Makro-Planar 100mm f/2 ZF	Carl Zeiss	A great piece of glass with an "old school" feeling, this lens is particularly good at rendering colors at wider-open apertures.
AF Micro Nikkor 105mm f/2.8	Nikon	This is the standard, all around macro lens that travels with me everywhere. I have an older version that is lighter than current models that feature image stabilization. I feel that image stabilization is not very useful for macro work since I mostly use a tripod. (See pages 64–67 for more about tripods.)
AF Micro Nikkor 200mm f/4 ED	Nikon	This a great lens that allows me to get very close shots of my subjects while keeping my distance. The design features a tripod collar (surprisingly useful) and a front optical element that doesn't change position no matter how the lens is focused. A drawback of longer lenses like this one is they may not actually get as close as 1:1.

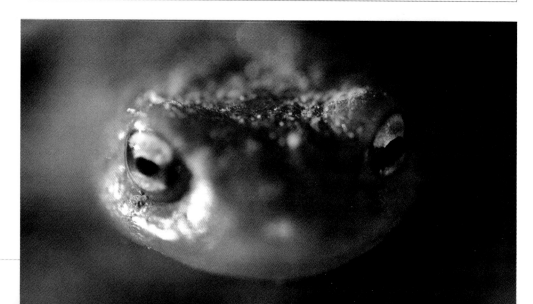

▲ I used a telephoto macro in this shot to compress the planes of this photo that shows an Iris on a mirror. This focal length helped to emphasize the strong vertical composition created by the decorative marking intended for pollinators.

200mm macro, 36mm extension tube, 7.1 seconds at f/40 and ISO 100, tripod mounted

◀ Using a telephoto macro allowed me to snap this photo that isolated the eyes of this newt.

200mm macro, 1/320 of a second at f/9 and ISO 640, hand held

Extension Tubes and Close-Up Filters

Extension tubes are hollow rings that fit between a lens and the DSLR. Close-up filters, sometimes called close-up lenses, screw on the front of a lens. Both are inexpensive alternatives to a macro lens, or they can be used (either individually or together) in conjunction with a macro lens to get you really close.

Extension tubes let lenses focus closer than their normal minimum focusing distance. This has the effect of magnifying the subject. Since there are no optics in an extension tube, you can expect results on par with the lens being used.

With an extension tube in place, you cannot usually focus to infinity. Another drawback to using an extension tube is that adding a longer tube to the lens cuts down on the light that hits the sensor.

I use the DG extension tube set from Kenko. There are versions of this product that fit many DSLR brands, including Canon and Nikon. The set provides a 12mm, 20mm and a 36mm tube with electronic couplings which enable the light meter automation to work with the extension tubes in place. You can use these extension tubes individually, or together to get even closer. Don't get me wrong: extension tubes are simple devices with not much to go wrong. Any brand is fine.

A close-up filter is a piece of optical glass that screws into the front of a lens and provides magnification. Adding another piece of glass to the front of your lens potentially diminishes optical quality, and this can be a concern because the quality (and price) of close-up filters varies tremendously. Unfortunately, there's no good way to know how well a close-up filter will work until you try it with your particular lens. The good news is that you can get some perfectly acceptable close-up filters quite cheaply from companies not associated with making cameras themselves, such as the German optical firm B&W Schneider.

Both extension tubes and close-up filters can be low-cost and effective ways to enter the world of close-up photography.

◀ This photo shows a small portion of a starfish, less than half an inch long. I used a close-up filter on a Lensbaby to get this close, and I "pumped" the ISO so I could hand-hold the image. I think the result looks a little like the jaw of a prehistoric monster.

Lensbaby Classic, +10 close-up filter, 1/320 of a second using f/5.6 aperture ring and ISO 1000, hand held

▲ I used a telephoto macro equipped with an extension tube to shoot this "self portrait" that's reflected in a door knob.

200mm macro, 36mm extension tube, 1.5 minutes at f/36 and ISO 100, tripod mounted

More Close-Up Gear

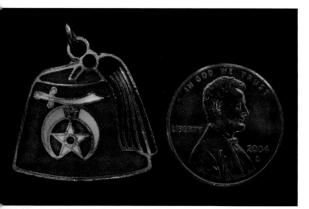

There's quite a bit of close-up gear available beyond macro lenses, extension tubes and close-up filters. Some common items you should know about:

- **Bellows:** Like extension tubes, a bellows fits between your lens and camera. The bellows is flexible black cloth or leather that uses a ratcheted rail to extend or contract. At its most extended, a bellows can get you very, very close to a subject with much the same benefits and drawbacks as extension tubes. It also provides greater flexibility as to the precise magnification you can achieve. One point worth noting in the digital era: bellows tend to collect dust in the folds and this dust seems to migrate easily to your sensor.

- **Lens Reversal Ring:** A lens reversal ring screws into the place where filters normally go at the end of a lens. With the lens turned around, because its front optic is screwed into the ring, the lens reversal ring mounts on your camera. A variation is to start with a macro telephoto lens, and then use a lens reversal ring to attach a reversed normal lens. The normal lens functions like a high-powered close-up filter when reversed.

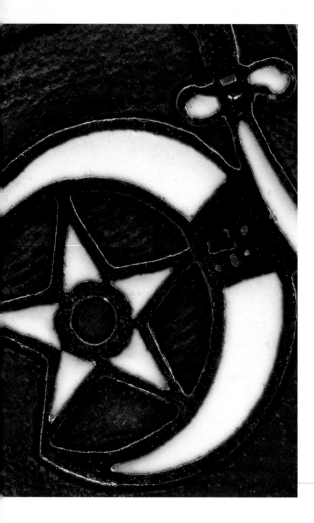

◀ I used a lens reversal ring to get extremely close to a detail in this affiliation pin. You can see how close this photo is by comparing the entire pin to a penny in upper photo.

Top: 50mm macro, 48mm of combined extension tubes, 6 seconds at f/32 and ISO 100, tripod mounted

Bottom: 50mm lens mounted in reverse, 1.5 minutes at f/32 and ISO 100, tripod mounted

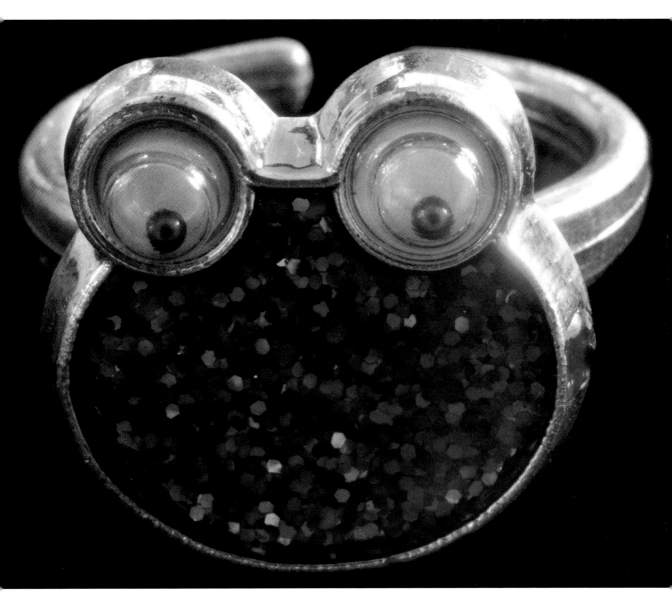

▲ I used a macro lens mounted on a bellows (extended to about 55mm) to get an extreme close-up of this small ring. The advantage of using the bellows was that I could control the exact magnification that I wanted, which allowed me to emphasize the eye pupils in the composition.

50mm macro, extension bellows, 5 seconds at f/32 and ISO 200, tripod mounted

Either setup for lens reversal gets you extremely close with good optical quality, although only at one extreme magnification. To buy a lens reversal ring, you need to know the filter screw size of your lens, which is usually expressed in millimeters.

- *Focusing Rail:* Like a bellows, a focusing rail is extended and contracted on a ratcheted rail. Unlike a bellows, your camera is positioned on the focusing rail using its tripod socket. You leave your camera in a fixed focusing position, and focus by moving your camera backward and forward on the rail. The point is to achieve more precise focus than you can by manually turning a lens barrel. Usually, the focusing rail is itself mounted on a tripod, although sometimes it is clamped directly to a work table.

As you can see, there's quite a bit of close-up gear out there. I'd encourage you to mix and match and experiment. Use some of this hardware in combinations that were never expected! There's nothing like trial and error for learning how this stuff works and for making creative close-ups.

Extreme Macro Photography

When you use the gadgets described on page 54, you'll probably be working at magnifications greater than 1:1. In this realm of the extreme macro, some special considerations come into play:

- Critical focusing is both more important and more difficult than in normal photography. (See page 68 for some suggestions to help with this.)

- The photographic apparatus itself tends to cut down the light that reaches the sensor. (See page 72 for more about macro exposures.)

- Continuous focusing is no longer possible. In other words, an object may be sharp at one distance from the camera when focused one way, and at another distance with a different focus, but not at any of the points in between.

- Looking through the viewfinder can be disorienting. It can be tough to "find" the area you want to photograph, and to know how to move the camera to get your composition.

- Small bits of dust and dirt on your subject have a greatly magnified effect, as you'd expect, since the whole thing is magnified anyway!

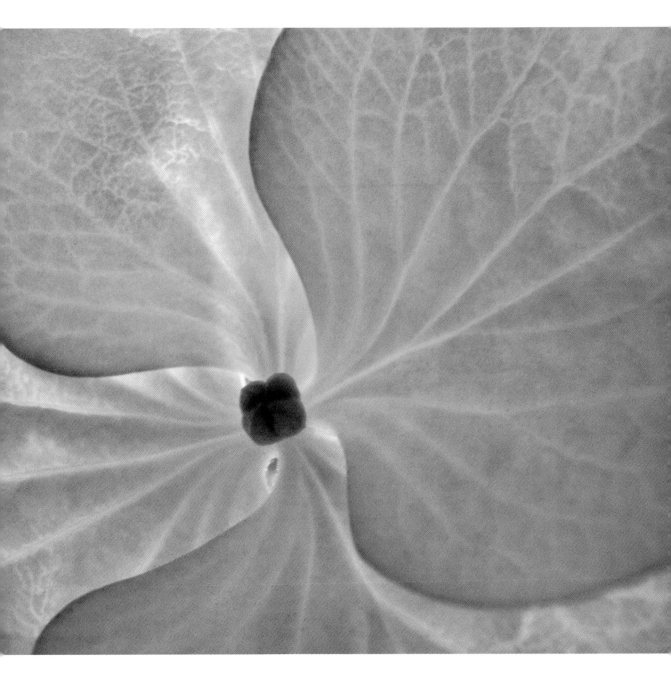

▲ I used a wide-angle zoom lens equipped with an extension tube to get closer than 1:1 magnification with this wide-angle macro of a tiny hydrangea blossom. The combination of unusual gear creates a seldom seen viewpoint—both wide and extremely close.

12-24mm zoom lens at 24mm, 12mm extension tube, 13 seconds t f/22 and ISO 100, tripod mounted

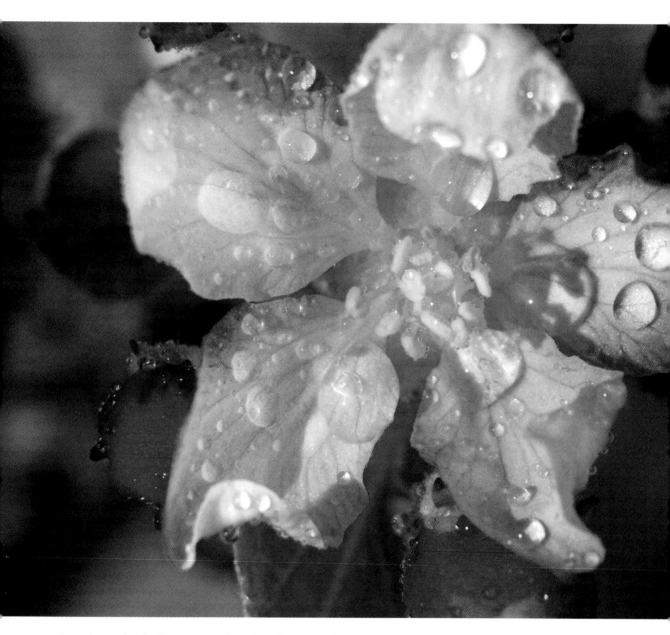

▲ I experimented with adding an extension tube and a close-up filter to my 18-200mm zoom lens (which has an image stabilization feature that's useful for hand holding). I don't think the designer of this lens ever thought it would be used as a macro lens, but it actually does a pretty good job. It creates a different, more soft-focus feel than a standard macro lens, as you can see in this photo of an apple blossom.

To use this combination of gear, with autofocus off, I set a fixed point of focus on the lens barrel. Next, I use the zoom control—rather than the focusing ring—to focus. It is not, as I said, what the designers of the lens had in mind, but it worked.

18-200mm zoom lens at 95mm, 36mm extension tube, +2 diopter close-up filter, 1/250 of a second at f/8 and ISO 100, hand held

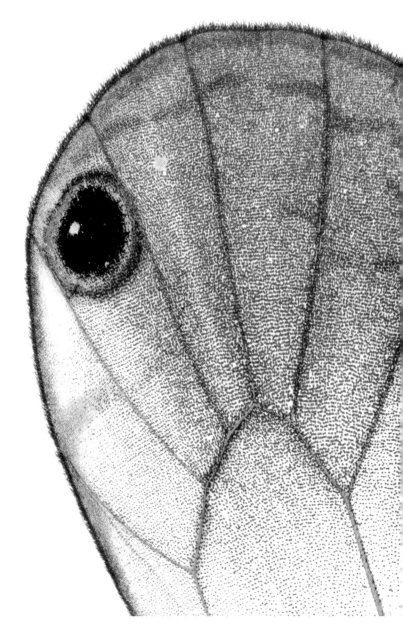

▲ This photo shows the fake "eye" of a butterfly—a pseudo eye on the wing that's intended to give predators the idea that the butterfly is a larger creature than it really is. I used a lens reversal setup to reach extreme magnifications; the apparent grain in the image is actually the delicate texture of the wing itself.

200mm macro, 50mm lens reverse mounted, 1 second at f/40 and ISO 100, tripod mounted

Lensbaby Close-Ups

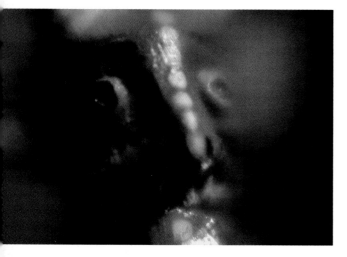

▲ I used the Lensbaby close-up kit to create a macro of a small statuette with emotional overtones. I read the expression on the face as fearful.

Lensbaby 2.0, +10 close-up filters, f/4 aperture ring, 1/320 a second at ISO 200, tripod mounted

The Lensbaby is an innovative lens—or system of lenses—that provides a way to move the barrel of the lens around on a flexible tube. This enables you to change the area of focus, called the *sweet spot*. The point of the Lensbaby is to allow you to control an area of focus within an overall composition that is attractively out of focus.

You don't set the aperture on a Lensbaby; instead, you use magnetic aperture rings that go inside the flexible lens barrel.

The Lensbaby Close-Up Kit provides a +4 and a +10 close-up filter for the Lensbaby. You can use them separately or together. If you choose to get really close by combining close-up filters, be sure that you put the +10 on first, closest to the lens.

The Lensbaby 0.42x Super Wide Angle Conversion lens screws apart to reveal a secret—a really sharp close-up auxiliary lens, which you can experiment with by itself or together with the +4 or +10 close-up filters.

I love playing with the Lensbaby with close-ups attachments as much—or more—than I love playing with the Lensbaby by itself. Truly close-up, this gadget is my baby!

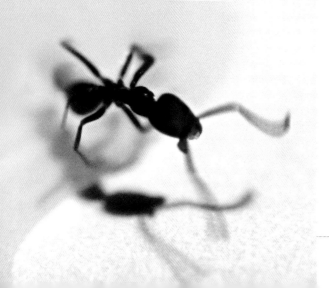

◄ This ant wandered over to where I was shooting still lives and got stuck in the museum gel I use to safely hold objects in place. I used the Lensbaby to create this character portrait of the ant.

Lensbaby 2.0, +10 and +4 close-up filters, f/8 aperture ring, 1/15 of a second at ISO 200, tripod mounted

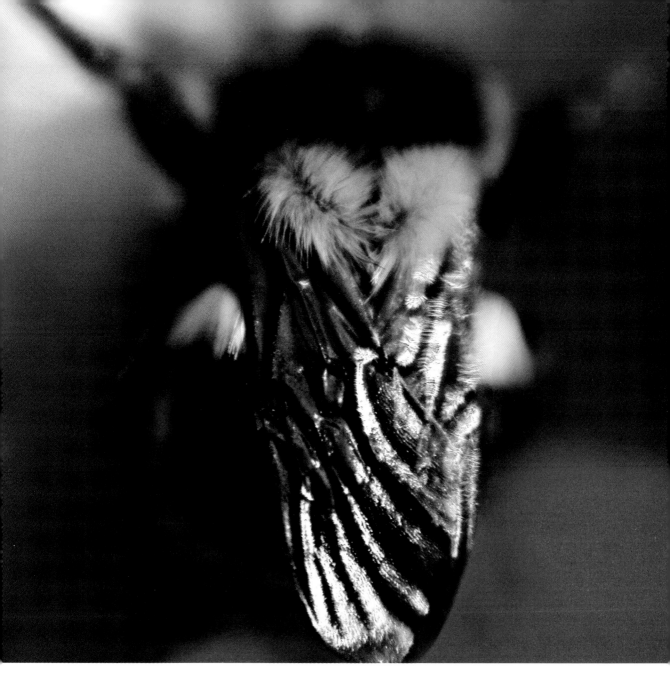

▲ I photographed this bee hand-held with the Lensbaby and macro kit +10 close-up filter with an intention to spot light the wings and "fur ruff" while letting the background go out of focus.

Lensbaby Classic, +10 close-up filter, f/5.6 aperture ring, 1/250 of a second and ISO 200, hand held

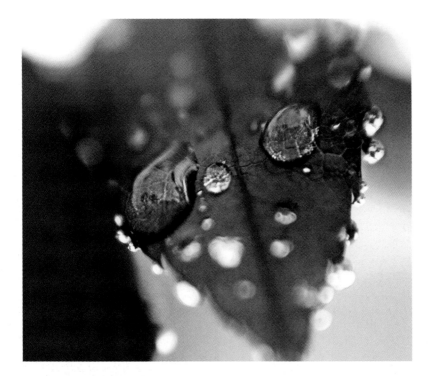

▲ I used a Lensbaby and close-up filters to focus on the drops of water on this leaf while letting everything else go out of focus; the effect reminds me of a leaf critter.

Lensbaby 2.0, +10 and +4 close-up filters, 1/250 of a second with no aperture ring at ISO 200, hand held

▶ This close-up shot of a succulent was shot with a Lensbaby at a high ISO. The highlight areas of the composition blew out because they were overexposed, which is usually not a good thing. In this case, the white from the overexposed areas added to the pattern that makes the photo interesting.

Lensbaby 2.0, +10 close-up filter, f/4 aperture ring, 1/250 second at ISO 1000, hand held

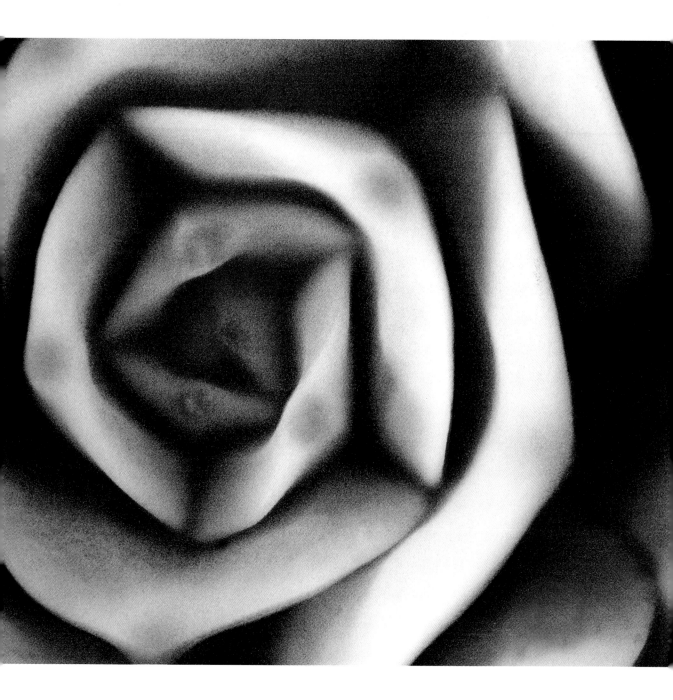

Using a Tripod

There's a very real place for hand-held close-ups using fast shutter speeds (see pages 72–79) or when using a strobe (see page 84). But the bulk of quality close-up photography is achieved with a tripod. This is because the closer you get to your subject, and the greater the magnification, the more impact even slight camera movement has on the sharpness of your photo.

Even apart from the technical consideration of holding the camera steady, a tripod is often an assist in making close-up photos because shifting the camera slightly has a huge impact on composition. When the camera is on a tripod, you can make movements in a controlled way.

It's likely that you will have your tripod longer than your camera, so it is worth investing in a good tripod.

The requirements for a close-up tripod in the field are different from what you need in the studio—although reasonable compromises are possible; you don't have to buy two. A field tripod should be lightweight, preferably with legs made of carbon fiber—the material used in applications ranging from aircraft and artificial limbs to high tech windmill blades.

Weight and portability aren't so important in a studio tripod, but the ability to hold the weight of even the heaviest cameras and lenses is vital.

Professional-quality tripods come in two parts: the legs and the head. When it comes to legs, two of the best manufacturers are *Gitzo* and *Manfrotto*.

Tripod heads come in many varieties; which you choose is a matter of personal taste. That said, a ball head is probably the best choice for close-ups and macros because this style of tripod head allows the greatest flexibility of motion and an ability to put the camera in any position. Kirk Enterprises and Really Right Stuff make good ball heads along with other gadgets for supporting cameras that are useful for shooting close-ups.

If you look at your camera, you'll see that it has a tripod screw hole on the bottom. But the professional-quality ball heads that I've mentioned do not provide the screw to fit. Instead, a quick release plate (sometimes called an *Arca-Swiss* plate, after the first manufacturer of this item) stays permanently attached to the camera with a screw. The plate can quickly and easily, but very firmly, get attached to the tripod ball head.

▶ I attached my telephoto macro lens to the tripod using the socket on the tripod collar of the lens. Since the front element of this lens doesn't change position when I focus, I knew I wouldn't get wax on the lens during this shot; I would be able to maintain a constant distance from the flame.

200mm macro, 0.8 of a second at f/40 and ISO 100, tripod mounted

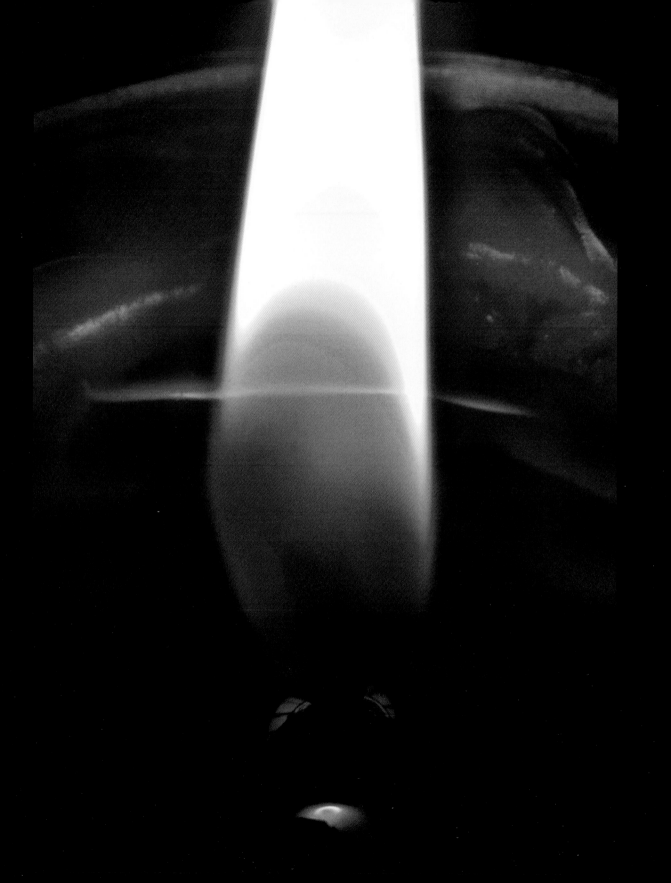

Both Kirk and Right Stuff make a variety of plates designed to fit many camera bodies or lenses with a tripod collar.

It's sometimes possible to improvise camera supports...by putting your camera on a rock, for example. Depending on the weight of your camera, you can also look into other support devices, such as the Gorillapod, a lightweight tripod alternative with flexible legs that can clamp onto poles, rocks, chairs, trees—or almost anything. Some photographers swear by using a beanbag as a lightweight and portable field support (and also for taking photos from a car window).

Getting close to the ground is a problem with conventional tripods. For my close-to-the-ground work, I like to use two products marketed by Kirk. One is the Low Pod Mount (see example on page 14). The other is the Kirk Mighty Low-Boy, a chopped Manfrotto tripod with the center column removed. The point of the Mighty Low-Boy, which is specifically intended for macro photography, is that with the legs spread wide it can rest right on the ground.

You'll find websites for the manufacturers I've mentioned on page 234.

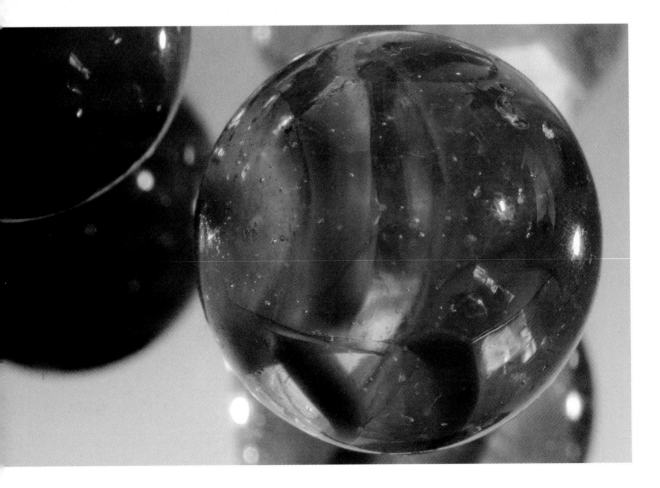

▲ I focused straight down on the eyes of this hermit crab, which was hiding under a rock, and used a moderate aperture to create shallow depth-of-field. That way, only the creature's eyes were in focus. Perhaps I could have hand-held this photo (taken at 1/160 of a second shutter speed); but I'm convinced that by using a tripod, I was better able to create a sharp image and concentrate on focusing precisely rather than holding my camera steady.

It was reassuring to know that the carbon fiber legs of my tripod would be completely undamaged by the salt water they rested in to make this photo.

200mm macro, 1/160 of a second at f/7.1 and ISO 100, tripod mounted

◀ To get down low and close to this marble, I mounted my camera on a Kirk Mighty Low-Boy cut-off tripod and spread its legs wide.

105mm macro, 2.5 seconds at f/40 and ISO 200, tripod mounted

Focusing

Accurate focusing is a crucial issue in close-up photography, whether you are making images with a selective focus or ones that are fully in focus.

If you are going for a selective-focus image, small variations in the point of focus have a large impact on your composition.

Carefully observe the angle of your camera to your subject. Many focus problems can be resolved with slight adjustments to the camera angle; try making the camera more parallel to the subject.

If you are looking to create a close-up photo that is in focus from end to end, you should:

- Position your camera so that it is as parallel as possible to your subject. If the camera is at an angle to the subject, then it becomes harder to end up with the entire subject in focus.

- Stop down your lens to a small opening for greater depth-of-field. (See page 76 for an explanation of depth-of-field and aperture.)

- Pick your point of focus carefully, bearing in mind that there is slightly more depth-of-field behind the focal point than in front of it. For maximizing depth-of-field, assuming that you stop down your lens, the best place to focus is slightly in front of your subject.

Many specialized macro lenses do not have an autofocus capability. Even if your macro lens does autofocus, you should mostly turn it off for shooting close-ups. I say this because precise focusing is crucial for this kind of photography, and autofocus gets it wrong more often than not. At best, autofocusing with a macro lens (or a normal lens at close-up distances) tends to be a slow and clunky affair.

It's worth taking the time to observe your point of focus and the angle of the camera to your subject very carefully, because these issues can make or break a close-up photo.

▶ I used a telephoto macro positioned parallel to this sand dollar, and a magnifying eyepiece for precision focus, to present the sea creature at the structural level. Each of the "dots" in the photo is smaller than a grain of sand and shows the animal at its cellular level.

200mm macro, 36mm extension tube, 2 seconds at f/36 and ISO 100, tripod mounted

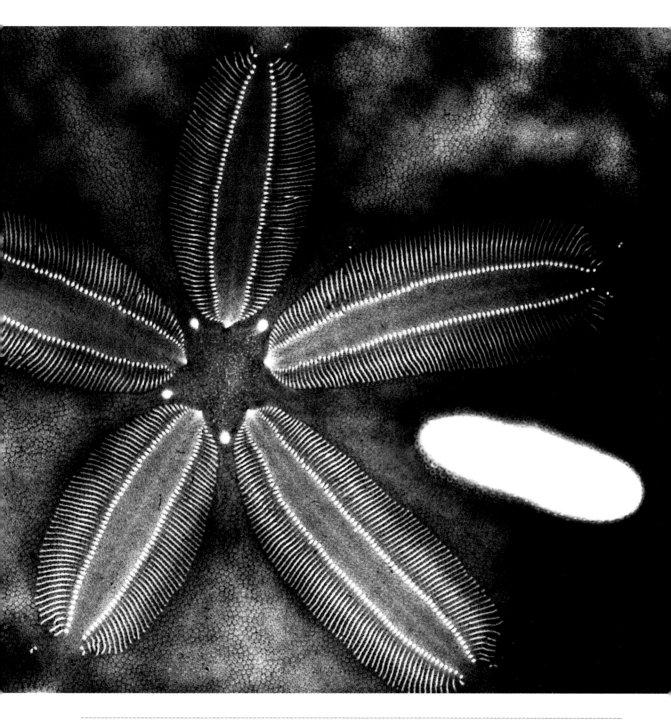

Accessories for precision focusing

I confess: my eyesight isn't what it was a number of years ago. If you are like me, you may find that a couple of simple accessories, available for many DSLRs, can help you focus your close-ups with precision.

A magnifying eyepiece in place of the regular eyepiece on the viewfinder of your camera does exactly what you'd expect. This is a great thing to have as part of your camera kit. I've often had the experience of thinking I had focused optimally with my normal eyepiece; but after slipping on the magnifying eyepiece just to check, I've found that my focus was slightly off.

A right-angle finder attaches to the eyepiece of your viewfinder and then swivels at a 90-degree angle. My right-angle finder also magnifies the image; but I'm not very happy with this feature, because (unlike my magnifying eyepiece) it cuts off so much of the image when magnified that I can't really compose with it. So I use my right-angle finder for situations in which I can't see through the viewfinder because of camera position, such as when the camera is close to the ground.

▶ To create this selective-focus image, I used a Lensbaby and close-up filter. I positioned the camera parallel to the Poppy and made sure that the center of the flower was in focus.

Lensbaby Classic, +4 close-up filter, f/4 aperture ring, 1/125 of a second at ISO 200, handheld

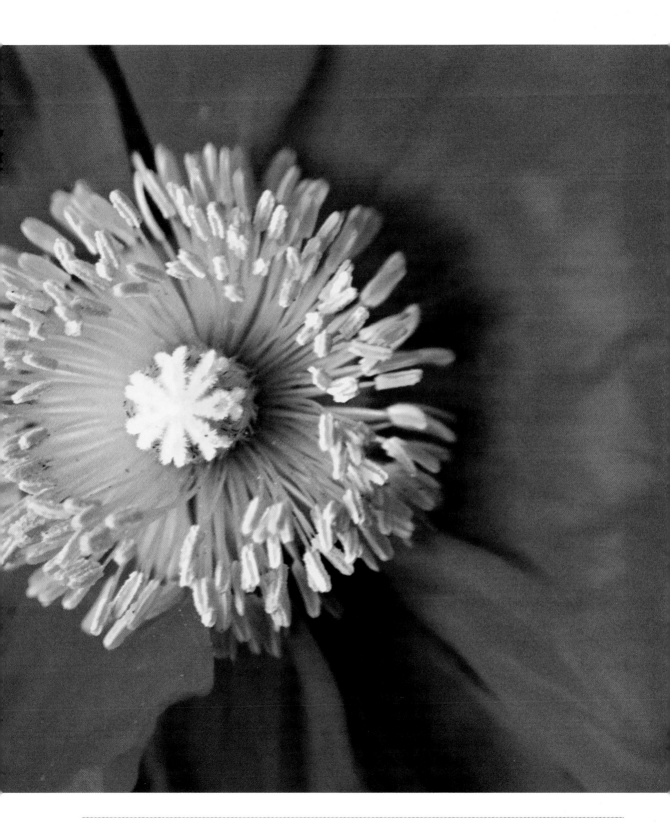

Exposing Close-Ups

An *exposure* represents the amount, or act, of light hitting the camera sensor. It is also the camera settings used to capture this incoming light.

Given a particular camera and lens, there are three settings that are used to make the exposure: shutter speed, aperture and sensitivity.

- *Shutter speed* is the amount of time that the camera is open to receive incoming light. In other words, it is the amount of time that the sensor is exposed to light coming through the lens. With close-up photography, it is not uncommon to have shutter speeds in the seconds, because many close-up subjects don't move.

- *Aperture* is the size of the opening in the camera's lens. The larger the aperture, the more light that hits the sensor. The size of the aperture is called an *f-stop*, written f/n, and n is also called the *f-number*. Somewhat confusingly, the larger the f-number, the smaller the hole in the lens; and the smaller the f-number, the larger the opening. *Depth-of-field*, the field in front of and behind a subject that is in focus, depends largely upon aperture. You'll find more about aperture, depth-of-field and close-ups starting on page 76.

- *Sensitivity* determines the degree to which a sensor is affected by light. Sensitivity is set using an ISO number; the higher the ISO, the more sensitivity to light.

Changing any of the three exposure settings impacts the lightness or darkness of your photo. So, assuming you want to keep your photo constant, if you change one setting, you also need to change another to compensate. Each of these adjustments has compositional implications.

Balancing the relationship of shutter speed, aperture and sensitivity is filled with possibilities and constraints that change the way your photos turn out. For more information about exposing photos, see the suggestions for further reading on page 234.

Using Exposure Histograms

A *histogram* is a bar graph that shows a distribution of values. An *exposure histogram* shows the distribution of lights and darks in an exposure. Check your camera manual for details on how to display exposure histograms.

In light conditions where you can't see your LCD screen (when it is very bright), a histogram is an invaluable aid to exposure.

▶ To create this nautilus shell image, I had to overexpose relative to my camera's overall average reading of the light. Otherwise, the details of the chambers in the shell would have been too dark; "overexposing" the all-white background didn't matter.

50mm macro, 8 seconds at f/32 and ISO 100, tripod mounted

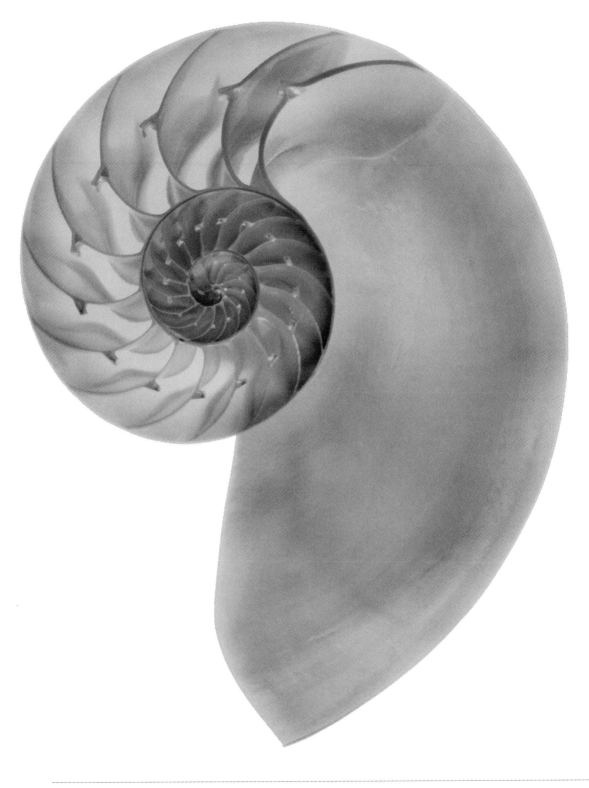

Aside from being unable to review a photo because of brightness, a histogram can help you figure out how to expose your image in many other situations.

The exposure histogram of an underexposed photo is bunched to the left, and the exposure histogram of an overexposed photo is bunched to the right. A theoretically "correct" exposure will be represented by a histogram with a bell-shaped curve smack dab in the middle. However, it sometimes makes sense to deviate from the "correct" exposure, which may be based on an overall average. Try deviating in favor of a "creative" exposure that is intended to capture a specific part of the composition or to emphasize certain tonal values.

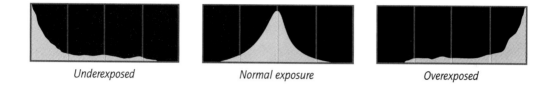

| Underexposed | Normal exposure | Overexposed |

Magnification and Exposure

Exposing a close-up photo is not much different from exposing any other photo, except that by adding to the length of the lens tube—for example, when you focus close with a macro lens or add an extension tube between your lens and camera—you cut down the amount of light that reaches the sensor.

Depending upon the lens and close-up equipment, at a 1:1 magnification, you can lose as much as two f-stops. With a two f-stop loss, the lens would let in 1/4 of the light it would in normal focal ranges; for example, a nominal aperture of f/5.6—the aperture set on your lens or in your camera—would become an actual aperture of f/11. If you use an extension tube, you will further cut down the amount of light hitting the sensor—more than if you only use a macro lens.

At other magnifications, the formula for the loss of light hitting the sensor is roughly:

Effective Aperture = Lens Aperture • (1 + Magnification)

Since you can usually use the light meter in your camera for your close-up work, you don't really need to quantify the adjustment for loss of light due to magnification, because the camera does it for you.

Still, you should know that you are reducing the light hitting the sensor by getting close. In addition, some equipment—such as a lens reversal ring—is simply not going to coordinate very well with an onboard exposure meter.

Fortunately, with digital you get instant feedback on your exposure after you've taken your photo. But when you're calculating your initial exposure in situations that baffle your camera's meter, you'd do well to remember the exposure impact of magnification.

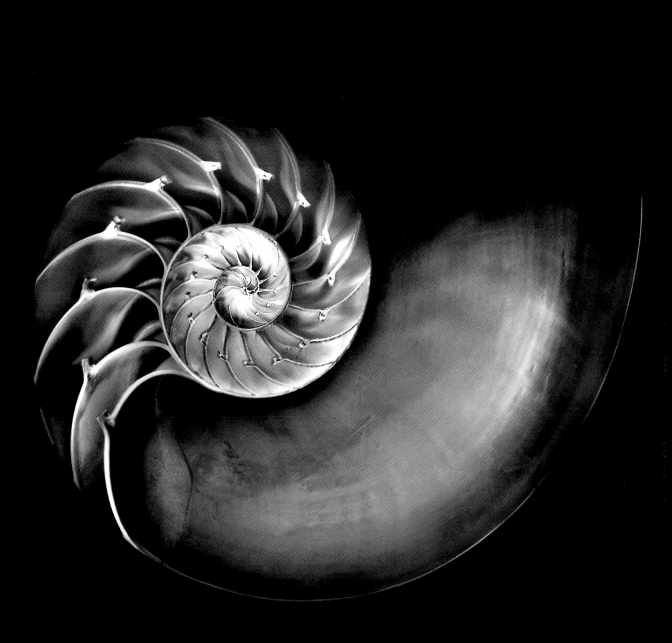

▲ This version of a nautilus shell was shot on a black background, so I needed to "underexpose" relative to my camera's overall average reading of the light. If I hadn't, the details in the shell would have been too light; "underexposing" the all-black background didn't matter.

50mm macro, 3 seconds at f/32 and ISO 100, converted to black and white in Photoshop, tripod mounted

Aperture and Depth-of-Field

The *aperture* is the size of the opening in a lens. The smaller the aperture opening, the larger the f-number that's used to designate the aperture.

An f-stop is one over the f-number. So f/36 refers to a very small opening in a lens, whereas f/3.5 refers to a much larger opening. If, say, the lens can't be opened any wider than f/3.5, then f/3.5 is called the *maximum aperture* of the lens.

As already noted, depth-of-field is the distance in front of and behind a subject that is apparently in focus. If your image has a great deal of depth-of-field, then more of it will be in focus; whereas, if a photo is low in the depth-of-field department, important portions of the image can be in focus and isolated from an out-of-focus background.

The closer you go, the more important depth-of-field becomes because the range of distances that are in focus get shallower. At 1:1 magnification ratios (or greater), we are looking at paper-thin edges.

All other things being equal, aperture controls depth-of-field. Some other factors that have a bearing on depth-of-field are sensor size—smaller sensors provide more depth-of-field at a cost, as I explain on page 46—and the focal length of the lens. The longer the lens, the less depth-of-field, as explained on pages 48–51.

You also need to pay attention to where you focus and the camera's angle in relationship to the subject. (For more about this see pages 68–71.) Camera position and angle doesn't impact the amount depth-of-field per se, but it does have major consequences in terms of how much of your photo is in focus.

By the way, depth-of-field should not be confused with sharpness, which also depends on variables such as optical quality, atmospheric conditions and so on.

The smaller the lens aperture, the more depth-of-field there is. At its maximum aperture, say f/2, a lens has almost no depth-of-field; at intermediate apertures, such as f/11 and f/16, there is some depth-of-field; and at the minimum aperture, say f/36, there is a great deal of depth-of-field.

To visualize the impact of your depth-of-field choice on your photo, you can snap the picture and view the results in your LCD. If you don't like what you see, change the settings and try again. You can also use the depth-of-field preview. (Check your camera manual to find the location of this control.) The depth-of-field preview on a

▶ For this not-so-close close-up of an antique typewriter, I wanted the typewriter completely in focus. I used a normal angle macro lens (50mm), focused on the middle row of keys, and stopped the lens down to its smallest opening (f/32) for maximum depth-of-field.

50mm macro, 0.6 of a second at f/32 and ISO 100, tripod mounted, converted to black and white with sepia tint in Photoshop

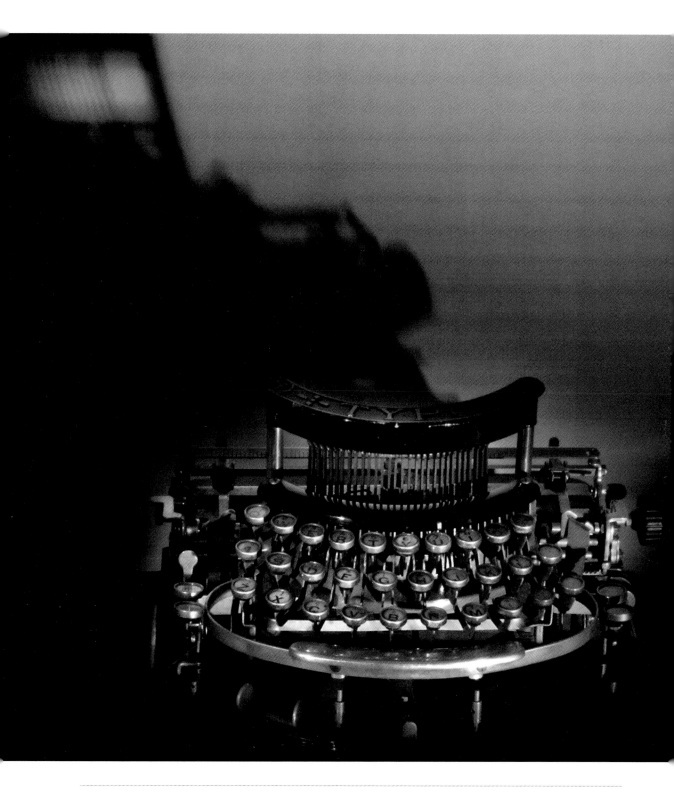

DSLR lets you look through the lens while it's stopped down. However, it may be hard to see anything in the dim light of a lens when it is fully stopped down to a small aperture, as is the case for many close-ups.

Some cameras let you check depth-of-field in real time in the LCD using a "live view" mechanism. (Check your camera manual to see if yours has this feature, and for details.)

As I've mentioned, depth-of-field is a critical issue for many macros because at greater magnifications, focus is inherently shallow. Before you jump to the conclusion that you should therefore stop your lens all the way down to its smallest aperture to get the most depth-of-field when shooting macros, bear in mind that there is a loss of optical sharpness due to diffraction—the bending of light rays—at macro magnifications when you use a small, stopped down aperture. When I need them, I tend to use these small apertures regardless of the diffraction effect, but keep this in mind. Also note that the impact of diffraction varies, depending upon your lens.

You may want to run tests on your lenses at one close-up magnification and different f-stops to see if you notice any difference in optical sharpness when you blow up the resulting photos.

▶ The idea for this photo was to isolate the typewriter key used to type French accents, because it looks like a little funny face. This meant it was important to keep the circumflex (^) key sharp, while letting everything else in the image go out of focus.

To achieve a shallow depth-of-field, I used a telephoto macro lens opened up to its widest aperture (f/4.5), and I used a magnifying eyepiece for precise focus on the key.

200mm macro, 1.3 seconds at f/4.5 and ISO 100, tripod mounted, converted to black and white with sepia tint in Photoshop

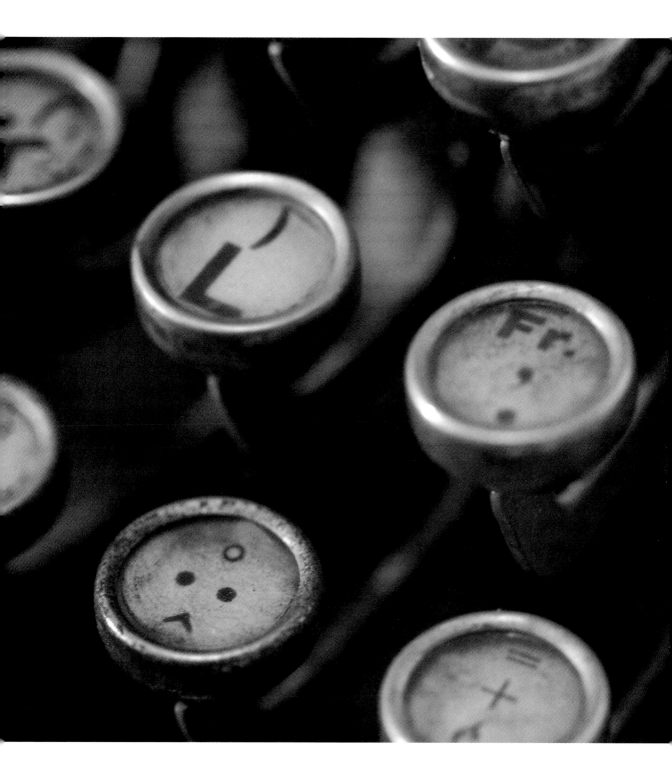

Lighting Close-Up Photos

The word *photography* comes from the concept of "writing with light," so it's not surprising that lighting plays a crucial role in photography. The topic of lighting includes both the ability to accurately analyze existing light and how to light a subject artificially. Since the subjects of close-up photos are small in size, and close-ups are often shot in controlled environments, lighting close-ups is actually easier than lighting photos on a larger scale.

If you are capturing close-up subjects in motion and don't want a motion blur effect, there are only two approaches to consider. One, you can boost the ISO so it is high enough for a fast shutter speed. This will increase the level of noise in your photo, but perhaps not to unacceptable levels. Also, cameras are getting better at processing noise all the time.

The other approach for "stopping" motion is to use a flash, also called a *strobe*. (See pages 84–87 for information about using macro flash to light close-up photos.)

Close-up photography can generally be divided into studio work and field photography. For the record, my studio is my home and vice versa.

In a studio, when it comes to close-up still life work, there are a great many lighting options you can use that create great lighting effects without requiring fancy equipment. You'll find information about lighting close-ups in the studio starting on page 168.

In the field, lighting options are more limited. If you are not using flash, you can augment light with a portable device such as a powerful flashlight. You can also use metallic or white boards to reflect light into a macro subject.

But the truth is that most of the time my field close-up work relies on an ability to place myself in the path of "good" light. To do this requires skills in observing light. As you might expect, learning to closely observe light is very important in the studio as well.

There's no cookie-cutter approach to finding out when light is going to work for field close-ups, so I use the Internet to learn as much as I can about topographic and atmospheric conditions when I'm on a field shoot. For close-ups, I often look for overcast but bright days with a touch of moisture in the air.

Be mindful of the intensity, quality and direction of light. *Intensity* refers to how

▶ In my studio, I placed this semi-transparent pencil shaving on a fluorescent lightbox to backlight it. I intentionally overexposed the image to create a high-key lighting effect. (See pages 102–107 for more about high-key lighting.)

200mm macro, 36mm extension tube, 0.4 of a second at f/13 and ISO 100, tripod mounted

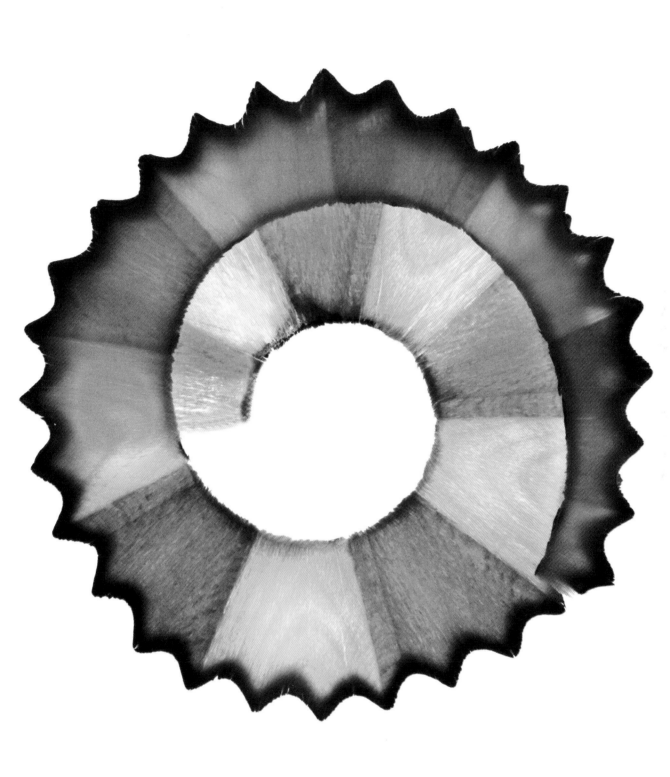

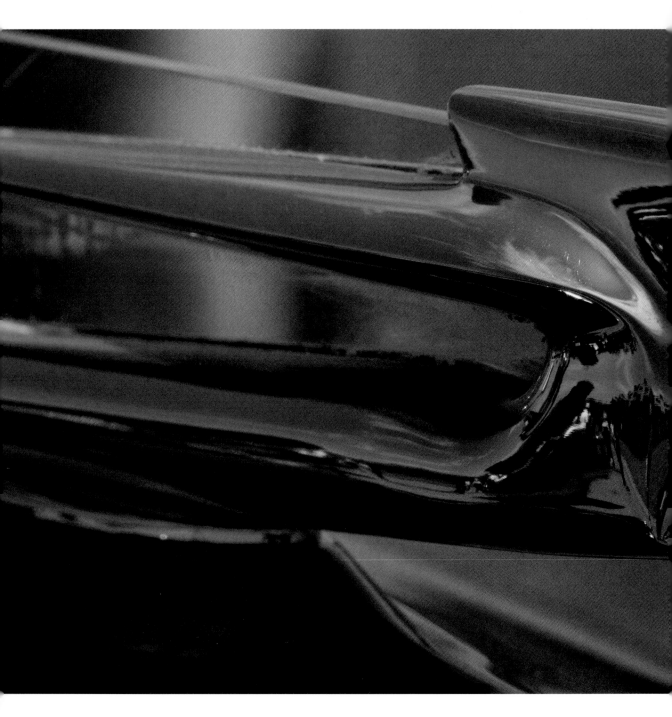

▲ At an outdoor classic car show, I observed that the sun was front lighting this hood ornament. I carefully positioned myself and tried a variety of apertures to create the biggest possible "star" effect of the sun hitting the ornament.

200mm macro, 1/200 of a second at f/16 and ISO 100, tripod mounted

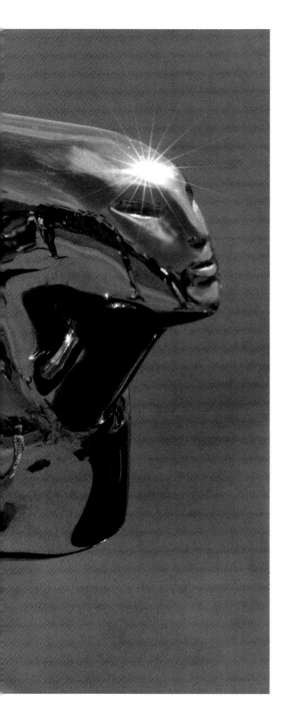

strong light is. *Quality* is basically a measure of to the color temperature of the light, referring to where the light fits on the visible frequency of light waves. No doubt, this measure is in part subjective.

The *direction* of light is usually described in relation to the subject of a photo, as shown in the table. Of course, in many cases light is coming from a number of different sources at once. I make it a point to observe the direction (or directions) of light hitting my subjects no matter what the subject is—from flowers and people to mountains and bridges—and certainly in my close-up work. If you don't understand the direction of light, then you don't really know what you are photographing.

Front lighting	Illuminates the front of the subject and is usually coming from behind the photographer. It's great for illuminating details in a subject but may cause blown-out highlights (see example page 82).
Back lighting	Comes from behind the subject and is, roughly speaking, pointed at the camera. This can be used effectively as a specialty lighting direction with translucent subjects or to create a halo effect (see example page 73).
Side lighting	Predominantly hits the sides of the subject; a strong light with distinctive shadows can work well, particularly when side lighting from several different directions is involved (see example page 79).
Bottom lighting	Generally not flattering and (when it comes to portraits) has been called "monster lighting." However, some interesting close-up effects are possible with bottom lighting that isolate a bottom-lit subject from the rest of a dark composition (see example page 77).
Top lighting	Can flatten subjects in an unflattering way and is therefore not usually appreciated in general photography. However, in close-up work, a strong but diffused top light can be ideal (see example page 66).

Using Macro Flash

There are many good reasons to use flash to light close-up photos. Some things to consider:

- Flash allows you to stop motion without having to jack up the ISO.

- Flash units used to light close-ups are probably more portable than any other artificial lighting setup.

- Flash has roughly the same color temperature as sunlight, so it works very well with natural light.

The number one rule of quality flash photography is to get the flash unit off your camera, because an on-camera flash unit almost invariably produces harsh front-lighting. If you decide to disobey this prime directive, be sure to take off your lens shade, which will probably produce a large, unattractive shadow when used with a built-in flash.

You can use almost any separate flash unit to effectively light close-ups. A bracket attached to your camera gets it off the camera. Or you can hold the flash or clamp it to a light stand or other support. It's easier to position the

► Using a telephoto macro lens let me get far enough away from my close-up subjects to use flash units mounted on a ring on the front of the lens. However, when photographing a reflective surface like a water drop, if you light them with strobes, the reflections in the drops will change, depending upon the position of the strobe itself. So to create this photo, I experimented with hand-holding one of my macro strobe units in a variety of positions to see what worked best for creating an interesting reflection in the water drop.

200mm macro, 36mm extension tube, 1/60 of a second at f/40 and ISO 200, two wireless strobe units (one attached to the front of the lens, the other handheld), tripod mounted

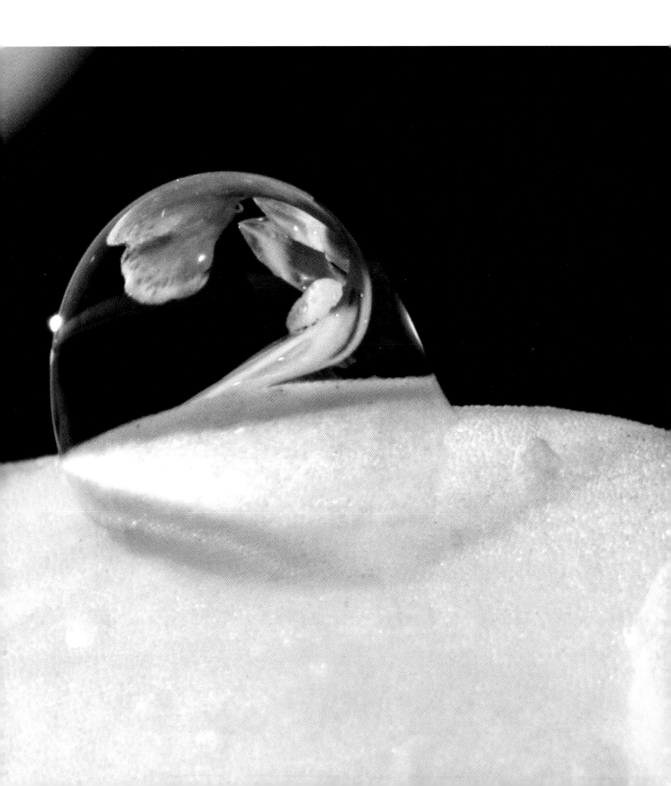

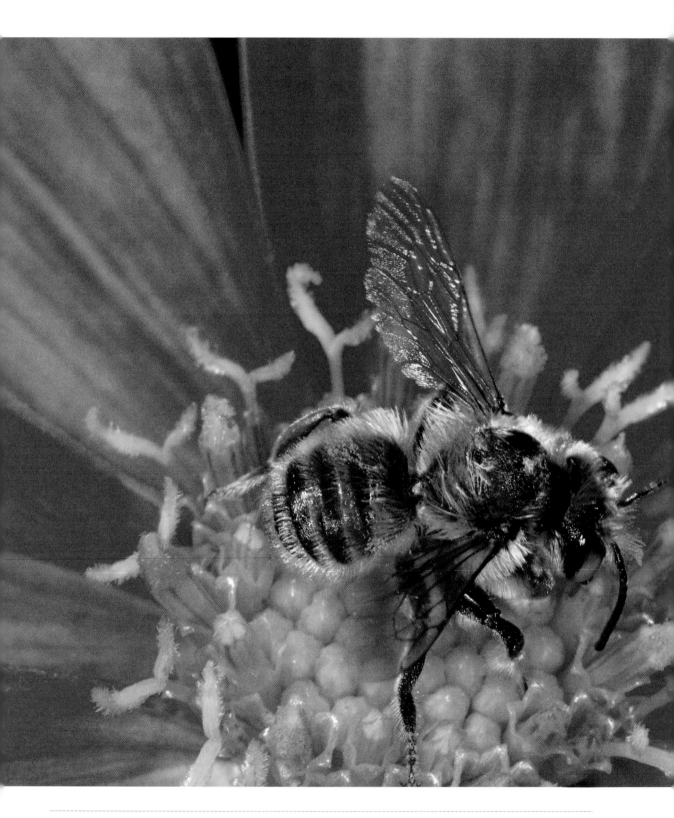

flash well away from your camera when it is controlled wirelessly—a standard feature in many DSLRs.

To get a better quality of light, bounce the flash off the ceiling, add diffusers and experiment with adding cardboard modifications to the front of the flash. Several flash units positioned in different locations work better than a single unit.

For close-up subjects, use flash units specifically designed for macro work. It's possible to buy ring flashes that fit on the end of a macro lens for this purpose, but I prefer to use two small flash units designed for macro work. These strobes are triggered wirelessly from the camera in aperture-preferred or manual mode. In this setup, the camera is the *controller* and the macro flash units are its *slaves*.

For convenience, I can attach both units to a ring that screws into the filter holder on most macro lenses. It's very effective to light a subject from two sides—one side per unit.

I can also use these units in conjunction with a larger strobe that creates background lighting. In this case, the strobe becomes the controller and the small flash units—usually positioned closer to the subject than the bigger unit—are its slaves.

If macro flash intrigues you, I suggest jumping right in. You'll find that hardware costs are not too high, and automation built into cameras and flash units makes it pretty easy to learn the process of lighting close-ups with small flash units.

◀ I used two wireless macro flash units attached to a ring on the front of my lens to stop the motion of this bee in flight on a Dahlia.

200mm macro, 1/60 of a second at f/16 and ISO 100, wireless strobe, tripod mounted

Botany of Desire

Michael Pollan's fascinating book *The Botany of Desire* explores the question of who is the boss: Do we cultivate flowers because they happen to be beautiful? Or, have flowers made themselves beautiful to people so that we will cultivate and spread them? Are people manipulating flowers, or do flowers manipulate people?

This question of who is doing what to whom comes up in the general context of human desire, and it's a safe bet that the truth is a bit of both. There's usually a complex interlocking relationship when it comes to appearance and desire. Undoubtedly, people find flowers and other plants decorative. Equally unquestionable, the history of human cultivation of decorative plants has manipulated the genetic course of these botanicals to make them evolve toward our culturally idealized sense of plant perfection.

There is a connection between the botany of desire and flower photography, but

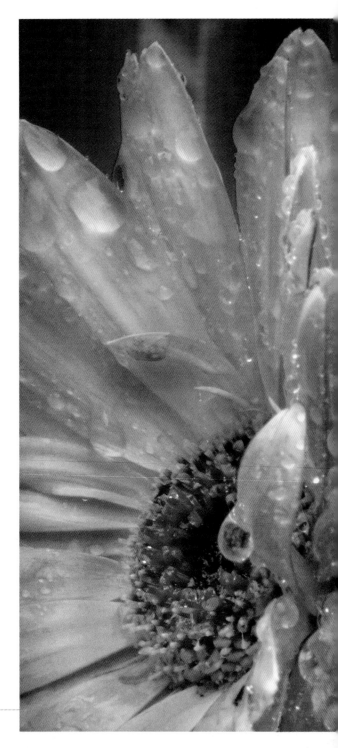

▶ Flowers that are wet with drop from an early morning rain, like these Gerbera, are always more attractive to me than flowers than have not been moistened. I often try to get out to photograph flowers first thing in the morning.

200mm macro, 0.7 of a second at f/36 and ISO 100, tripod mounted

▲ Pages 88–89: Roses have been cultivated for centuries for their luscious perfection. I photographed this rose to emphasize the romantic spirals at the core of the flower.

105mm macro, 1 second at f/36 and ISO 100, tripod mounted

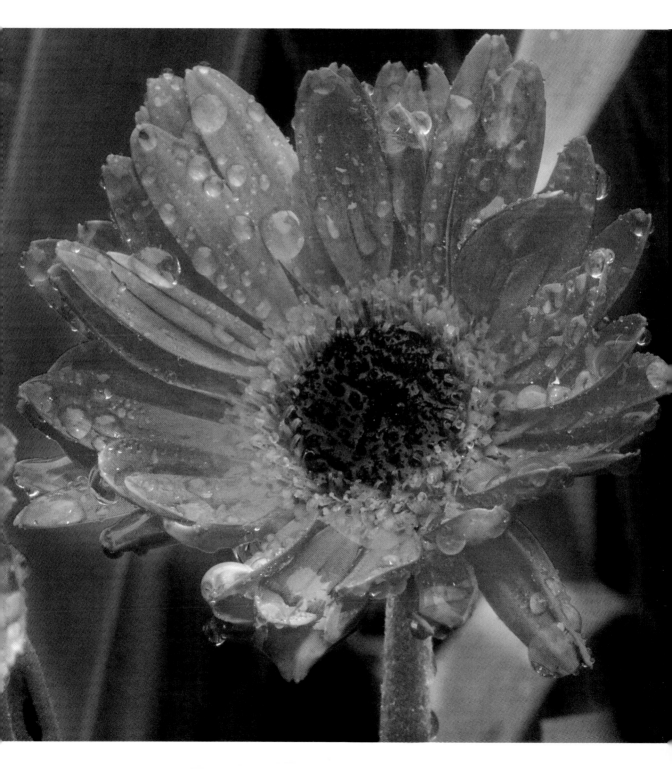

before I get there, consider that humans may not be as important to flowers as other species. Flowers need to be concerned about attractiveness to their natural pollinators.

Many of the striking markings we see (and don't see) on flowers are designed to attract bees, pollinating insects and hummingbirds. Some of these "decorations" show the pollinator where to go, in much the way that runway markings direct an airplane pilot to land.

Your close-up photography of flowers will be more powerful if you take the time to become familiar with the aspects of the botany of desire.

For instance, when I'm looking closely at a flower, I always like to consider:

- The reproductive systems of the plant; I want to understand the sexual organs of a flower I photograph and how the parts of this system relate to each other.

- Markings that flowers use to entice pollinators, such as the "flight path" on an Iris (see page 106).

- Flowers and fashion; what is particularly attractive in a human sense about the flower in front of me?

On the first of these topics, here's a bit of Botany 101 for flower photographers.

Each flower has both male and female reproductive organs. The stamens are the male sexual organs of each flower. The stamen consists of the anthers at the top of a delicate stalk and the stalk itself, called a "filament." The anthers host the pollen used

◀ This orchid has an extremely unusual male reproductive organ—anther and filament. From this angle, the flower looks almost like an art deco sculpture to me.

Original Lensbaby, 1/250 of a second with no aperture disk at ISO 400, hand held

▶ This photo shows the sexual apparatus of an Easter Lily, a flower from a bulb originally imported from Japan. The bird's eye view of pistils drenched in pollen attracts both pollinators and humans.

200mm macro, 36mm extension tube, +4 close-up filter, 2 seconds at f/40 and ISO 100, tripod mounted

for fertilization. You can see anthers clearly in the photo of an Easter Lily on page 93 and the stamen clusters in the photos on page 96-97.

While each flower has a number of stamen, the flower has only one pistil, the female sexual organ. The stalk of the pistil, which can be seen in the photos on pages 96-97, is called a "style."

In the pictures on page 96-97, you can't really see the "stigma" (it would be at the top of the styles shown in these photos) or the ovary at the base of the pistil. (The poppy version of the ovary is the green center core shown in the photo on page 95.)

We tend to think of the ovary in non-botanical and imprecise terms as the flower's "bud"; although this is approximately right, it isn't always precisely true. Another great photographic example of a flower ovary is shown in the transparent anemone image on page 107.

Of course, great flower photos are not really about botany and the sexual parts of flowers, unless the photos are gracing a botany textbook.

Great flower photos are about color, lines and grace. But no knowledge is wasted. The more you know about flowers, the more likely you are to make close-ups of these gorgeous life forms that go a step beyond the ordinary. Like some human beings, flowers present their "private parts" brazenly, coyly or matter-of-factly. Your approach to photography of these aspects of a flower should vary depending upon the presentation made by the flower.

▶ This photo of a wet poppy clearly shows the flower's ovary, pistils and stamen as well as pollen that has mingled with the rain drops. The forthright presentation of the flower's reproductive organs is partially what gives the image interest and power. Perhaps the contrast between these parts of the flower and the signs of its swift life cycle is what gives this photo poignancy. The pollen has, after all, mixed with the rain drops and can no longer be gathered.

200mm macro, 1/25 of a second at f/36 and ISO 200, tripod mounted

▼ Pages 96-97: These photos show a group of stamen standing upright, anthers waving in the breeze. The stamens are grouped around a single style, which is perpendicular to the stamens. The stamen cluster is apparently holding the style in a posture that is reminiscent of dancing.

Page 96: The style is part of a pistil with stigma to the left (out of the photo), and it comes out of an ovary to the right (also not visible).

50mm macro, 24mm extension tube, 1 second at f/32 and ISO 100, tripod mounted

Page 97: Compared to the photo on page 96, the camera is pulled back a bit in this view. From further back, the stamen appears to dance around and embrace the pistil.

200mm macro, 36mm extension tube, 1.6 seconds at f/45 and ISO 100, tripod mounted

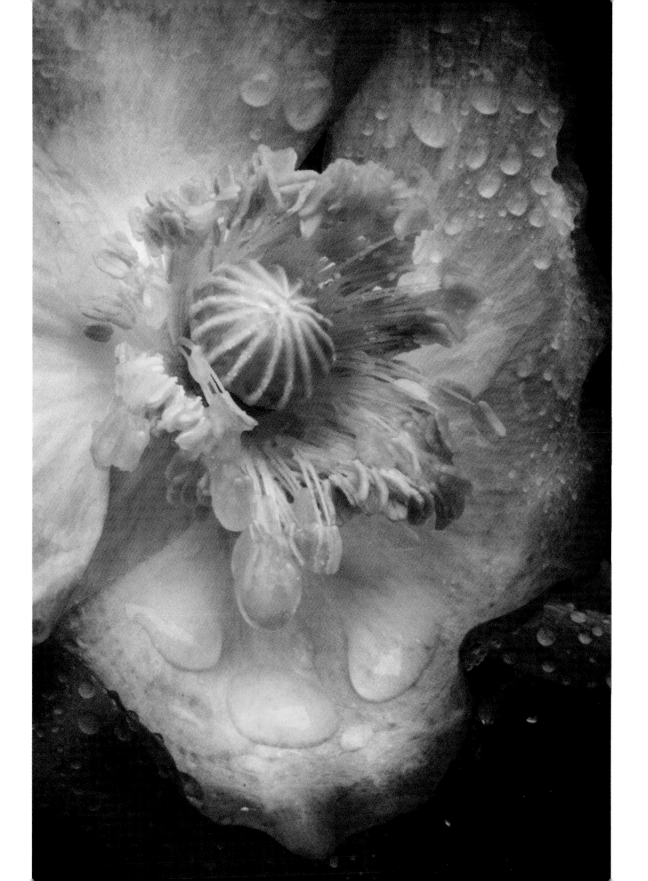

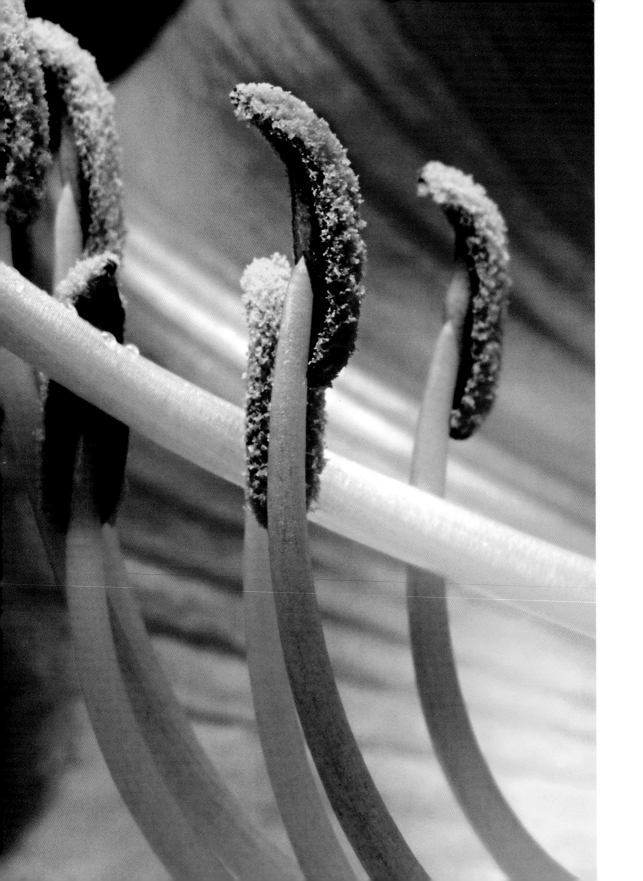

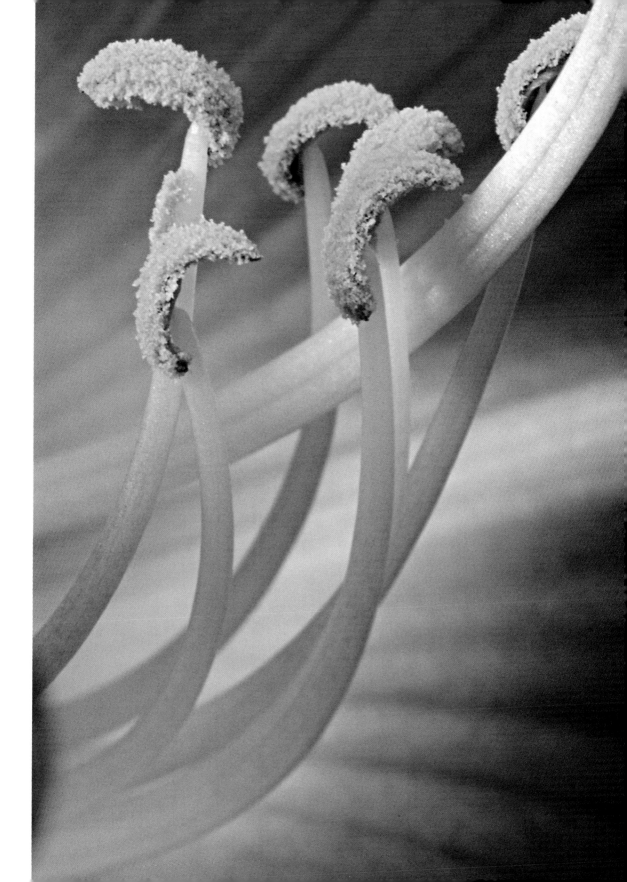

Flowers and Light

On page 90, I wrote about "the botany of desire," and covered some of the things that make flowers a special subject matter to so many photographers. Viewed another way, as Gertrude Stein put it, "a rose is a rose is a rose"; to me meaning it's just another object to be photographed. As with anything you photograph, when seen this way, the key issue is lighting and how it interacts with the flower.

Flowers can be successfully photographed indoors, where you can control the lighting. Also, in a studio you don't have to worry about movement from the wind spoiling long exposures. When I first started photographing flowers, I was hesitant to bring my flower close-up work indoors

▶ I cut a bunch of these poppies, Papaver rhoeas, from my garden and arranged them on a fluorescent lightbox to best show off the beautiful translucent reds of these petals. The trick to this kind of studio flower photo lies in arranging the flowers in a pleasing way You should also overexpose the image, because brighter photos appear more transparent.

85mm Perspective Correcting macro, 8 seconds at f/51 and ISO 100, tripod mounted

▼ It rained overnight. In the first light of the morning sun, I photographed the translucent petals of this Rose (Rosa 'Rio Samba'), lush and drooping from the weight of the water. A moment later the sun had moved on and was no longer hitting the water drops.

200mm macro, 1/80 of a second at f/40 and ISO 200, tripod mounted

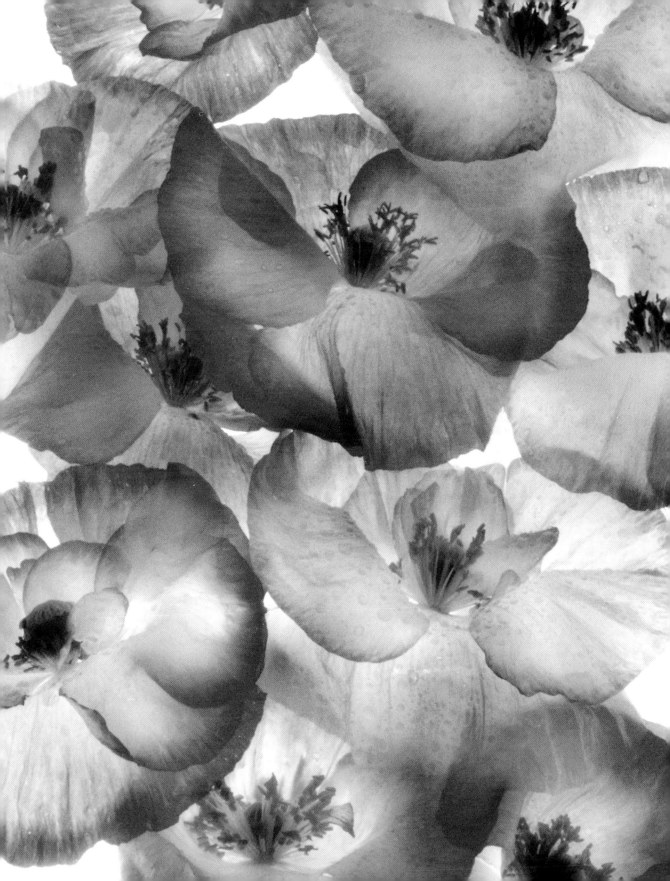

because I was afraid that the results would look unnatural. But as my technique has progressed, I've come to see controlled photography of flowers in the studio as complementary rather than competitive to outdoor flower photography. For example, I use the studio on days when the outdoor weather prohibits working because the light is "no good."

Indoors, I like to photograph flowers against a black background (see pages 108–111) or on a lightbox for a very white "high key" effect (see pages 102–107). Either way, you'll probably need to light your subject at an angle from the front, using a somewhat diffused light source. See pages 80–83 for information about the direction of lighting and see pages 202–211 for more information about lighting close-ups.

Outdoors, the key issues are perception and patience: perception because you need to be able to clearly see the effects of natural light on the flowers you want to photograph close-up, and patience because getting good results depends upon waiting for just the right light.

While waiting for perfect lighting conditions in the garden takes time, the good news is that it is almost always a wonderful place to wait and meditate about the state of the universe. When I've spent a great deal of time waiting for the light to become "right" in the garden, I've noticed alternative subjects to photograph that I probably wouldn't have seen if I were rushing through the motions of photography without pausing to observe.

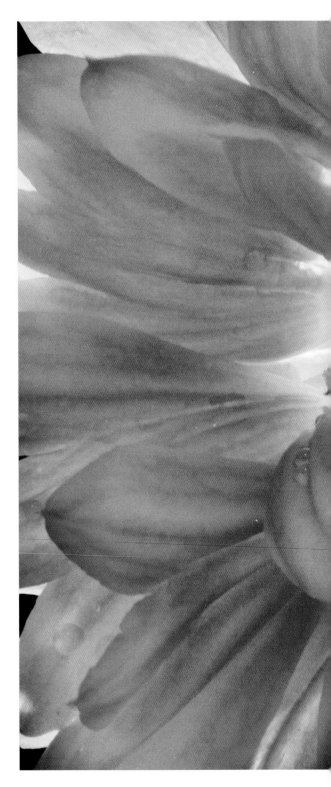

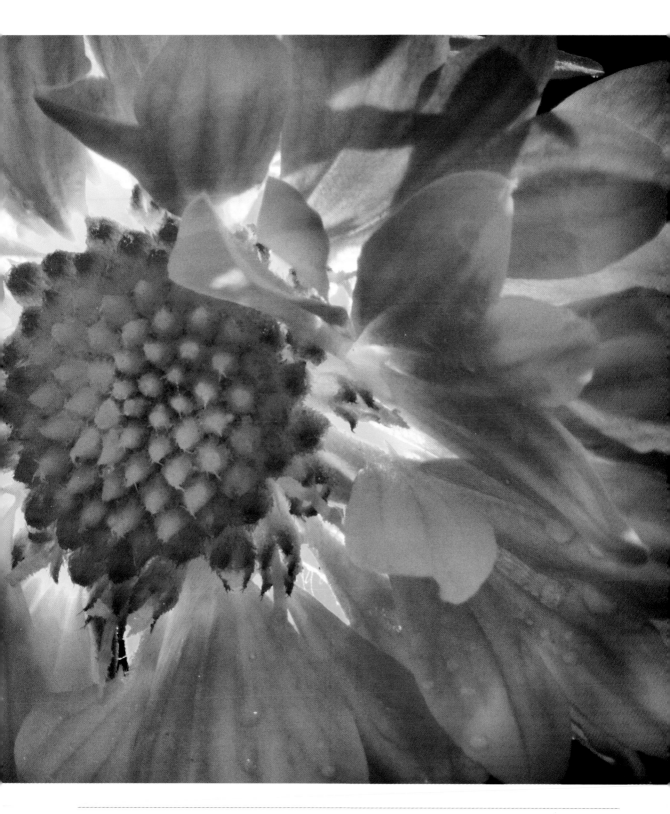

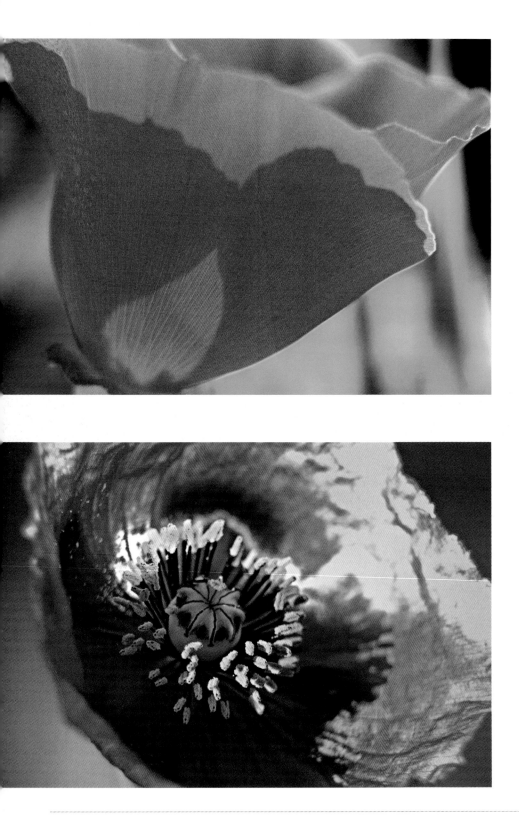

▲ Pages 100–101: To create this studio image, I placed this Gaillardia x grandiflora on a black background and lit the front of the flower using natural light and a diffuser. Then I used an LED light to shine pinpoint light from behind the flower at the center of the Gaillardia.

200mm macro lens, 36mm extension tube, 4 seconds at f/36 and ISO 100, tripod mounted

▶ Calypso Orchids grow wild and close to the ground in shaded forests on the slopes of Mount Tamalpais, California, for a few weeks in the spring. I try to make a pilgrimage to photograph them every year.

This specimen held still for me for a full-second exposure as the dappled sunlight came through the forest cover.

105mm macro, 36mm extension tube, 1 second at f/36 and ISO 200, tripod mounted

◀ Top: The California poppy, Eschscholzia californica, native to California, was so named by the naturalist of an early Russian exploration ship to California after his good friend, the ship's doctor. When I photographed this wildflower during its brief but intense life cycle in the California hills, I was struck by the intense backlighting and how the lighting from behind the flower projected a shadow of the flower's petals on its front petals.

105mm macro, 1/250 of a second at f/7.1 and ISO 200, hand held

◀ Bottom: This opium poppy was brilliantly lit by the sun, with blown-out highlights. So I created a shallow-focus image centered on the flower core, which was shaded by the broad petals of the flower.

90mm, 36mm extension tube, 1/160 of a second at f/5.6 and ISO 200, handheld

Transparency in the Garden

Transparency in the garden is a function of the direction and intensity of the light source (usually the sun) and the opacity of the parts of the flower, particularly its petals. Some flowers are simply opaque, and no matter what you do, light won't shine through. Others have natural translucence, and when the sun is at the right angle, its light can be used to make photos with a great natural "stained glass" effect.

When I'm aiming for a photograph showing transparent flower petals in the garden, I look first for perfect petals. The strong back lighting required for a transparent effect magnifies even slight imperfections.

The best transparent effects are created, as I've already noted, by strong backlighting. At the same time, you don't want the sun to be straight overhead, as this is more likely to produce a washed-out looking image than the vibrant colors you see in the most exciting transparent flower

photos. So the best transparent effects in the garden occur shortly after the sun emerges from the horizon and just before it sinks below the horizon line. At these times of day, there's enough light to create transparency, but it's likely to be pleasing and not overly harsh.

A little moisture on the flower petals—from overnight rain, morning dew or sprayed on with a mister by the photographer—helps to add to the transparency effect.

The camera's position is also a vital aspect of garden images that showcase transparency. Most of the time, the camera needs to be more or less opposite the sun, meaning low to the ground and pointed obliquely up at the flower (with the sun illuminating the opposite side). If you are using a tripod, you may need to consider a special setup for low-to-the-ground photography (see pages 64–67).

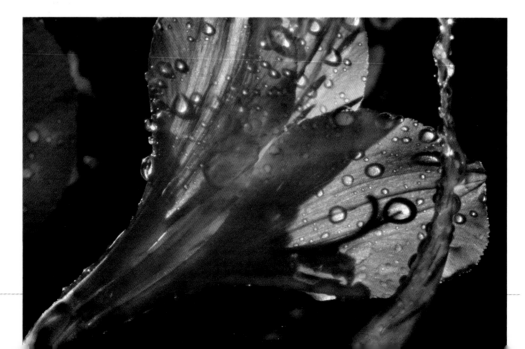

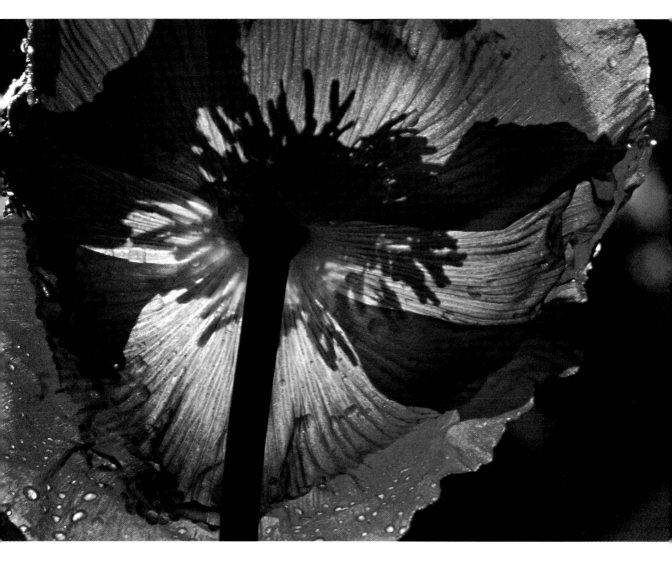

▲ I laid flat on the ground and positioned my camera on a Kirk Mighty Low-Boy cut-off tripod to capture the transparency of the petals on this poppy as lit by the morning sun.

200mm macro, 0.1 of a second at f/36 and ISO 100, tripod mounted

◀ When I was looking at this alstromeria through my viewfinder, the lone water drop in shadow caught my eye. This shadow is created by the transparency of the petal as the sunshine filtered through the petal.

85mm Perspective Correcting macro, 0.2 of a second at f/45 and ISO 100, tripod mounted

Transparency in the Studio

One of my favorite effects to capture when I'm photographing flowers indoors is transparency. In this context, transparency means taking advantage of the inherent translucence of flower petals. This partial opacity is enhanced by either shining a light through the petals or placing the flower on a light source. Sometimes I even use both techniques at the same time.

To pull off this technique, the first thing to look for is flower transparency. Before you start sending me e-mails to tell me how obvious this point is, bear in mind that it is not always clear what flowers, or portions of flowers, will actually be transparent until you shine a light through them. You may be surprised to find that flowers which at first glance appear fully opaque are actually semi-transparent when backlit.

I find that a bit of moisture tends to increase apparent transparency. I use a small spray bottle dedicated to this purpose. Depending upon the final image that I've visualized, I'll either leave small

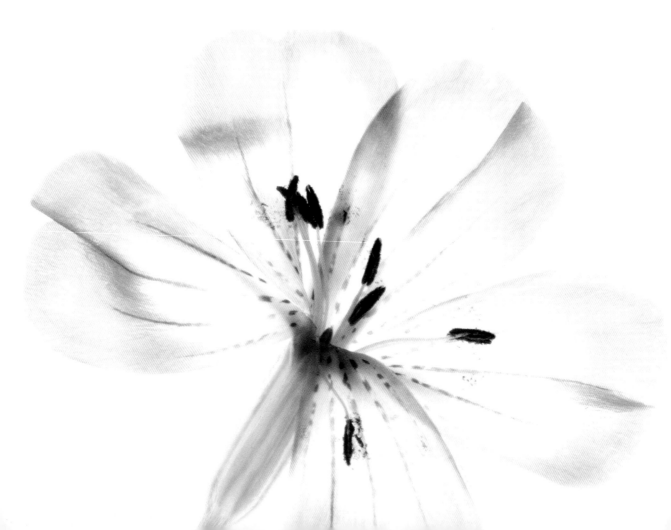

▶ A white anemone is the simplest and most elegant of flowers. I used this composition to show off the elegance of the white-to-transparent anemone petals while contrasting the petals with the relatively opaque stem and flower core.

105mm macro, 2 seconds at f/40 and ISO 100, tripod mounted

◀ I carefully applied a patina of water to enhance the natural transparency of this small flower.

200mm macro, 8 seconds at f/36 and ISO 100, tripod mounted

drops of water on the petals, or I'll use a soft cloth to gently coat the petal with a bit of moisture.

Even with flowers that have quite transparent petals, like the ones shown on these pages, you need to consider where opaque parts of the flower—such as pistil, stamen, style and ovary—will fit in your composition. I try to arrange these parts of the flower to reveal a pleasing but natural contrast to the softer and more transparent petals.

Transparent flower images work best when they are somewhat overexposed, meaning the exposure histogram is biased to the right side. (See pages 72–75 for more about exposures and flowers.)

A transparent flower image is generally lit with high-key (overexposed) lighting like that shown on these pages, particularly if the flower has been placed directly on a light source. In this case, the image of the flower benefits from the additional brightness of nuanced overexposure. Yet the overexposure makes no difference to a predominantly white background; after all, white is white.

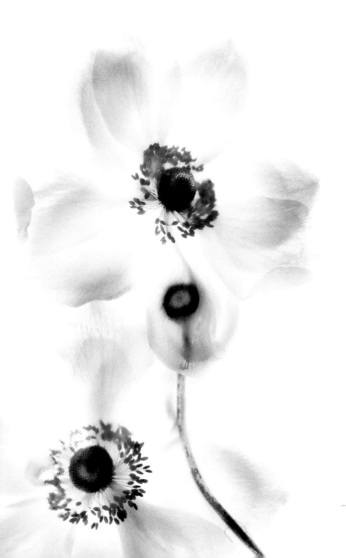

◀ I placed this anemone on a lightbox and substantially overexposed it to create the subtle effect shown here.

200mm macro, 3 seconds at f/36 and ISO 100, tripod mounted

▶ This dinner-plate-sized clematis blossom was placed on a lightbox for transparency. When I processed the blossom image, I combined six exposures. (See pages for 112–119 for more information about combining flower exposures.) All six were skewed toward high key, meaning a right-facing histogram and over-exposure bias.

I used my PC Micro Nikkor 85mm f/2.8, a wonderfully sharp and old-fashioned lens. This lens allows modified tilts and swings, which lets me get the perspective exactly right so the flower appears centered in the frame.

85mm Perspective Correcting macro, 1 second and f/14 at ISO 200, tripod mounted

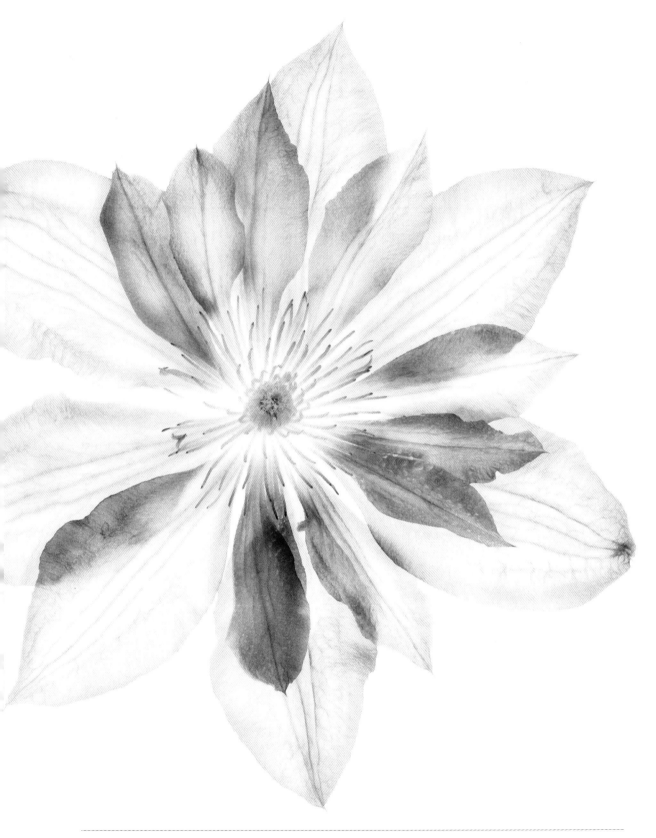

▶ These poppies were arranged on a lightbox and I carefully uncurled the lower petals. These flowers are not as transparent as they may seem in this photo. I orchestrated the impression of transparency by making sure that the outer petals—naturally the most transparent—were the flattest. The illusion of transparency on the outer portions of these flowers draws in the eye and makes the whole image seem more transparent than it actually is.

105mm macro, 0.8 of a second at f/36 and ISO 100, tripod mounted

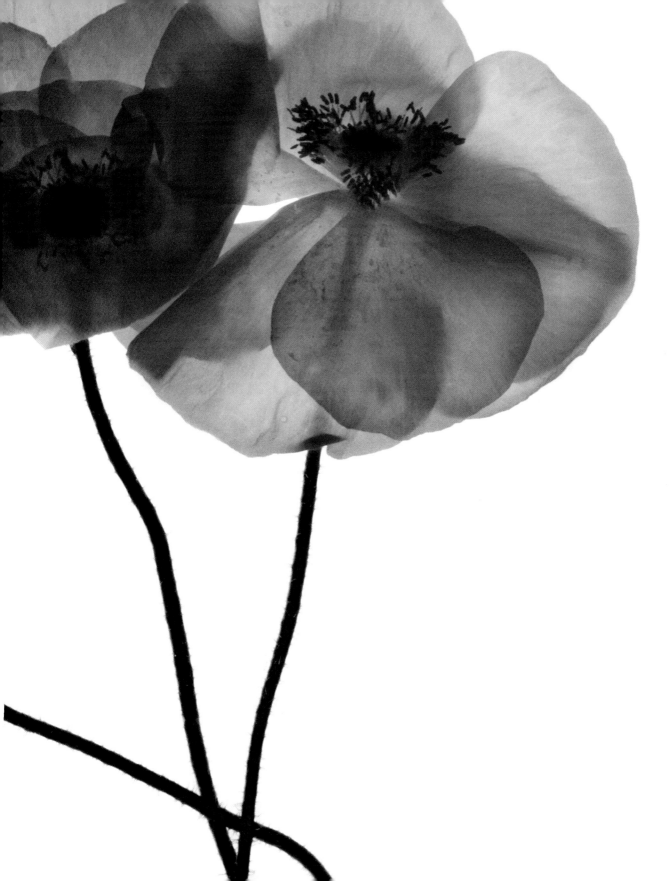

Flowers on White

Flowers can look great on a white background, even when the desired effect is not transparency. (For information about transparent flower images on white, see pages 102–105.) I've found that the most important issue in creating interesting photos of opaque flowers on a white background is the contrast between the flower and the background.

Perhaps the small tendrils at the end of the flower curl to make an exotic pattern as in the Rose Cone Flower on white shown below. Or maybe the pollinator's flight path is marked and seems to stand out in three-dimensional space as in the Iris on a white background to the right.

The common thread of these photographs is that specific elements contrast in an interesting way with the white background. When selecting a flower for a shoot, look at the edges of the flower to see how well they contrast with the background. Also, take into consideration the markings on the flower and see if they work well with white.

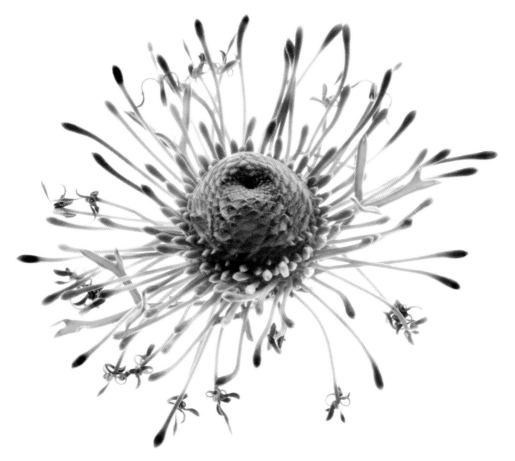

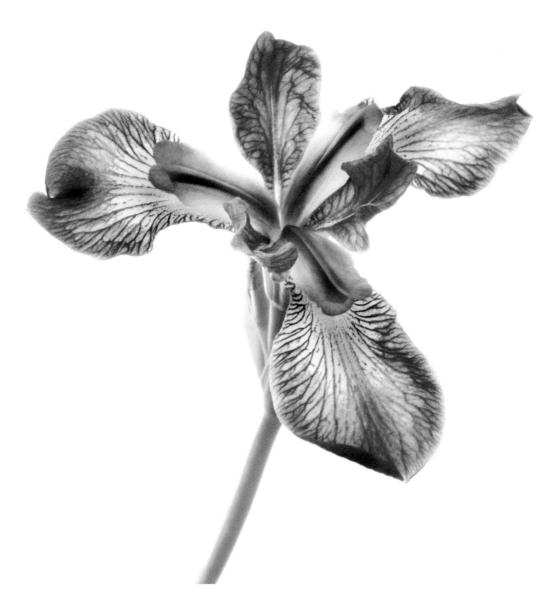

▲ I photographed this Iris against white to emphasize the petal markings and yellow glow (toward the rear of the petals) that are intended to attract and guide bees and other pollinators.

100mm macro, four exposures at shutter speeds from 1/2 of a second to 2 seconds, combined in Photoshop, each exposure at f/22 and ISO 100, tripod mounted

◀ To create this photo of a Rose Cone flower, I snipped the flower off the bush and placed it on a lightbox. With a macro lens, I shot a wide range of exposures, and all at the same stopped-down f-stop (f/36). I ended up with five exposures at 1 second, 2 seconds, 4 seconds, 8 seconds and 16 seconds.

In Photoshop, I started with the lightest exposure (16 seconds) to get a pure white background. Then I layered in the different exposures, getting selectively and successively darker.

200 mm macro, five exposures at shutter speeds from 1 to 16 seconds at f/36 and ISO 100, tripod mounted

Flowers on Black

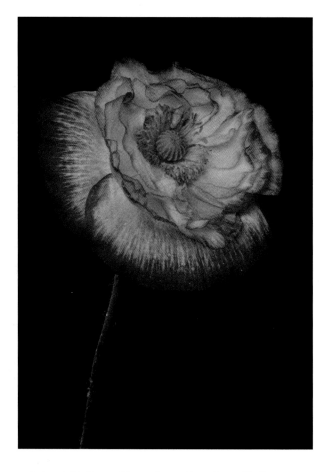

▲ I placed this Papver Rhoeas 'Dawn Chorus' on a black background to bring out the colors in the flower as much as possible using contrast.

200mm macro, 36mm extension tube, three combined exposures at shutter speeds from 1/4 second to 1 second; each exposure at f/36 and ISO 100, tripod mounted

A white background allows you to show off the delicacy and transparency of your flower subjects (see pages 102–107). A black background is also great for flower photographs and it is perhaps the most dramatic setting for floral imagery. On black, you can still photograph with the aim of displaying delicacy; yet it also provides opportunity to bring out the drama in flower coloration.

When photographing flowers on a white background, I normally overexpose and aim for a rightward-biased histogram. The opposite is true when I photograph flowers on black: I underexpose and aim for left-biased histograms. Some under-exposure deepens the black background and adds to the saturation of colors in the flowers.

If you are planning to photograph flowers on black, consider the material of the background and how the flowers will be positioned on it. Black velvet cloth works well because it doesn't reflect light. You can drape it as a background for larger flower arrangements or pin single blossoms to it using a pin inserted in the flower stem. Also you can suspend a flower or branch over a black background using a thin wire and light it from behind; the wire can be retouched out later in post-processing.

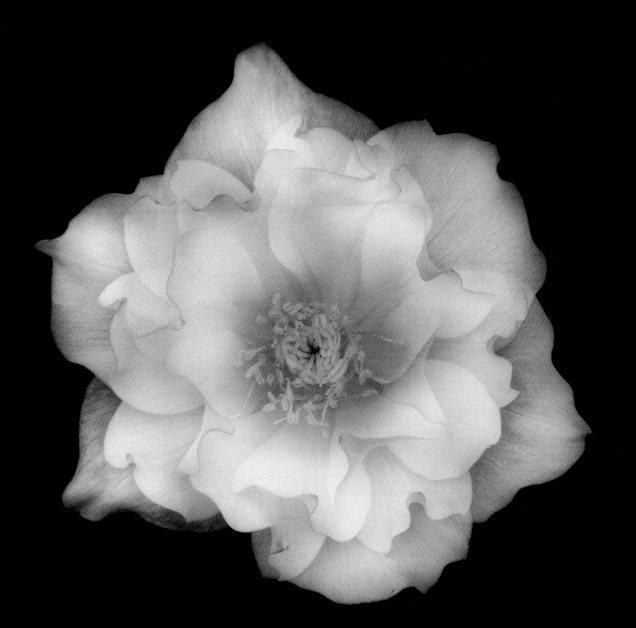

▲ Hellebores are delicate flowers that bloom close to the ground in partial shade. They are typically a spring flower and one of the first of the year. This almost-all-white blossom was hidden from view on a stalk that almost bowed to the ground. I cut the flower from its stalk and then mounted it with a pin on black velvet backed with cardboard.

I lit the flower evenly from both sides and shot straight down, taking care to underexpose with a histogram biased to the left. My choice of exposure let the background go completely black, which brought out the detail in the delicate white flower.

100mm macro, four exposures at shutter speeds from 2 seconds to 8 seconds, combined in Photoshop; each exposure at f/22 and ISO 100, tripod mounted

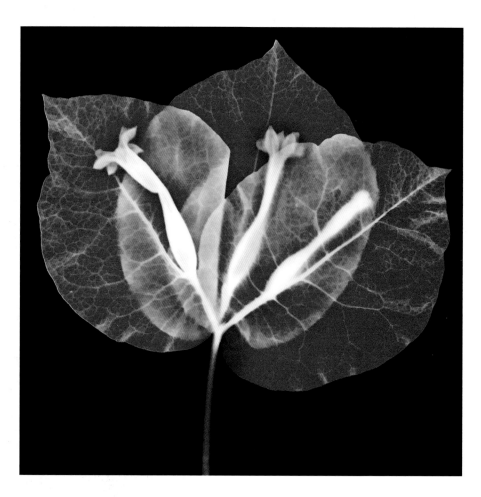

▲ With bougainvilleas, the actual flowers are not very interesting. The real action is in the *bract*, the specialized leaf structure that hosts the somewhat-uninspiring flowers.

To photograph this bougainvillea bract, I placed it on a black background, suspending it with tiny wires that I later retouched out. I lit the bract evenly from both sides. Then I brought out the transparency of leaf portions with a small LED spotlight positioned behind the leaf.

200mm macro, 1.6 seconds at f/36 and ISO 100, tripod mounted

▶ I photographed these roses on a black velvet background using sunlight that was focused using window shades. In this kind of situation, it is important to underexpose relative to an overall meter reading; because you want the background to go completely black, and you want the flowers to appear as saturated as possible.

35mm, 1.6 seconds at f/29 and ISO 100, tripod mounted

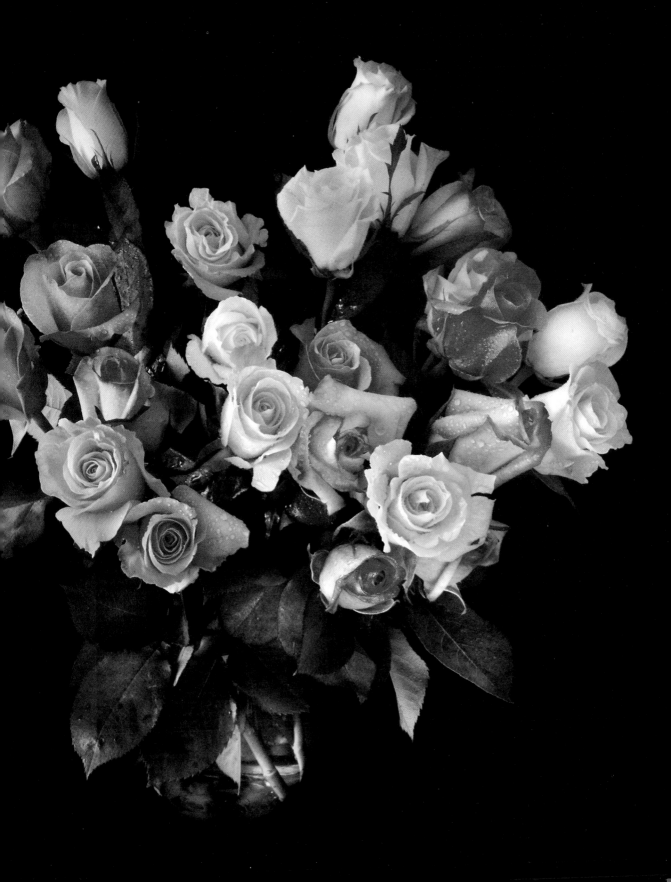

HDR Flower Photography

My assignment: to shoot a flower for a cosmetics advertising campaign. According to the art director, I needed to capture "unimaginable folds of pink softness." I choose Papaver rhoeas 'Falling in Love,' a double variety of Papaver rhoeas, for one of the subjects of this campaign.

In my studio, I put a cut flower in a glass flute to keep it upright, and I then placed the flute on a black velvet background. The background rested on a board and a rod placed between two supports. I positioned the flower so sunlight struck it from behind and to one side. Then I used a large piece of soft gauze to soften the sunlight.

Looking at the initial results of my shoot using this simple setup, I saw I had a problem. The exposures that were perfect for the portions of the flower in the sun made the rest of the flower too dark, and the exposures that worked for the darker areas made the sunlit areas too bright. (See versions A through C below.)

To get the image of unimaginable folds that my client wanted, I needed to combine different exposures of the flower. Here's where HDR came to my rescue.

HDR is short for *High Dynamic Range*, and it is used to describe images in which the light tones are brighter and the dark tones

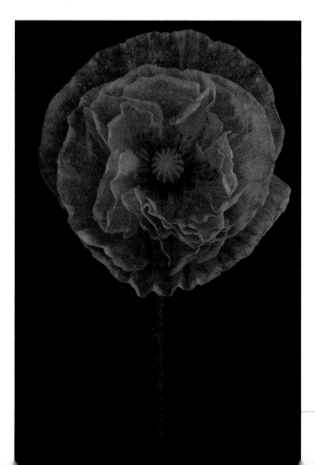
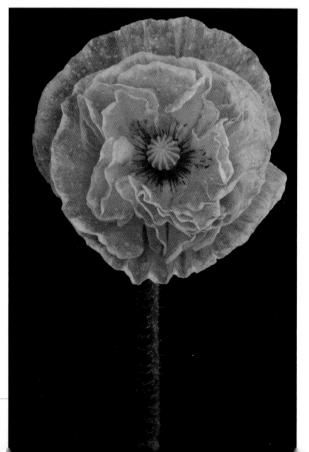

are darker than we've come to expect from photographs. HDR achieves its goals by combining different exposures of the same image.

Put a little differently, *dynamic range* is the difference between the lightest tonal values you can see (the bright sunshine on the flower) and the darkest tonal values in which you can still perceive a faint bit of detail (the shadows). Bright areas, also called *highlights*, that are so bright that you can no longer see any details are said to be "blown out"; dark areas that have gone totally black are "plugged."

Mastering the craft of extending digital dynamic range opens the possibility of compositions that would have been impossible in the past because of dynamic range limitations.

While most people think of HDR as a technique that is applied to landscapes with bright skies and dark foregrounds, it also works extremely well with floral imagery. One great thing about well-handled HDR photos is that people don't know how it was done; but if the process is done well, they realize that the results are subtle and beautiful.

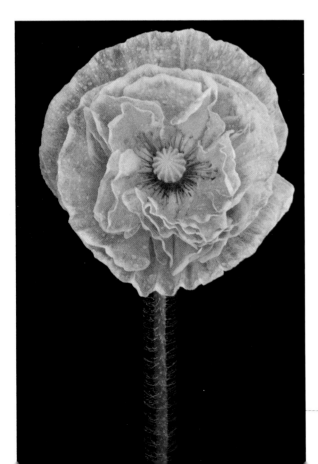

◀ All three versions: I photographed this dramatic poppy on a black velvet background. (See text on the previous page for the details of the setup.) To compensate for the varied lights and darks in the flower, I shot three versions at different shutter speeds and the same aperture.

Page 118, left: Version A, 200mm macro lens, 1/2 of a second at f/36 and ISO 100, tripod mounted

Page 118, right: Version B, 200mm macro lens, 1 second at f/36 and ISO 100, tripod mounted

Page 119: Version C, 200mm macro lens, 2.5 seconds at f/36 and ISO 100, tripod mounted

There are quite a few software programs you can use to combine the different exposure versions. Photomatix is the best-known software application known specifically for the HDR imaging process, and Photoshop also has some decent automated HDR capabilities.

I prefer to manually process my HDR images of flowers using *Hand HDR*.

With this technique, I place the different exposures on top of one another as layers in Photoshop, and then decide on an area-by-area basis how to combine the exposures. (See page 234 for resources related to HDR and Hand HDR processing.)

To create the final image of the poppy with an extended dynamic range, I carefully combined the three exposures as follows.

▶ Step 1: With the three versions of the poppy opened in separate windows in Photoshop, start with the darkest poppy as the bottom layer in the Layers palette. This layer will be used for the black background, and it will also be used for darker portions of the flower.

▶ Step 2: Hold down the Shift key and use the Move Tool to drag the medium version from its image window on top of the darker version. Release the mouse before you release the Shift Key. This will perfectly align the layers on top of each other. There are now two layers, "Medium version" and "Darkest version," in the Layers palette.

▶ Step 3: With the "Medium version" layer selected in the Layers palette, choose Layer ► Layer Mask ► Hide All to add a Layer Mask to that layer. The Hide All Layer Mask hides the "Medium version" layer and appears as a black thumbnail in the Layers palette.

▶ Step 4: Select the Brush Tool from the Toolbox and set Opacity set to 50% and Flow to 50%. Make sure the layer mask on the "Medium version" layer is selected. Use white to paint on the layer mask in the areas where the flower needs to be lighter.

This is how the painting on the layer mask looks.

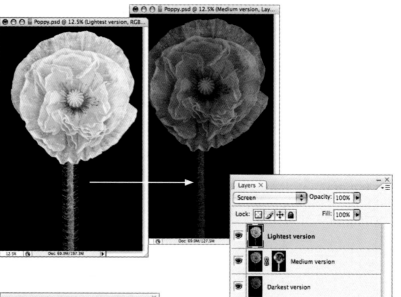

▶ Step 5: Repeat Step 2, but this time drag the lightest version from its image window onto the image window you've been working in. There are now three layers: "Lightest version," "Medium version" and "Darkest version."

▶ Step 6: Repeat Step 3 but with the "Lightest version" layer selected in the Layers palette. Choose Layer ▸ Layer Mask ▸ Hide All to add a Layer Mask to that layer.

▶ Step 7: Repeat Step 4, but this time paint on the "Lightest version" layer mask to paint in lighter areas and highlights. The results are shown on the right on page 123.

This is how the painting on the layer mask looks.

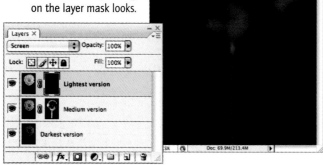

▶ In Photoshop, I combined three exposures at times from 1/2 of a second to 2.5 seconds to capture the full dynamic range of the light falling on the delicate pink petals.

200mm macro lens, three exposures: one at 1/2 of a second, one at 1 second, and one at 2.5 seconds; all exposures at f/36 and ISO 100, tripod mounted

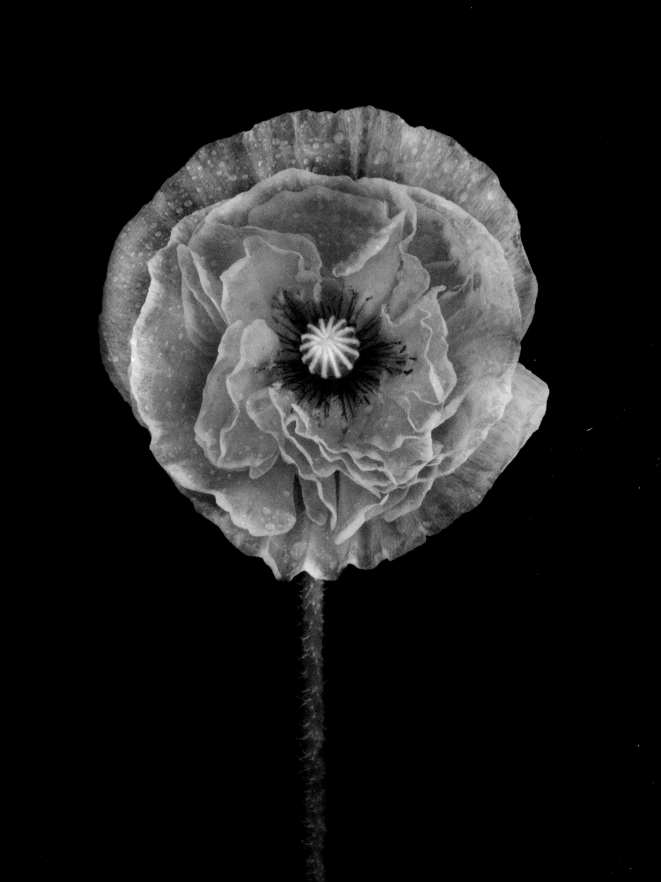

Focus Stacking

Focus stacking—also called *HFR* (High Focal Range)—is a technique that combines two or more exposures that are focused on different spots to create an image with a greater range of focus than any single image could. Like HDR, to get good results with focus stacking you should plan to use the same aperture in each exposure that goes into the blended focus stack.

As with HDR, you can use Photoshop to create a focus stack automatically, or do it manually in Photoshop using layers and masking. I'll show an example of both techniques in this section.

Generally, you do better with automated focus stacking with five or more exposures. Yet if you are manually creating an image that includes two focus points, it can work fine with just two exposures, provided that one of the images "sits" nicely on top of the other. For this to happen, there must be a clear demarcation between the two

▼ Step 1: Shoot five or more images at the same aperture, making sure that every spot in the image is in focus in at least one image. For this demonstration, I shot twelve versions of this orchid with focal points all over the flower. (Only nine are shown here in this window.)

exposures (the core of a flower and the petals, for example, like the red flowering dogwood shown on pages 130–131).

When I shoot a series of images for focus stacking in Photoshop, I make sure to focus on every plausible point that I see. The biggest mistake you can make in shooting these images is to omit a point of focus by mistake. However smart the software is, it cannot possibly include something in focus if the object is not in focus in at least one of the source images.

Also bear in mind that being partially out-of-focus can enhance many flower images; like with glamour portraits, end-to-end sharpness can be a mixed blessing.

The following pages show how to create an image using focus stacking in Adobe Photoshop CS4.

▼ Step 2: Process the images you are going to stack in Adobe Camera RAW (ACR). Select all of the images and process them at the same time using the same settings. Save the images as PSD files (Photoshop's native format) in one folder and then close them.

▶ Step 4: In Adobe Bridge, select all the images. From the Bridge Tools menu, choose Photoshop ► Load Files into Photoshop Layers.

▶ Step 5: In Photoshop, each image is now a layer in a single multi-layered document. Open the Layers Palette and multi-select all the layers.

▶ Step 6: Choose Edit ▸ Auto-Align Layers. In the Auto-Align Layers dialog, select Auto and then click OK. You may want to go out and get a cup of coffee while your system works, depending on the number of layers and your system. Photoshop aligns the layers by matching the features in each image. So if your tripod slips a bit and the center of the image shifts while you take multiple captures, Photoshop will fix it for you.

▶ Step 7: Choose Edit ▸ Auto-Blend Layers. In the Auto-Blend Layers dialog, select the Stacking radio button, and then click OK. Go get another coffee.

▶ Photoshop creates a mask for each layer so that only the elements in each layer that are in focus are visible.

▶ Step 8: Choose Layers Flatten to merge all the layers into one layer. You can now process your hyperfocal photo as you would a normal photo. The results are shown to the right on page 131.

▶ To create this demonstration of focus stacking, I lit this orchid from behind and intentionally chose a wide open aperture (f/4.5) for low depth-of-field.

200mm macro, 36mm extension tube, twelve exposures (each at a different focus point and combined using focus stacking in Photoshop); each exposure at 1/40 of a second and f/4.5, tripod mounted

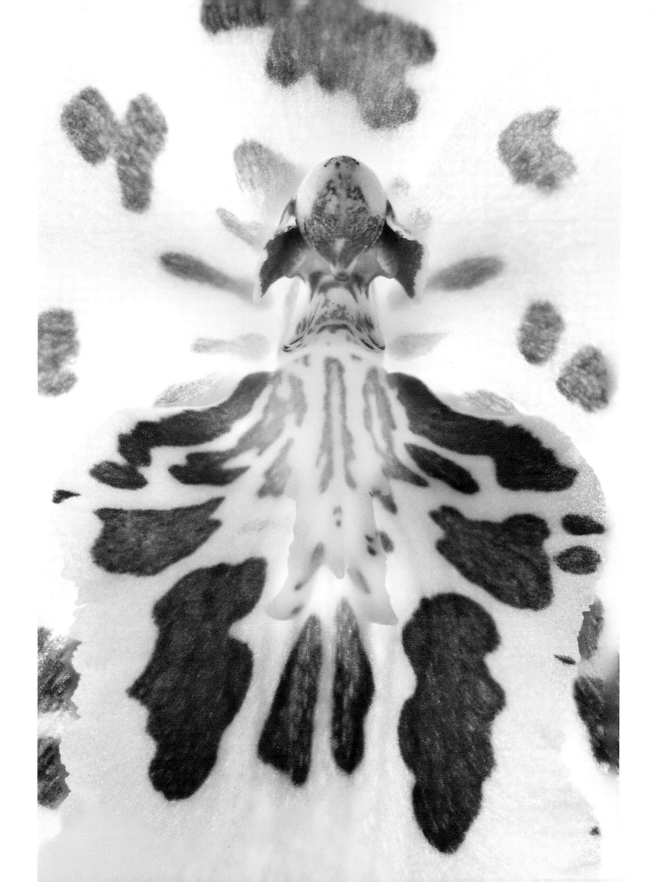

Putting Images Together by Hand

In many situations, you don't need software to combine images to extend focal range—in fact, you may be able to do it better than any machine!

The things to look for are pieces that seem to logically fit together and an object in the front focal plane that "hides" the connection to the rear plane of focus. For example, the core of the red flowering dogwood shown on this page covers the connection between the flower core and the petals behind it.

◀ This photo was focused and exposed for the dogwood flower core.

200mm, 0.8 of a second at f/40 and ISO 100, tripod mounted

◀ This photo was focused on the dogwood petals.

200mm, 1/6 of a second at f/40 and ISO 100, tripod mounted

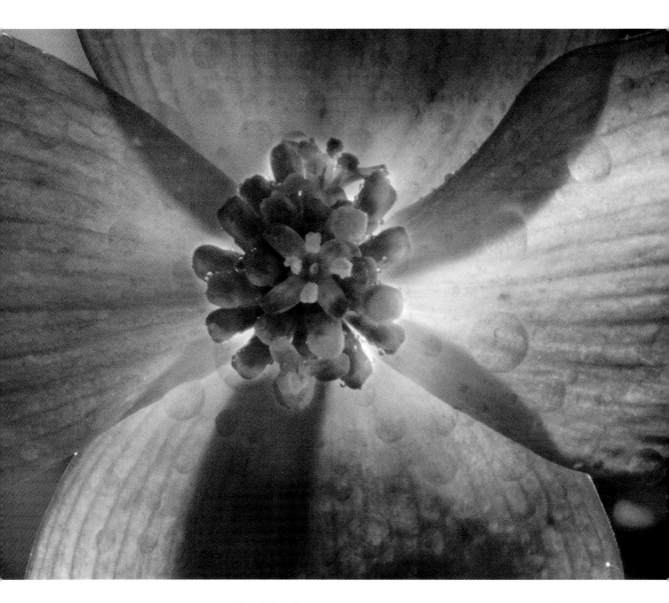

▲ When I shot this red flowering dogwood on a bright spring day, I realized that even fully stopped down I could get both the reproductive organs of the flower and the petals in sharp focus. Using the same aperture (f/40 for maximum depth-of-field), I shot one image of the flower core (page 132 top) and the other of the petals (page 132 bottom). This composite is an example of HDR as well as focus stacking. Since I knew I would be compositing anyhow, I exposed the version that shows the brighter petals at a shorter time (1/6 of second) than the darker core, which needed a 0.8 of a second exposure.

200mm, two exposures combined in Photoshop with different focal points, combined using layers, masking and the Brush Tool: one at 1/6 of a second and one at 0.8 of a second; both exposures at f/40 and ISO 100, tripod mounted

Selective Focus

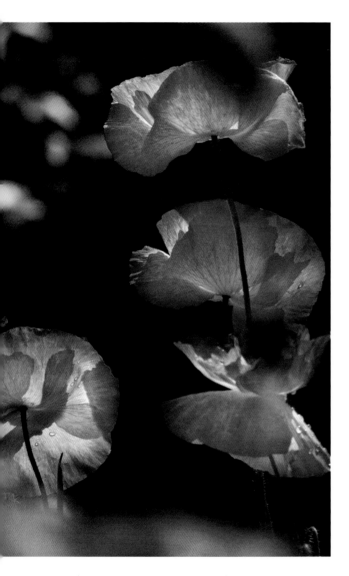

With focus stacking, the goal is to create a floral image that is entirely in focus. But sometimes out of focus is good, particularly when it comes to colorful flowers.

Good selective-focus images hone in on the most important element in a composition by making sure the rest of the close-up is attractively out of focus. The areas that are out of focus in the photo don't compete with the central elements, and they make the main subject seem more important.

To create a good selective-focus image, look for flowers that can be isolated against the background or against other clumps of flowers that contrast in some important way with the in-focus flower. Out-of-focus elements should frame the central in-focus flower, so it seems as though you are peering through a window, and only the central pane is really clean. Using focus as this kind of framing device adds to the compositional interest of a flower close-up, and it is a technique to remember when photographing in the garden.

▲ I used a 200mm telephoto lens focused on the flowers that are the subject of this photo to frame these central flowers using the out-of-focus flowers on top and bottom. I picked an intermediate f-stop (f/14) that kept the subject flowers in focus, without extending the field of focus too far.

200mm, 1/250 of a second at f/14 and ISO 100, tripod mounted

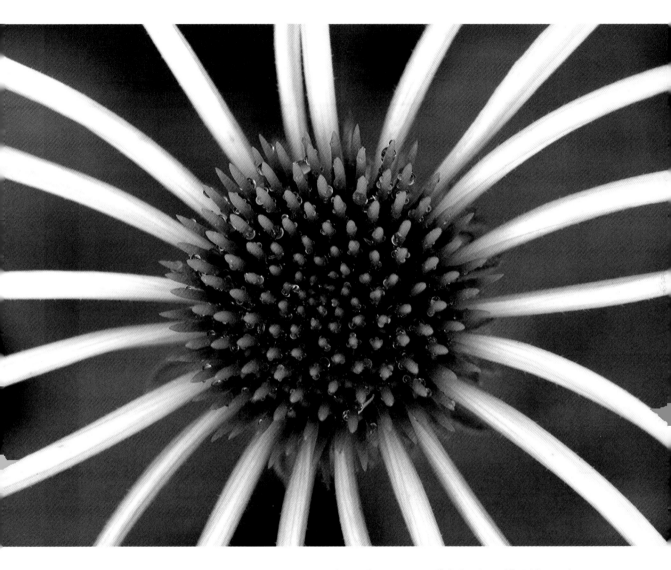

▲ I used a moderate aperture (f/14) to keep this Echinacea 'Harvest Moon' core and petals in focus while allowing the background to blur. The contrast between the thin, white petals and the green background helps to make this image work for me.

105mm macro, 1/4 of a second at f/14 and ISO 100, tripod mounted

Motion

Motion is often the enemy of close-up photographers in the garden or field. One approach to stopping motion is to use flash for lighting your photos, so that your effective shutter speed becomes the duration of the flash (see pages 84–87). But if you are relying on natural lighting, stabilizing flowers in the wind is such an issue that several specialized clamps have been invented just to keep flowers still (see sidebar).

There's a saying about "making lemonade from lemons." If you are in the garden photographing flowers and it is windy, it makes sense to see if you can take advantage of the situation. Look for moderate shutter speeds in the range of 1/15 to 1/125 of a second that enable you to retain some of the shape of the moving flower without making it utterly unrecognizable. Also look for situations in which some flowers are moving faster than others. The contrast in effect between the faster flowers—which will appear quite blurred from motion—and the slower moving flowers that mostly keep their shape makes for interesting imagery.

Plant Clamps

Even slight amounts of wind can be frustrating to photographers looking to make close-up photos of flowers, because many flowers are engineered to be especially sensitive to motion. Moving around in the wind may help these flowers spread their pollen; it's part of a species-survival strategy. Check out a flower in your garden or in the wild. It is likely to be at the end of a long, slender stalk that is in near constant motion.

There are several specialized clamps on the market to help deal with this problem. One end of the clamp is specially designed to protect and be gentle with flowers. Flower clamps themselves are made of bendable plastic, and they attach to a stake in the ground (the McClamp Stick) or to your tripod or other solid support (McClamp and the Plamp). See page 234 for web addresses for these products.

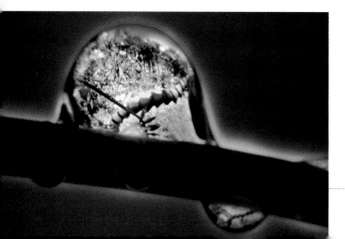

◀ I used the McClamp Stick (that you can see reflected in the water drop) to hold the branch and drop in position so I could use a fairly long (1/3 of a second) shutter speed.

200mm macro, 55mm extension tube, 1/3 of a second at f/36 and ISO 100, tripod mounted

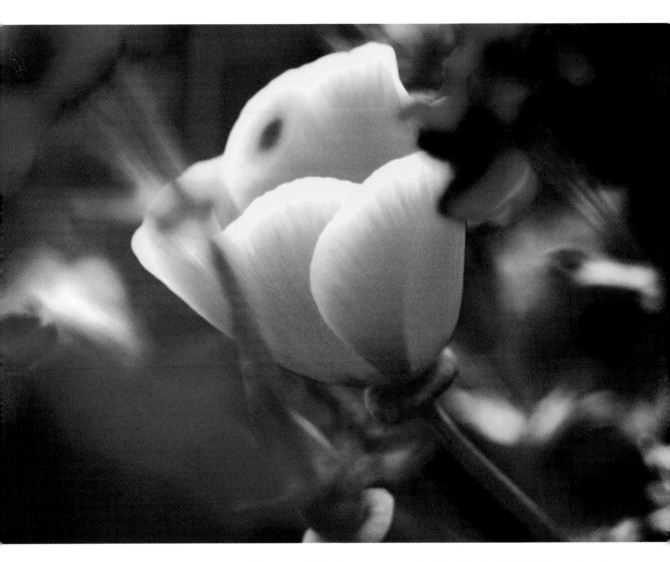

▲ The orange California poppy was moving fiercely in the wind, but it was not as fast as the surrounding purple flowers. It took some experimentation, but I found a shutter speed (1/125 of a second) and aperture (a wide open f/5.6) combination that isolated the poppy in motion, allowing its essential shape to be captured while rendering the surrounding flowers only as motion blurs.

130mm, 1/125 of a second at f/5.6 and ISO 200, tripod mounted

Impressionism

Impressionism was a movement of painters in the 19th century who reacted against strict conventions of painterly realism by emphasizing light, color and motion in their work. Just like the impressionists, close-up photographers do not need to be bound by the strictures of working to create photos that are sharp and realistic end-to-end. Impressionistic flower close-ups can be very beautiful.

Photographers work with cameras and lenses, not paintbrushes. Often, the impressionist painters used visible brush work to create their masterpieces. The photographic tools are different.

First, look for subject matter that emphasizes highly saturated and attractive colors. A contrast of complementary colors may add to an impressionistic photo composition, as it did to the paintings of the impressionists.

Strong lighting sources may also help provide an impressionistic effect, particularly when the flower you are photographing is backlit.

You can help to create impressionistic effects from your flower images by taking advantage of selective focus (pages 124–145) and by selecting a shutter speed intended to enhance motion blurs (pages 126–127).

▼ I photographed this California Poppy, *Eschscholzia californica* "Purple Gleam," hand held and into the sun, with the idea of creating an impressionistic effect using the strong backlit colors.

200mm, 36mm extension tube, 1/250 of a second and f/8 at ISO 200, hand held

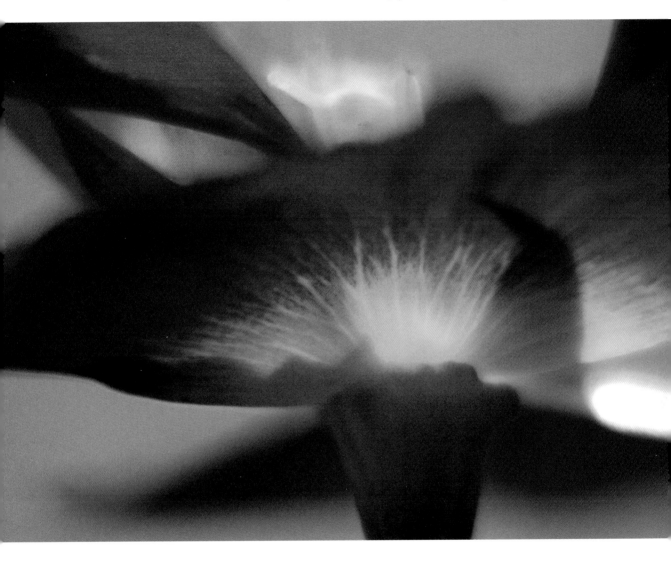

◀ This image combines selective focus and motion blur to create an impressionistic effect.

200mm macro, 1/40 of a second at f/16 and ISO 100, tripod mounted

▼ Pages 132–133: I used a wide-open aperture (f/2) to create an impressionistic, painterly overall effect in this flower close-up.

100mm macro, 1/800 of a second at f/2 and ISO 200, hand held

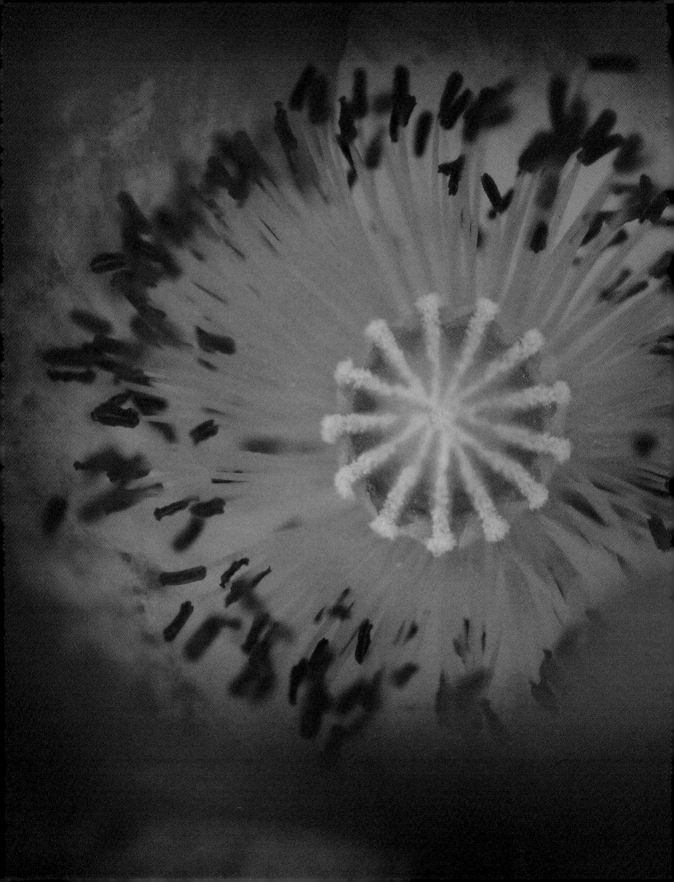

Colors and Abstraction

It goes almost without saying that one of the most enticing things about flowers, and why they make such great close-up subjects, is their colors. It's the very attractiveness of these colors that can take your flower close-ups to another level.

Create compositions that are elegant and filled with powerhouse color combinations, and you'll be on your way to an abstraction that has appeal even beyond its origins as a flower close-up.

To make this kind of photo, look carefully at the colors in the flowers you are photographing. Try to emphasize colors

that are especially vibrant, and find color combinations that work well together.

When it comes to color, painters such as the impressionists (see pages 128–131) emphasized complementary colors. These are color pairs that are opposite to one another on the color wheel. Two of the basic complementary color pairs are blue-yellow and red-green.

To create effective color abstractions when you photograph flowers, learn to recognize complementary color pairs and feature them in your close-ups.

▼ I knew that the drops of water in motion would make an interesting semi-abstract pattern in the sun. I framed the photo to include the complementary red flowers on a green background. These elements are partly obscured, which adds to the abstract effect.

200mm macro, 1/350 of a second at f/10 and ISO 100, tripod mounted

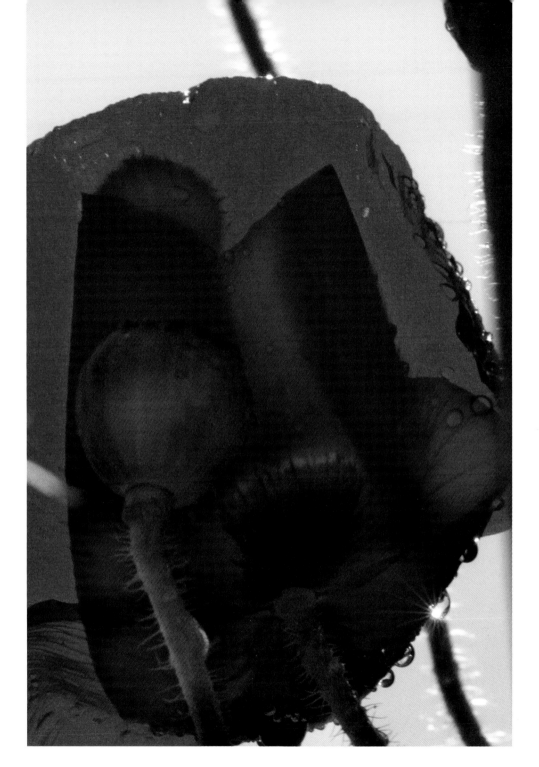

▲ I got low to the ground so I could photograph the incredible brilliance of red presented by the petals of this flower in contrast to the sky.

200mm macro, 1/20 of a second at f/36 and ISO 100, tripod mounted

▲ When I framed this composition, I was struck by the intense colors and abstract shapes. My idea was to create an image that could work on its own as abstraction of shadows and light, even if the viewer didn't know it was an Iris.

105mm macro, 1.3 seconds at f/32 and ISO 200, tripod mounted

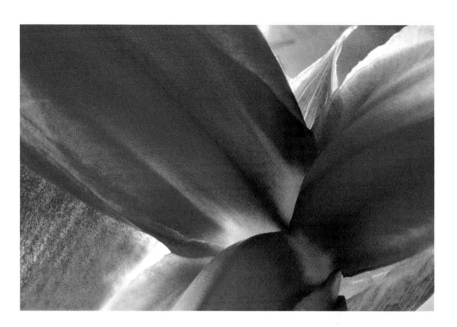

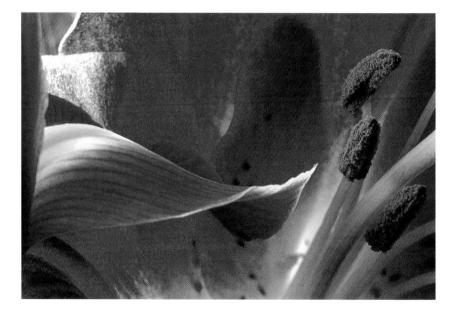

▲ Top: Close-up, the folds of this Iris have an intimate, but abstract, look.

105mm macro, 10 seconds at f/40 and ISO 200, tripod mounted

▲ Bottom: In this composition, I took advantage of the resemblance between the Iris petal and a tongue trying to "taste" the pollen.

105mm macro, 2 seconds at f/32 and ISO 200, tripod mounted

Flowers and Digital Painting

I believe that digital photography is one part photography and one part digital post-processing. In this sense, digital photography is a new art form.

One shouldn't forget the lessons of the past; it pays to learn as much about conventional photographic technique as possible. But it also doesn't make sense to be limited by the techniques available only in the camera. This is why I sometimes use my close-ups of flowers as the basis for digital painting. It's a way to take them to another level.

By digital painting, I mean using Photoshop to combine portions of images with themselves, using layers, blending modes, alternative colors spaces and—perhaps most importantly—painting directly on the photos using the Photoshop Paintbrush tool. I use a wide variety of Photoshop techniques. If you want to

learn more about my techniques, there is a suggestion for further reading on page 234.

If you are interested in shooting a flower close-up as the basis for a digital painting, try to visualize what your final image will look like before you start shooting. With the final image in mind, you can make decisions about background—whether to shoot on white or black, for instance—how to light the subject, and what exposure to use.

When I start a digital painting based on a flower photo, I realize that I will be spending more time on the computer than behind camera. Even if my digital paintings based on flower close-ups are not entirely realistic, I try to create images that are faithful to the spirit of my idea of nature. These images do not stray completely from their origins as photos of botanical objects.

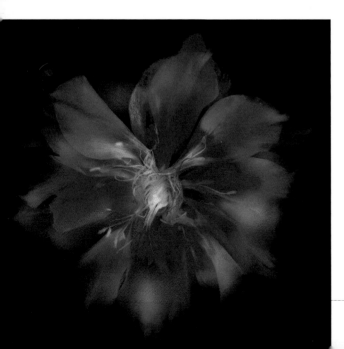

◀ Starting with a photo of a white Hellebore like the one shown on page 115, I used the Photoshop Brush Tool to add blue to the petals of this flower.

100mm macro, 1/2 a second at f/11 and ISO 100, tripod mounted

▶ I photographed this small *anemone Japonica* on a white background and used LAB color inversions in Photoshop to put the flower on a black background and add color. (See page 234 for further reading about these techniques.)

200mm macro, 3 seconds at f/36 and ISO 100, tripod mounted

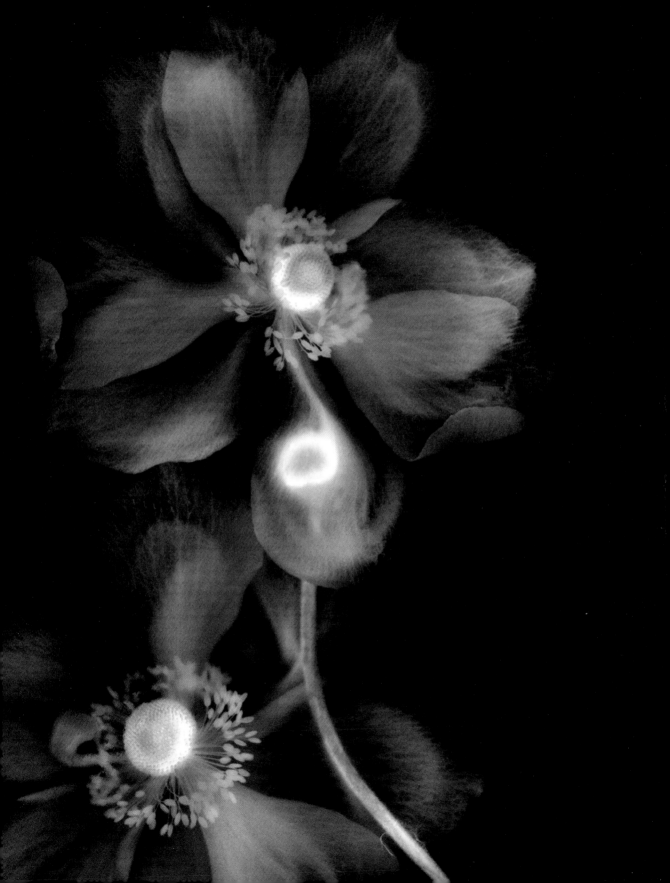

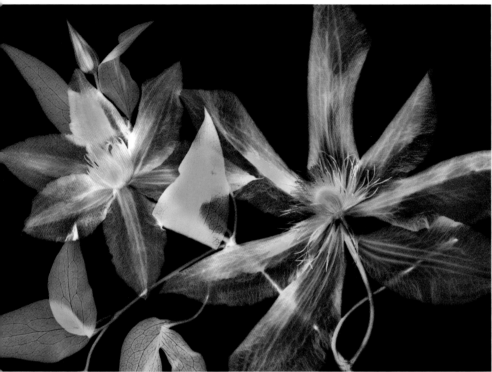

▲ I started with a straightforward shot of a large Clematis blossom mounted in front of a black background and lit from behind. In Photoshop, I used a blending modes, layers, masking and painting on the masks to create this effect. (See page 234 for further reading about these techniques.)

105mm macro, 0.6 of a second at f/36 and ISO 100, tripod mounted

▶ Starting with the image shown above, in Photoshop I inverted the colors using the LAB color space and then placed the results on a white background. I tweaked the image by directly "painting" on the petals.

105mm macro, 0.6 of a second at f/36 and ISO 100, tripod mounted

Water Drops on Parade

Water drops are an extraordinary—but challenging—subject for extreme close-up photography. Reflecting the world around them and the light that shines on them, water drops often enclose attractive detritus in their own hermetic bubble. Adding to the challenge of photographing a subject at sizes ranging from small to absolutely tiny, most water drops—especially outdoors—are subject to constant motion.

To make up for these difficulties, water drops can be extraordinarily fascinating and beautiful.

As I've mentioned, motion is a particular problem with water drops because I like to use a stopped-down small aperture for high depth-of-field. In addition, water drops are often in dark places, and less light hits the sensor as close-up magnification gets greater. So, this is a triple whammy. You need a longer shutter speed here because of three factors:

- The small aperture used to increase depth-of-field

- Light fall-off because of the magnification factor of the macro lens

- The dark conditions where water drops are usually found

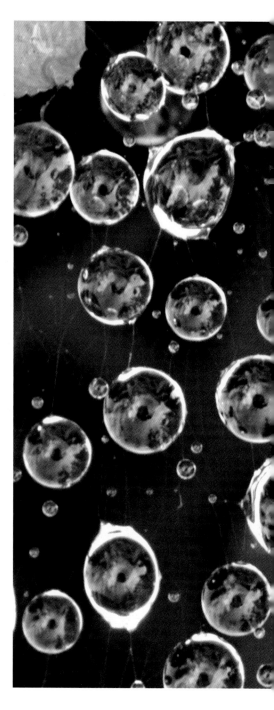

▶ After a heavy rainstorm, I found these water drops en masse on a spider web. The water drops reflect what's around them, including—in some drops—me, my camera and my tripod; although you have to look really close to see this.

105mm macro, 68mm combined extension tubes, +4 close-up filter, 0.3 of a second at f/36 and ISO 200, tripod mounted

▲ Pages 150–151: Looking through the viewfinder at this water drop, I was reminded of the line from the William Blake poem about seeing the world in a grain of sand. I made sure to focus on the sand within the water drop—rather than the external wet membrane of the drop itself—so that the clarity of the internal world of sand became evident in this photo.

200mm macro, 36mm extension tube, 1/2 of a second at f/32 and ISO 100, tripod mounted

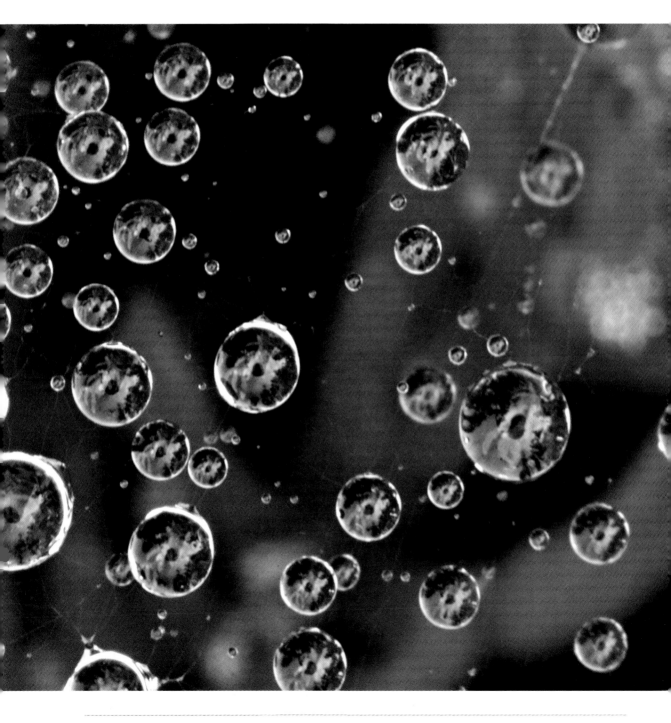

It's normally not practical to use a flash because of the reflectivity of the drop itself, though it is possible sometimes. See pages 84–85 and page 180 for examples of successful water drop flash technique.

There's really no good answer to the problem of needing a long shutter speed to photograph an object that moves. You just have to wait for the right moment. In some cases you may be able to use a flower clamp to restrain the surface on which the water drop rests. (See page 126 for more information about flower clamps.)

Another issue when photographing water drops is focus. As with any really small object, critical focus is both crucial and difficult. A magnifying eyepiece may help, as I suggest on page 70.

Even with a focusing aid, you'll find that the interior of a water drop with reflections may focus as far out as infinity, while the surface of the drop is extremely close.

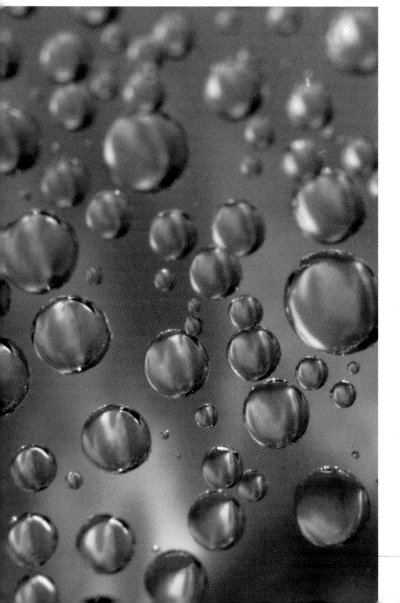

◀ The color in these water drops on a spider web comes from the pink flower seen out-of-focus in the background.

200mm macro, 36mm extension tube, +2.9 close-up filter, 0.3 of a second at f/45 and ISO 100, tripod mounted using a Kirk Mighty Low-Boy (see page 67)

▶ Drops from heavy morning dew lay on the Rosa 'Rio Samba'. I arranged the composition so all the water drops reminded me of a city, or civilization, all huddled together on the side of a flower cliff.

200mm macro, 36mm extension tube, 1/30 of a second at f/36 and ISO 200, tripod mounted

There's no perfect solution for this dilemma: you'll have to decide to focus on the scene inside the drop or the exterior surface of the drop. You can also sometimes focus on a third area, the reflections toward the surface of the drop where they've been bent by refraction and do not look like the normal world. (See pages 168-179 for more about reflections and refractions in water drops.)

Water drops don't just come solo. Often, drops are part of packs or flocks—and make a pattern of small objects. When I first started photographing water drops, it was drops en masse that I found most interesting. I looked for spider webs and leaf surfaces that catch and hold groups of drops after rain, and I tried to create interesting compositions out of the water drops on parade.

▼ Following an overnight shower, the drops of water on this blade of grass reminded me of people queuing for a bus, or lemmings about to fall off a cliff. I waited for the blade to be absolutely still in the wind and focused on its center to get as much as possible of the composition in focus.

105mm macro, 68mm combined extension tubes, 4 seconds at f/36 and ISO 200, tripod mounted

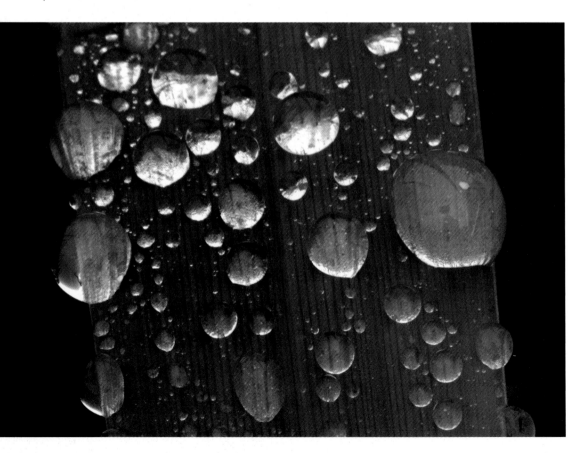

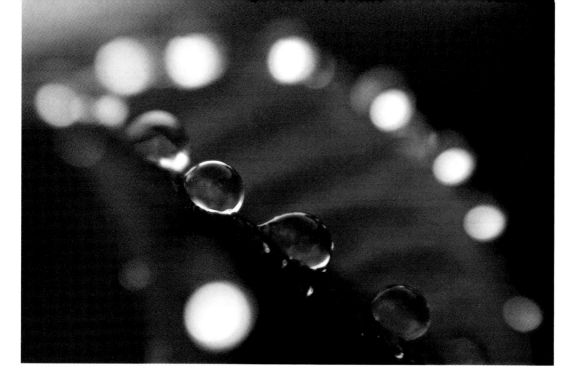

▲ With this photo, I experimented with the Lensbaby and its close-up filter kit to add excitement and drama to a shot of drops on a leaf. I was particularly pleased to see the halo effect around the out-of-focus drops that reflected the sun.

Lensbaby 2.0 +14 macro filters, 1/320 of a second using f/8.0 aperture ring at ISO 200

Drops, Drops, Drops

It may surprise you to know that water drops differ depending on their source. Raindrops (example page 154) look different from dew drops (example page 153). Raindrops are sharper and more defined than dew drops, and both are qualitatively different from the extremely regular water drops that result from irrigation (see page 173). Hoses produce large but irregular drops (see the example page 164), and sprayers create extra fine drops (see the examples pages 105 and 131). Of course, there are many other variables besides water source, including wind direction, temperature, humidity and force with which the drops landed.

Natural water drops tend to be less regular than those generated artificially, and they are usually more spread out. (This distinction reminds me a bit of fish caught wild versus farmed fish!) Raindrops are larger than dew drops, and water drops from a properly wielded hose are likely to be larger than drops from a hand sprayer or mister.

The moral here is that photographing water drops outdoors in an exercise in applied field photography. Even though water drops seem commonplace, to photograph them well, you need to use the same kinds of skills of observation and patience that you would use to photograph exotic flora or fauna.

Locking Up Your Mirror

When photographing water drops, slight movements in your subject can ruin the sharpness of these high-magnification and relatively long exposure images. The water drops, it turns out, are not the only thing that can wreck your photo by moving.

A good, steady tripod is an essential tool in close-up work. But even if your tripod is rock steady, DSLRs themselves can cause vibration when the mirror goes up to make an exposure.

As you may know, when you look through a DSLR, you are looking through the lens via a system of mirrors. When you make an exposure, the mirror goes up before the shutter opens. This can cause vibration.

It surprises many people to learn that this problem is worst at moderately long shutter speeds (between about 1/30 of a second and 2 seconds), and not at longer shutter speeds. The reason is that any vibration caused by the mirror takes up a smaller proportion of a longer exposure, and therefore doesn't matter as much.

These moderately long shutter speeds are water drop territory. For that matter, these shutter speeds are used for a great deal of close-up work. Therefore, to get the best results, you need to lock your mirror up before you expose.

It works like this. First, set the mirror to lock up. Then compose the photo and make your exposure settings. When you press the shutter release—using a remote to reduce vibrations—the mirror locks up. If you look through the viewfinder at this point (with the mirror locked up), you'll see nothing but blackness.

Wait a few seconds for mirror-related vibrations to tamp down. Press the shutter release a second time to make your actual exposure.

Check your camera manual to learn how to set the mirror to lock up.

▶ Top: I was surprised to find the extent of the water drops on this spider web hidden beneath an over-hanging bush. I photographed the drops on the web from a distance, trying to get as many drops as possible into the frame.

200mm macro, 1 second at f/36 and ISO 100, tripod mounted

▶ Bottom: The sunlight glinting on these water drops makes them look suspended in space, in part because I underexposed the photo so that the background (other than the water drops) went dark. To make this exposure as vibration-free as possible, I locked up my mirror before making the exposure, a technique I often use with extreme close-ups (see sidebar above).

200 macro, 36mm extension tube, +4 close-up filter, 0.2 of a second at f/36 and ISO, tripod mounted

▼ Pages 158–159: Photographing these drops caught in a spider web extremely close-up, the challenges were accurate focusing and waiting until the drops were still in the wind. Although a web inherently stabilizes the drops that rest on it, water drops are susceptible to any movement or breath of wind and are always in motion at the macro level. So a shot like this takes a great deal of patience. I had to find a period of a second (the exposure duration) without any breeze.

105mm macro, 68mm combined extension tubes, +4 close-up filter, 1 second at f/36 and ISO 200, tripod mounted

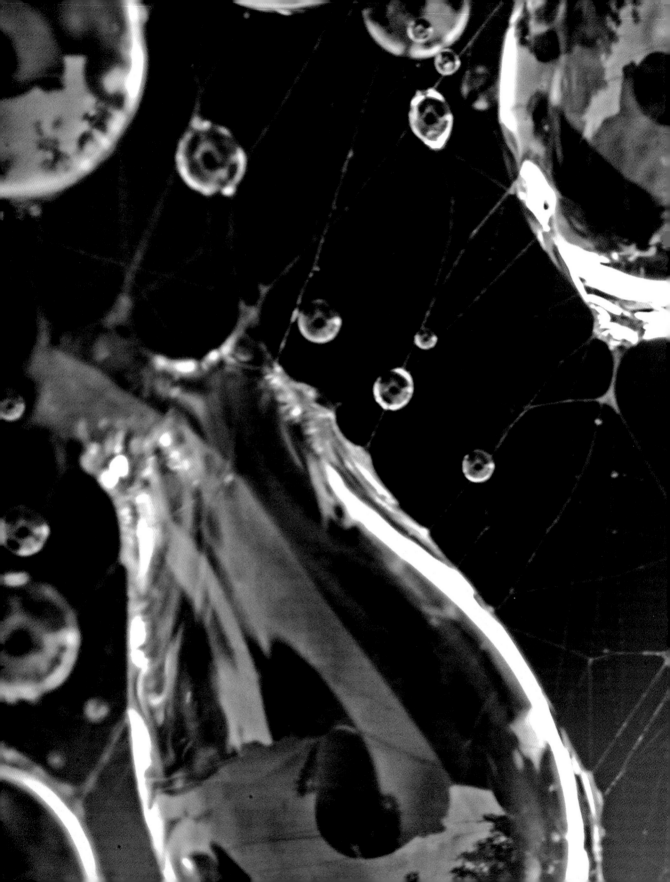

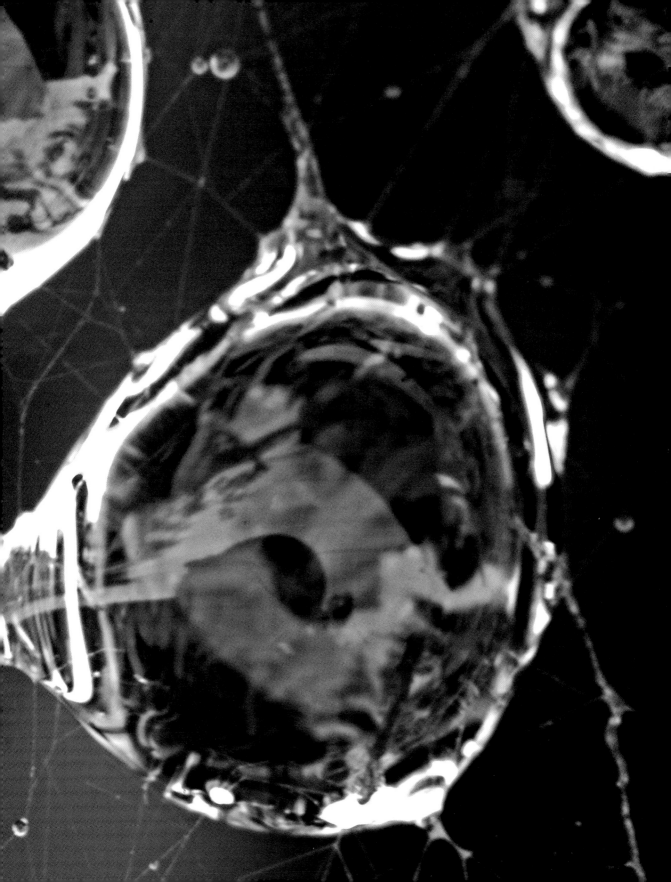

Natural Jewelry

My first interest in water drops was to create photos that showed their en masse patterns (see pages 150–159). But pretty soon I looked a little closer, and saw that smaller groups of drops had an interest of their own.

As I got closer, I felt that I was looking at nature's jewelry: objects that were small in scale but beautiful beyond the ability of words to describe. Like gemstones, I developed a water drop scale of size, clarity and color. The best of nature's water drops are large (for a water drop), colorful and have clear interiors. (You might be surprised at how murky the water in a water drop near mud can get!) Careful observation is the best place to start with this kind of water drop photography.

As I started to focus on small groups of drops, and got closer to them with my camera, the issues of movement and focus became even more critical than with larger groups of water drops. No longer looking for overall patterns, I tried

▶ Partly shaded by a climbing rose, water drops clung to a lovely clump of variegated gladiolas in the early morning. When I saw the flowers in each of these drops, I knew I had a winning photo…provided I could get the drops to stay still for the length of the exposure (1/4 of a second). I shot about 100 exposures, and when I examined them on the computer, the last exposure was sharp because the drops had been still enough.

200mm macro lens, 36mm extension tube, +4 close-up filter, 1/4 of a second at f/36 and ISO 200, tripod mounted

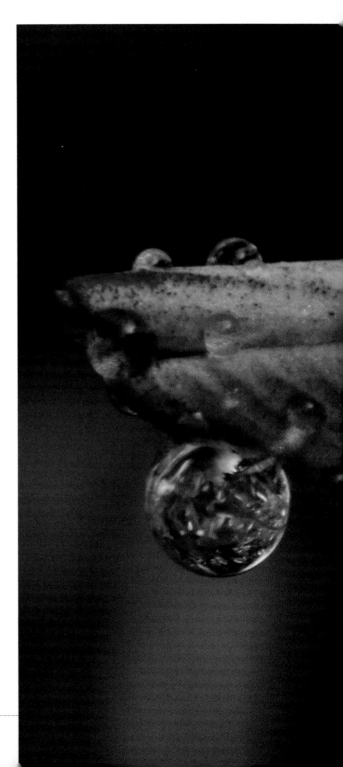

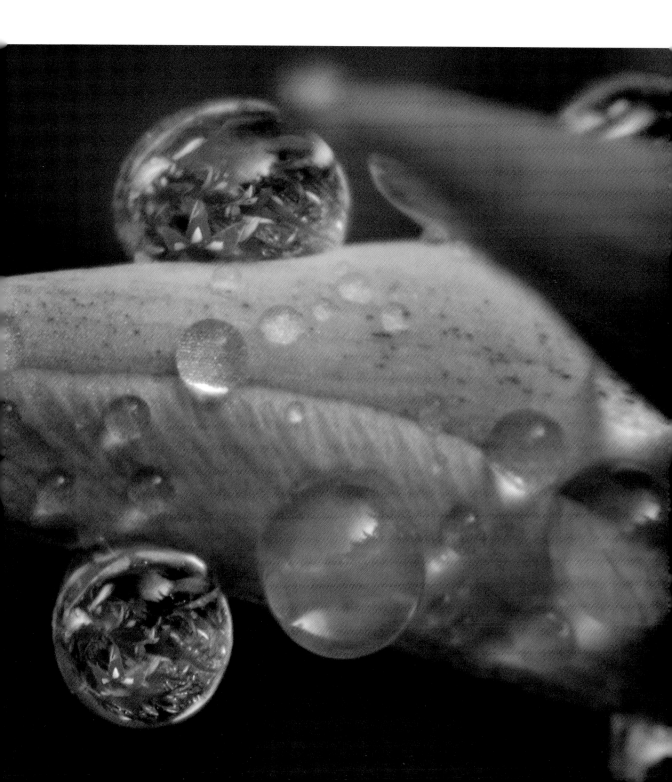

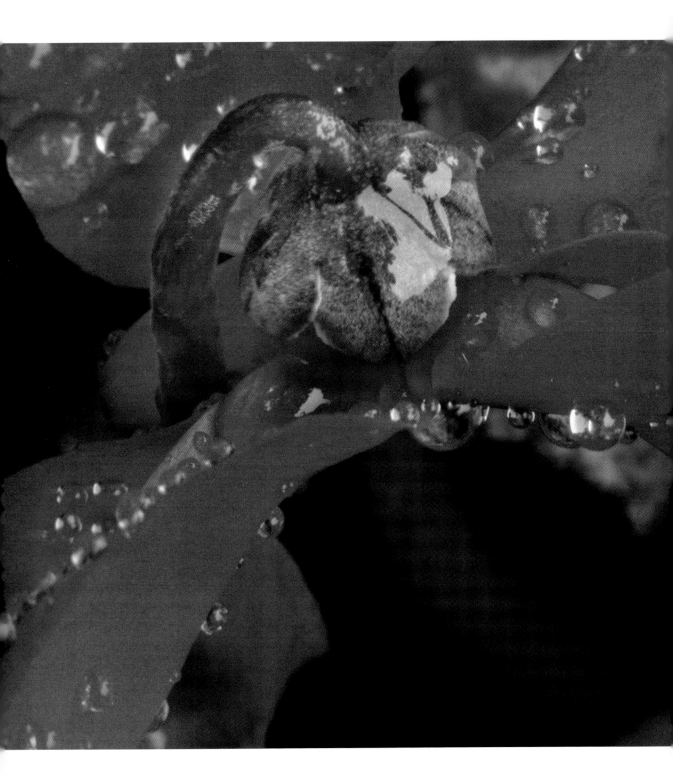

to find drops that singularly, or with their companions, showed an extraordinary glimpse into a new and different world.

I realized that with one exposure, I probably couldn't have both the interior and the exterior of a drop both fully in focus; so I chose my focus point with a great deal of care, and I experimented with different focus points.

There was no easy solution to the problem of drops in motion. I knew that if there was a spring storm overnight and a still morning, it was time to get out and photograph drops.

It's hard to tell as you shoot whether an image is really razor sharp, so I overshot—taking an exposure every time the wind seemed still... and hoping that one of the exposures would actually be crisp.

With water drops all together, the grouping and pattern made the photos compelling. On the other hand, with smaller groups of water drops, I had to pay more attention to issues of framing and image design. I looked for photos in which there was a context and effective framing, I also looked for some visual reason for the drops to appear where they did.

◀ To create this photo, I positioned my camera so the bright red cyclamen leaves appeared to be in the sunshine against a dark, shaded background.

When the composition of a photo is about pattern, a single color often plays an important role. Cases in point: this photo of the cyclamen above is almost entirely red, with a few green accents.

200mm macro, 36mm extension, 3 seconds at f/36 and ISO 100, tripod mounted

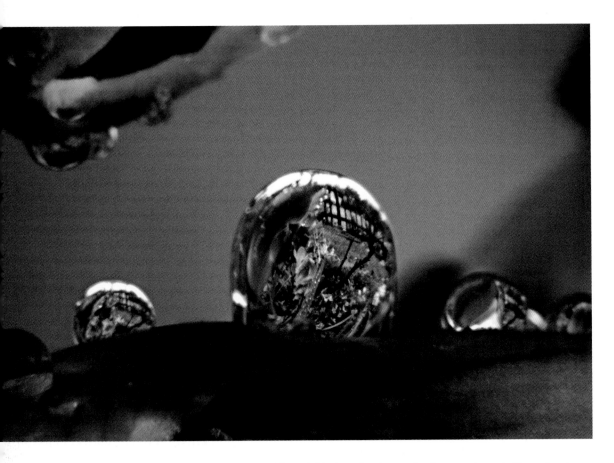

▲ I framed this shot of spring garden flowers using out-of-focus freesia buds on the borders of the composition.

200mm macro lens, 36mm extension tube, +4 close-up filter, 0.4 of a second at f/36 and ISO 200, tripod mounted

▶ After a night of gentle rain, I went out into the garden on a bright, overcast, windless morning. The patterns in the water drops on these freesias caught my attention. I tried to frame the composition so the water drops appear situated in a vast forest made up of flower stalks and buds.

200mm macro lens, 36mm extension tube, +4 close-up filter, 0.8 of a second at f/36 and ISO 100, tripod mounted

▼ Pages 166–167: To hold the branch bearing these water drops in place, I used a McClamp Stick (see page 126). I used a small aperture (f/36) to magnify the sunburst effect.

200mm macro, 55mm extension tube, 0.1 of a second at f/36 and ISO 200, tripod mounted

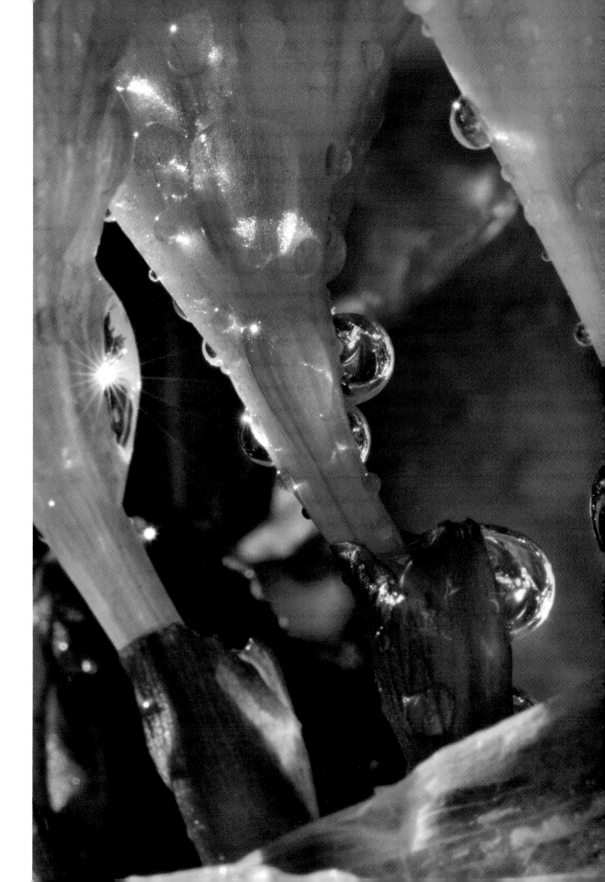

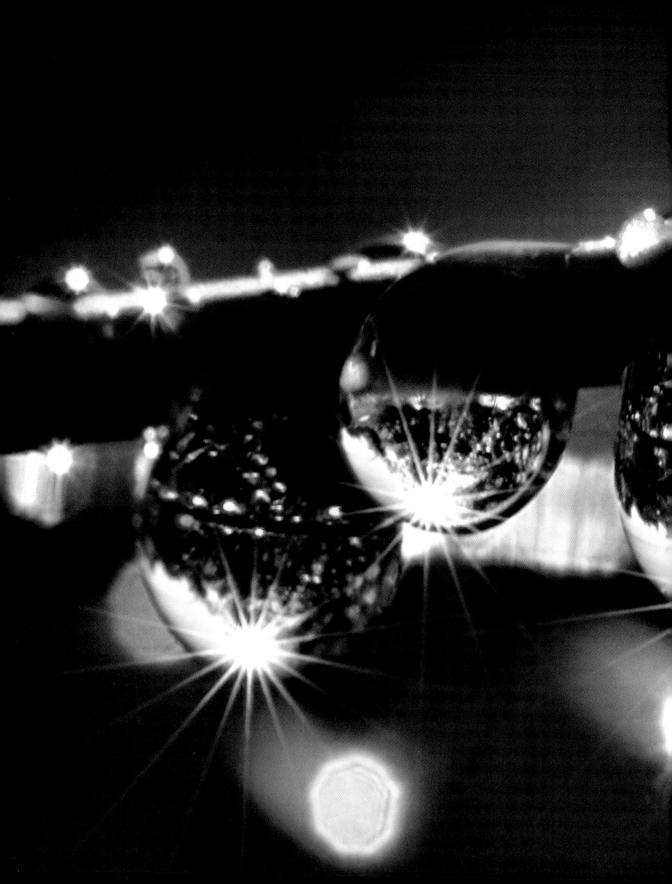

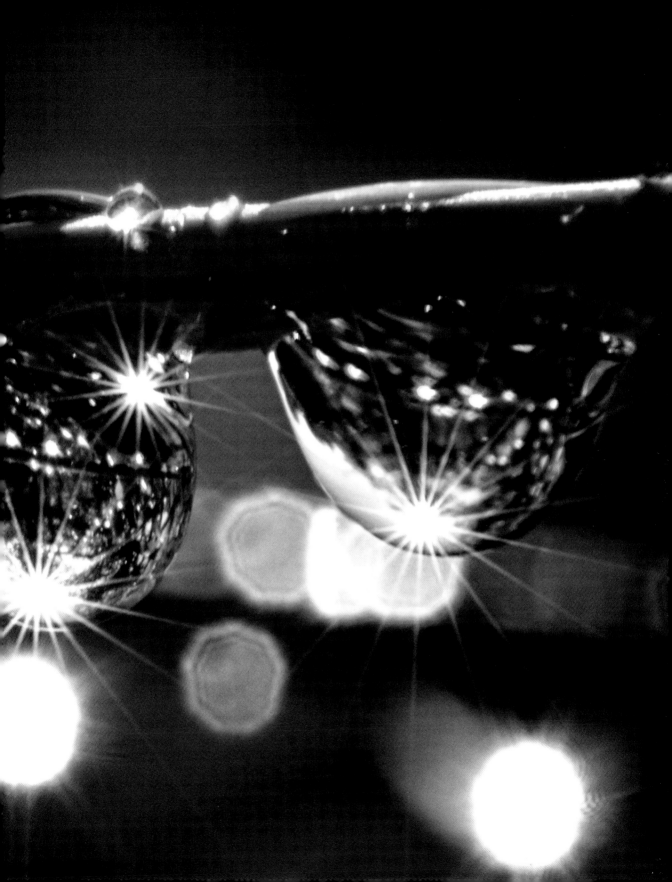

Reflections and Refractions

A *reflection* is a mirror image in which left and right are reversed. *Refractions* are caused by the change in a light wave in relation to its speed. Refractions are seen as curvatures and distortions in reflections (because the speed of the light changes as it enters the water).

Reflections depend upon light directed at a reflective surface and how reflective the surface is itself. Given a water drop in a decently lit position, it is quite likely to reflect some aspect of the world around

it. Considering the curvature of the liquid medium that is causing the reflection, any time you see a reflection in a water drop, you are also likely to see refractions.

Clear water as a medium is not particularly interesting. But when reflections are added, particularly when the reflections are of garden hues, along with some refraction, you get quite an interesting subject.

The way reflections and refractions appear in your photos depends upon the subjects that are reflected in the water drop. It also

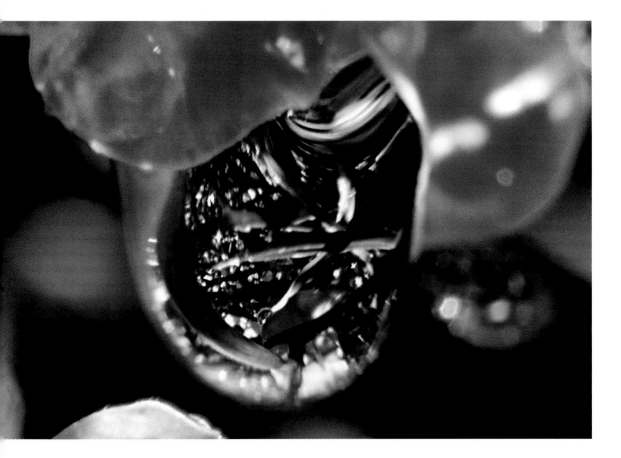

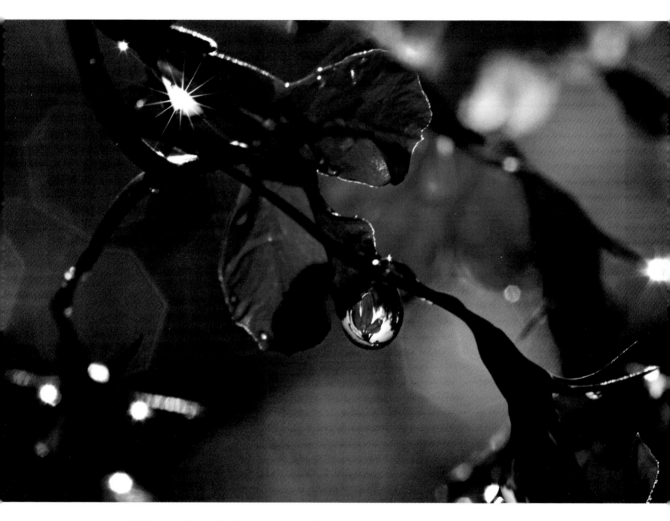

▲ I spotted this water drop reflecting a nearby Lobelia but realized that the drop was too near the ground to get a tripod into place. So I shot the image on my belly hand-held … not my usual practice when the subject is a water drop.

105mm macro, 1/60 of second at f/18 at ISO 100, hand held

◄ In making this photo, I was trying for a stained-glass effect. I shot the image first thing in the morning, down as low as possible, with the sun reflecting and refracting on a potted lobelia. This was one of those photo sessions that got me down on my belly, covered with water and mud, to find the right position.

200mm macro, 36mm extension tube, +4 close-up filter, 0.4 of a second at f/40 and ISO 100, tripod mounted

depends on the light hitting the drop, the precise angle of view you choose to use, your lens and your f-stop. This means that you should carefully try a variety of positions and distances from the water drop until you see the most colorful and clear reflections and refractions in the drop.

You may want to experiment with different lenses and a variety of f-stops. It makes sense to use a longer macro lens (see pages 48–51), so that your lens itself doesn't become the primary subject of reflections.

Don't forget to check your composition with the depth-of-field preview engaged. The appearance of reflections and refractions can change greatly depending upon your choice of aperture.

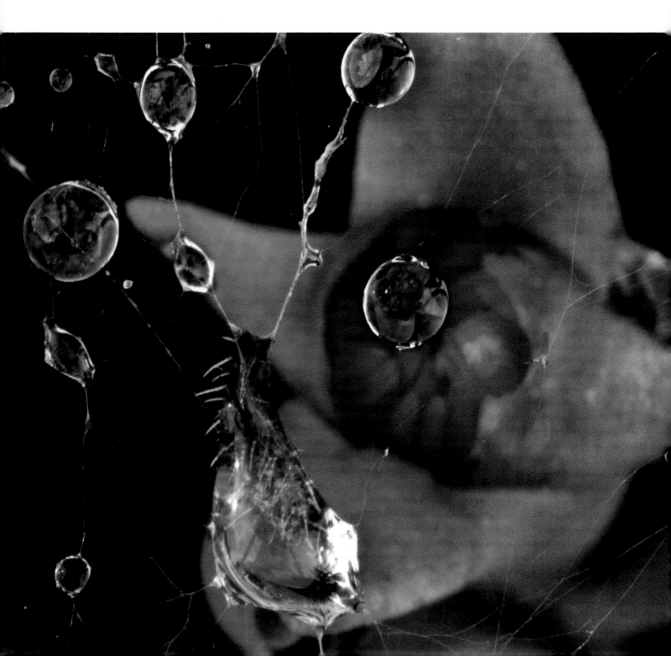

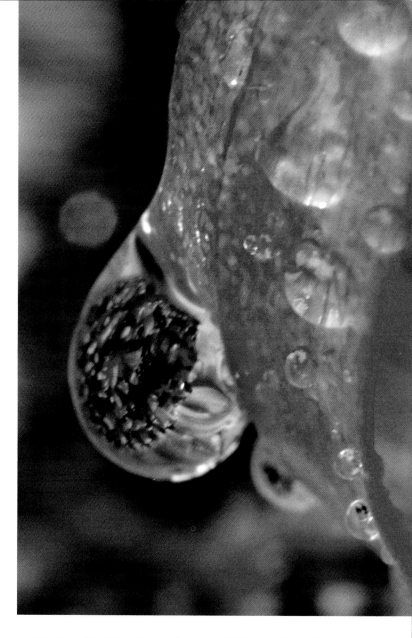

▲ Refraction distorts the flower reflections in this drop, making an image that is partially impressionistic.

200mm macro, 36mm extension tube, +4 close-up filter, 1.5 seconds at f/45 and ISO 100, tripod mounted

◄ This water drop suspended on a spider web reflects the flower below. I think the flower reflected in the drop is by far the most attractive thing in the composition, so I selectively focused on it to emphasize its importance—as opposed to the rather odd drop on the lower left.

200mm macro, 36mm extension tube, 1 second at f/36 and ISO 100, tripod mounted

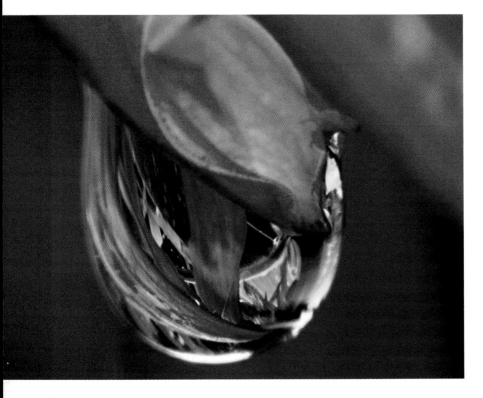

▲ This water drop, on a hybridized coneflower has been highly magnified. I used a combination of a macro lens, extension tubes and a close-up filter, with the most depth-of-field I could get. The technique here was to focus accurately and to be patient enough to wait for the subject to be still.

I like the way you can see a second reflection of the coneflower petal in this photo if you look down in the reflection to the right. The reflection is clear enough to have a great deal of depth.

200mm macro, 36mm extension tube, +4 close-up filter, 0.8 of a second at f/36 and ISO 100, tripod mounted

▶ The very clear reflections with slight refractions in this water drop show telephone wires and parts of the world that do not seem to belong in a garden; however, this contrast doesn't detract from the overall clarity of the reflections.

200mm macro, 36mm extension tube, +4 close-up filter, 0.2 of a second at f/36 and ISO 100, tripod mounted

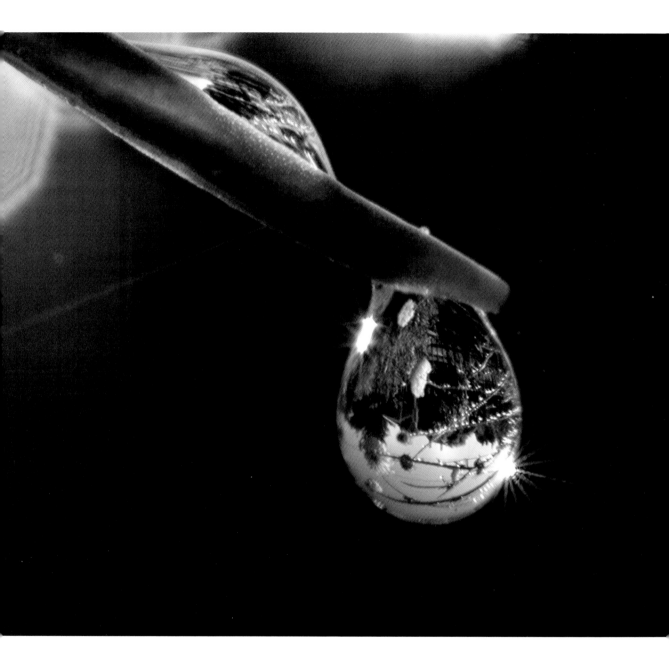

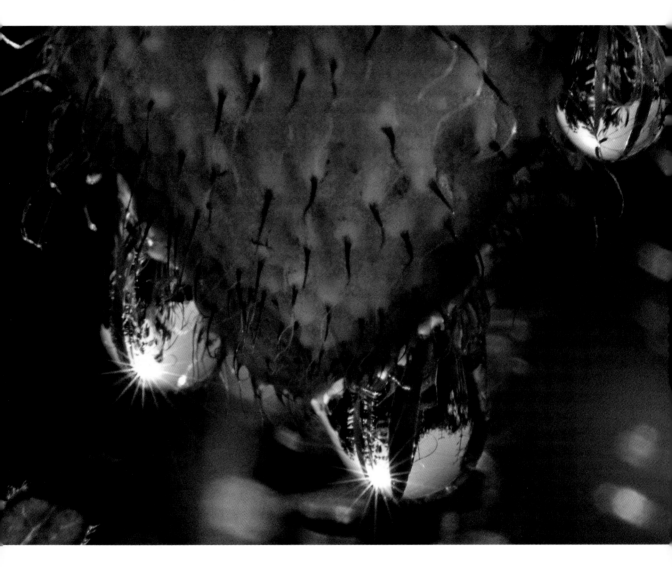

▲ I stopped down for maximum depth-of-field at f/32. Using a setting of ISO 200, I exposed the top image at 1/60 of second. While I was exposing for the bright water drops and not the darker background, I still intentionally underexposed so I could get a faster shutter speed and to avoid blow out of the highlights.

200mm macro, 36mm extension tube, +4 close-up filter, 1/60 of a second at f/32 and ISO 200, tripod mounted

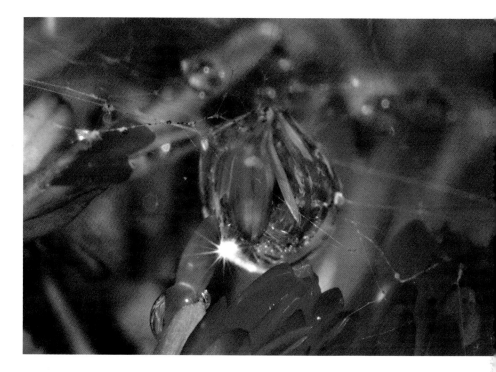

▲ This ice plant is heliotropic, meaning its buds only open when it is sunny. This makes water drop shooting dicey because drops evaporate quickly in the sun. So I was lucky to get a chance to capture this scene before the drops had faded at the beginning of a brief sunny interlude.

I thought the plant looked ethereal and ephemeral, not to mention pink, so I decided to exaggerate this effect by focusing primarily on the refractions on the upper part of the water drop rather than the internal reflections in the drop.

200mm macro, 36mm extension tube, +2.9 close-up filter, 1/8 of a second at f/40 and ISO 100, tripod mounted

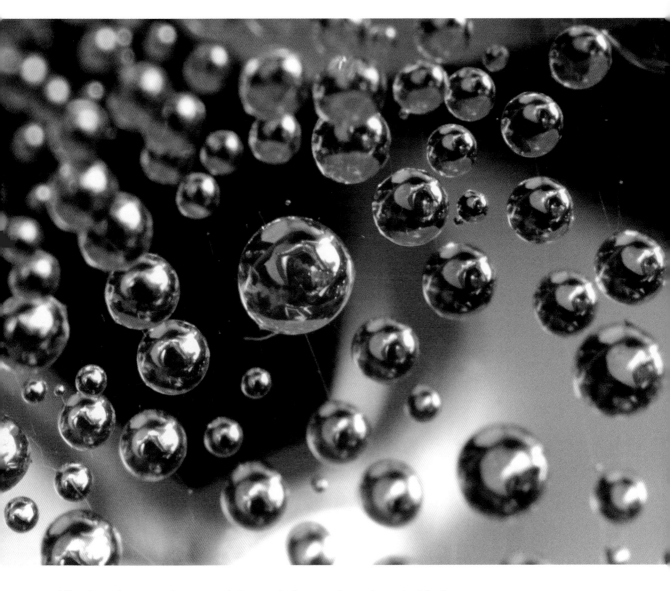

▲ When I saw these water drops suspended on a web above a cyclamen, I was struck by the way each reflection echoed—but reversed—the flower itself.

200mm macro, 36mm extension tube, +2.9 close-up filter, 1 second at f/40, tripod mounted on a Kirk Mighty Low-Boy (see page 66)

▼ Pages 176-177: As the morning sun rose, these drops on a Dahlia stem reflected Dahlia blossoms. I got very close to the drops, angled the camera to most magnify the reflections of the flowers and waited for a still moment.

50mm macro, 36mm extension tube, 1/13 of a second at f/32 and ISO 200, tripod mounted

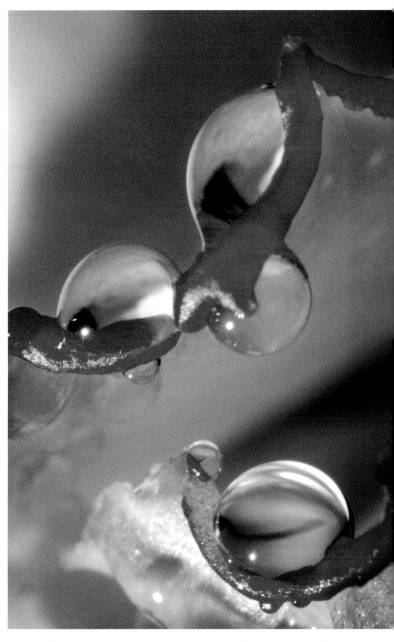

▲ The reflections in these water drops that were resting on the upper edge of a cyclamen petal reminded me of the eyes of living creature, so I framed my photo to emphasize this effect.

200mm macro, 0.4 of a second at f/40, tripod mounted

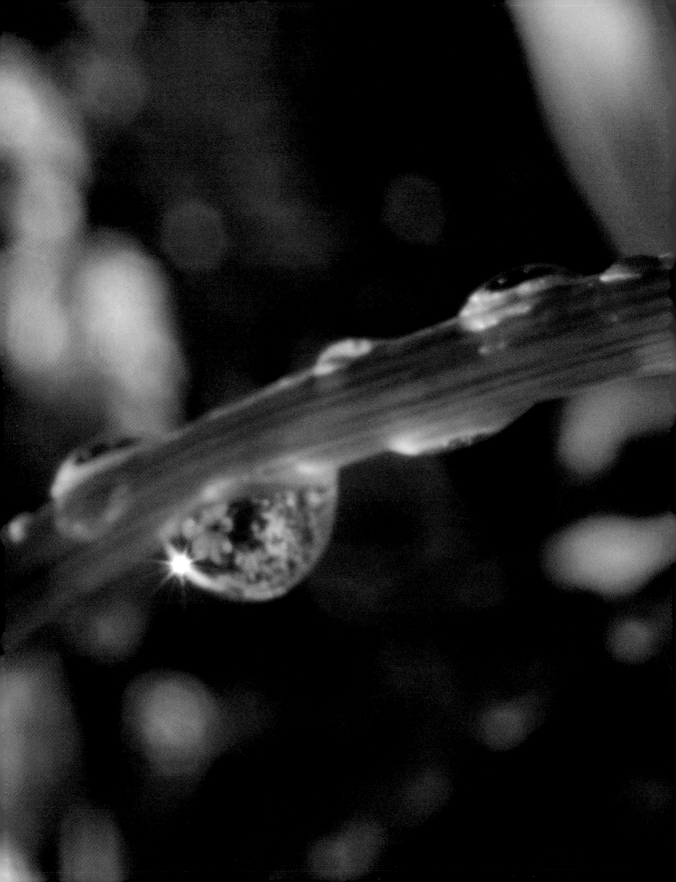

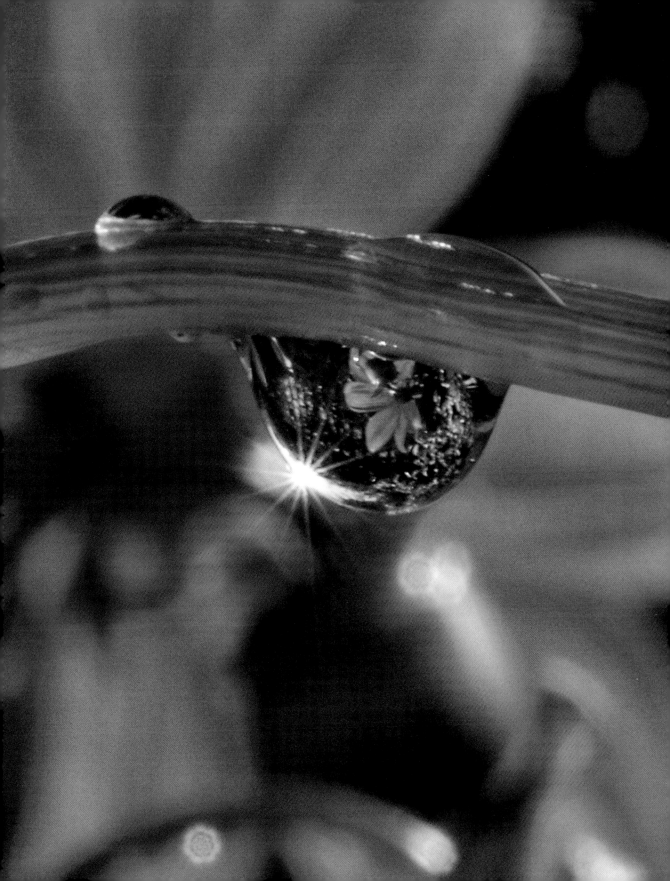

The Solo Drop

Starting with water drops en masse and moving to smaller collections of "natural jewelry," the progression leads toward single drops. These shots are close magnifications, often far beyond 1:1.

When I look for this kind of image, I usually try to find single large-sized drops that are in a stable situation. I want to be able to take my time and find the patterns of shapes, light and color. I'm looking for water drops that fulfill the idea of containing an entire world rather than having end-to-end clarity.

Sometimes small details within the drop—rather than the entire drop—interest me most about the final photo.

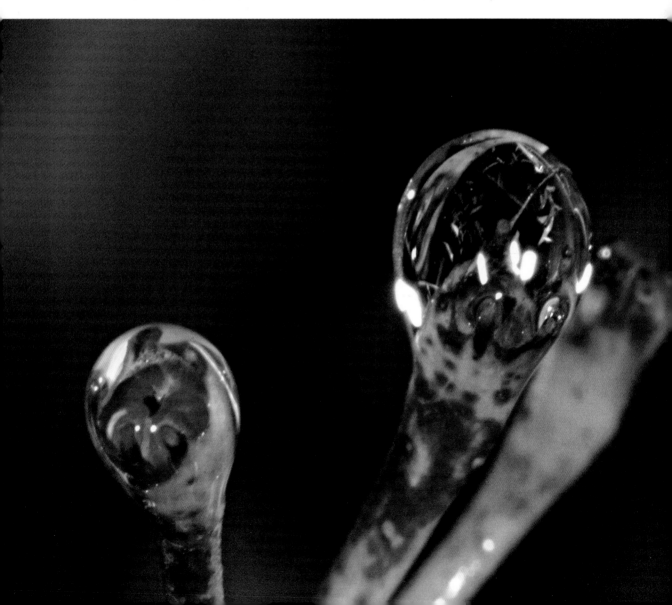

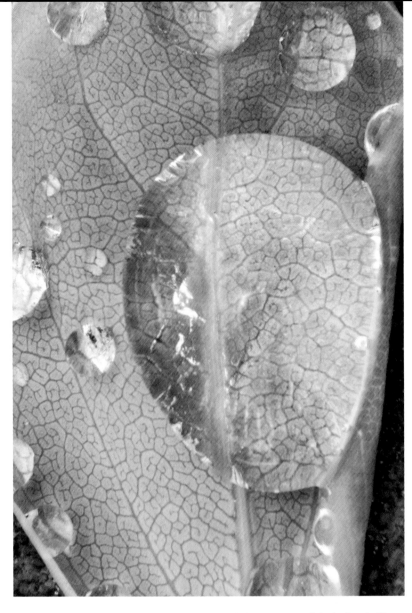

▲ This rather large drop slightly enlarged the underlying pattern of the leaf and offers a small amount of refraction. (You can easily see the refraction because the stem of the leaf does not quite align inside the drop and outside it.)

200mm macro, 36mm extension tube, +4 close-up filter, 1.3 seconds at f/40 and ISO 100, tripod mounted using a Kirk Low Pod (see pages 66–67)

◄ I used two macro flash units mounted at the end of my lens. They were controlled wirelessly on-camera so I could take this photo of a drop at the end of a twig in motion. For me, the smaller drop on the left with the reflection of a blossom is what makes this image worthwhile.

200mm macro, 36mm extension tube, +4 close-up filter, 1/60 of a second at f/40 and ISO 200, two macro flash units mounted on a ring at the end of the lens (see pages 84–87), tripod mounted

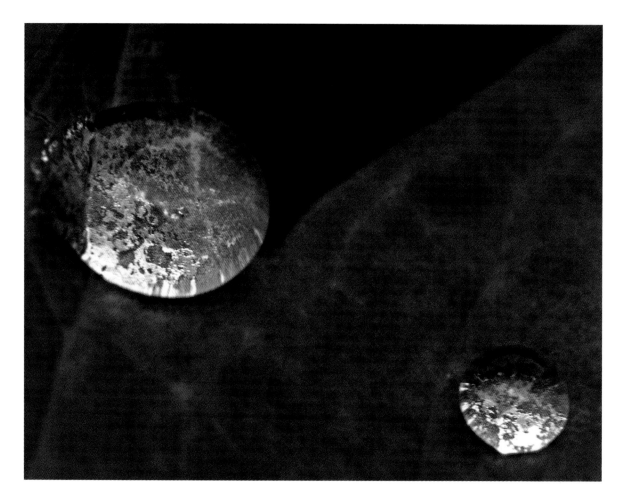

▲ Above and right: These photos show small-ish water drops on a
leaf of a peony bush. You don't really understand how great the
magnification is in these images until you look at the outline
of the leaves. Keep in mind the small size of a peony leaf, and
compare the leaf size in your mind to the drops.

I used a macro lens with a normal lens reverse mounted on it
to get really close. (See pages 54–55 for information about lens
reversal rings.) I used a moderate aperture (f/16) so the water
drops would be in focus...but not the leaf.

*Above: 105mm macro, reversed 50mm lens, 1/60 of a second and
f/16 at ISO 200, tripod mounted*

*Right: 105mm macro, reversed 50mm lens, 1/80 of a second and
f/16 at ISO 200, tripod mounted*

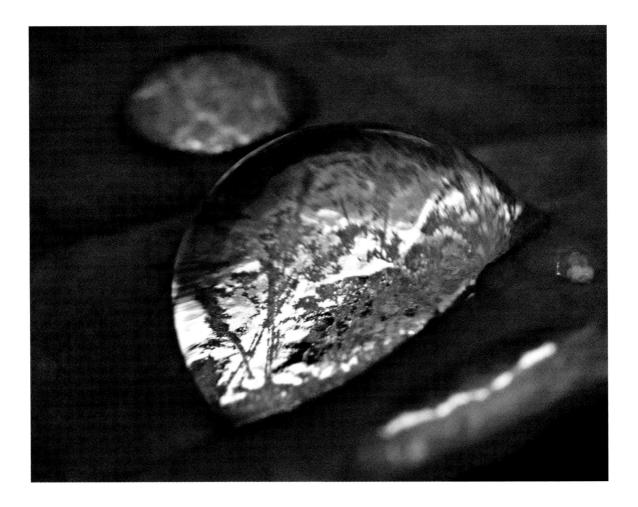

◀ In a break in wet weather, I went out to photograph raindrops. Looking down on this large drop, nestled in the cup of a petal, I was reminded of an entire green world with blue oceans, continents and cloud cover.

200mm macro, 36mm extension tube, 0.8 of a second at f/40 and ISO 100, tripod mounted

◀ This water drop, radiating light on a dark leaf background, is certainly a natural jewel if ever there was one.

200mm macro, 36mm extension tube, +2.9 close-up filter, 0.3 of a second at f/45 and ISO 100, tripod mounted

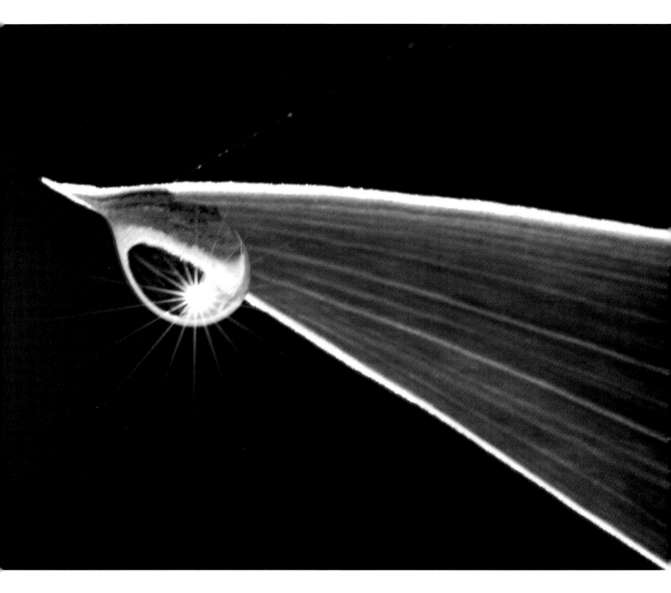

▲ I was struck by the simplicity of this single drop on a blade of grass, and I angled my camera to catch the sunburst in the drop shown here.

200 mm macro, 1/15 of a second at f/32 and ISO 200, tripod mounted

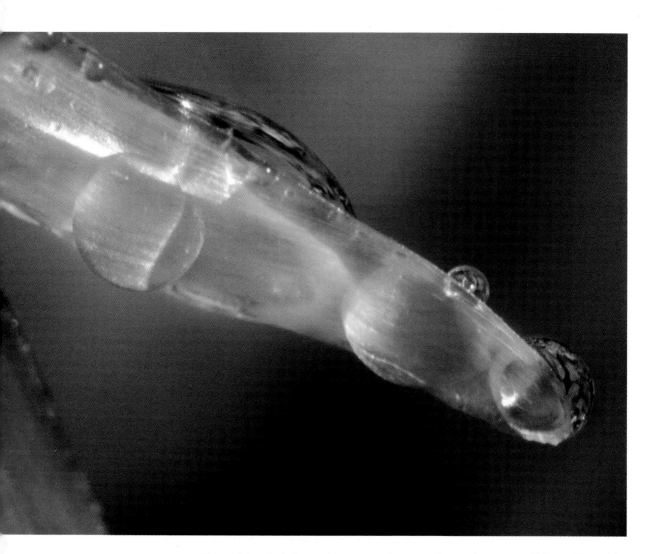

▲ No way this water-laden semi-transparent flower petal was going to stay still for me. The weight of water was making the petal act like a pivoting teeter-totter. So I boosted the ISO to 640 so I could use a faster shutter speed (1/40 of a second) to minimize the impact of the motion.

200 mm macro, 36mm extension tube, 1/40 of a second at f/36 and ISO 640, tripod mounted

▶ I focused on the water drop, letting the flower in the background go out of focus to become an abstraction. Not the biggest drop that I've shot, this one has a marvelous sense of combining clarity with a stained-glass effect.

200mm macro, 36mm extension tube, 0.2 of a second at f/32 and ISO 100, tripod mounted

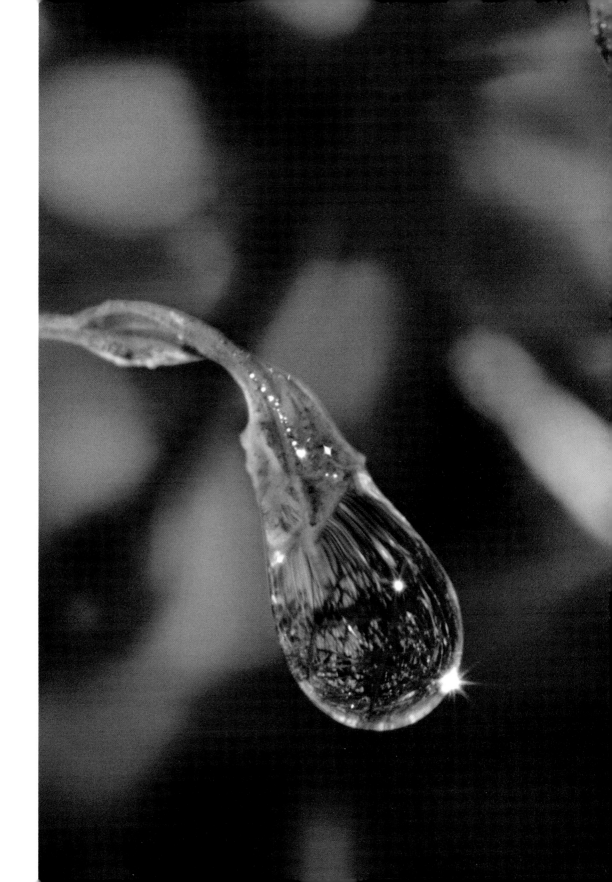

Still Life Photography

Still life photographs show arrangements of inanimate objects—such as food, flowers, shells, bottles, glasses, books, jewelry—captured in the studio or sometimes in the field.

One of the traditional forms of art, still life painting was practiced by the ancient Egyptians as a way to provide a symbolic send-off for the departed. This use of symbolic and religious objects as part of still life compositions continued through the Renaissance, after which the art form became a more secular playing ground for artists who could control entire compositions. This was just not possible when creating art from larger, or more animate, subject matter. In fact, most still lifes are close-up; once a photo has a person in it, it can probably no longer be considered a still life—both on grounds of animation and of scale.

As a photographer, when I'm in the field, I like to be prepared to make captures of still life compositions that I come across. But for me, still life really comes into its own in the studio, where I have control over every aspect of my still life compositions.

While still life photography is in some ways extremely demanding, don't let anyone sell you on the proposition that you need expensive equipment or specialized training to get started. As with any kind of photography, the most important tools are your brain and eyes. Use your eyes to conceptualize imagery and to see; use your brain to create setups, light images and understand how to set your camera.

Interesting still life photos are great fun to create. Except in the environment of fancy advertising studios, creating these images takes the skills of a cunning visual guerilla warrior, not an over-the-top studio filled with all kinds of props and lighting gadgets.

In fact, I do most of my "studio" work using improvised surfaces such as TV-tray tables or chairs with some stock backgrounds and only a couple of inexpensive lights.

▲ Pages 190–191: I placed a whole egg and the egg shell from a second egg on a slightly transparent white seamless paper background. The image was lit from behind the paper background by a strong late afternoon sun coming in through a window. I lit the eggs from the front by bouncing a 250-watt tungsten light off the white ceiling.

When I exposed the image, I was careful to focus carefully on the eggs and use a moderate aperture (f/8) for shallow depth-of-field, so that only the eggs would be in focus.

In Photoshop, I added the blue background seen toward the top of the image on a layer with low opacity. I used the Gradient Tool to blend the blue with the rest of the background.

200mm macro, 1/8 of a second at f/8 and ISO 100, tripod mounted

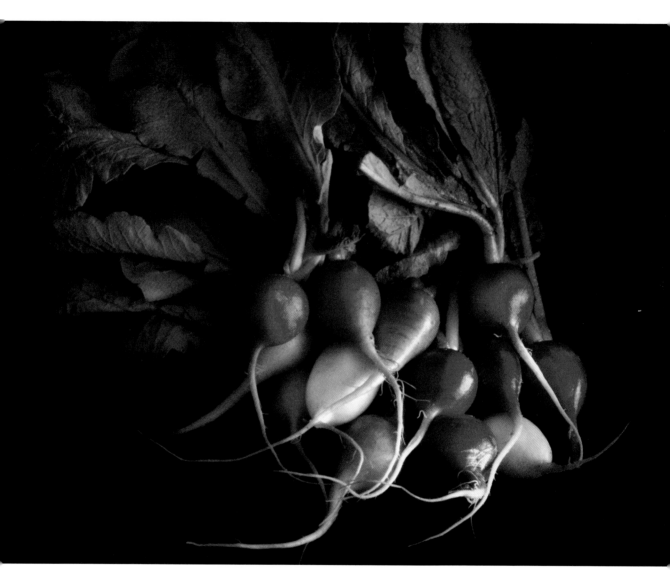

▲ I saw this bunch of ravishing radishes in the local supermarket and couldn't resist bringing it home to photograph. I put the radishes on a black velvet background and used a single tungsten light, positioned to the right of the camera and aimed up to bounce off the ceiling. I took great care to make sure the radishes were lit indirectly.

Needless to say, after photography was complete, we ate the radishes.

85mm Perspective Correcting macro, four combined exposures at speeds from 2.5 seconds to 15 seconds: each exposure at f/48 and ISO 100, tripod mounted

In case you hadn't noticed, I am not Annie Leibovitz. My still lifes are not elaborately orchestrated set pieces requiring numerous support people in the studio. Nor am I Irving Penn. The kind of still lifes I like to create most are not intended for advertisements.

In fact, I created the still life photographs in this book using simple props from the supermarket and a discount housewares store. For the most part, I used inexpensive lighting equipment that can be found at a hardware store.

My idea is to show you that still life photography can be created using simple, everyday materials. I hope these examples inspire you to do creative close-ups of your own. Now, go raid that funny old drawer in your kitchen—yeah, the one that has weird things left by Aunt Matilda—and find some kind of light!

On the topic of still life lighting (covered on pages 206–215), sometimes the best lighting is no lighting. Photographic still life masters such as Edward Weston often used natural lighting for their compositions.

Despite his reputation as the master of the grand landscape, Ansel Adams also enjoyed creating still life photos. As Adams noted,

"Very rewarding effects are possible with *available* light in the studio, whether from natural skylight or window light."

Of course, these photographers didn't take just any old available or natural light. They observed carefully, were patient enough to wait until the light was right for their subject, and they weren't above augmenting natural light with reflectors, mirrors and even studio lighting.

So let go of the idea that studio compositions require loads of fancy equipment. You need a good eye for composition and lighting and the patience to set up the still life stage (see pages 196–199).

You need to find and use appropriate backgrounds (pages 200–205) and you need to have the skill to set up interesting compositions and arrangements (pages 216–225).

Great still life photography requires a truly Zen photographic approach.

Subject, composition, lighting and background are entirely under your control in a studio still life. If you think being the Master of a Universe in this sense, albeit a small universe, sounds like fun—you are right, it is!

▶ I used rear-light projection to send the shadows created by a Venetian blind against draped semi-transparent fabric. I placed the partially filled glass on a mirror in front of the fabric. No other lights were used, and the sepia glow from the light coming through the fabric gives this image its predominant color cast.

50mm macro, 1/15 of a second at f/13 and ISO 100, tripod mounted

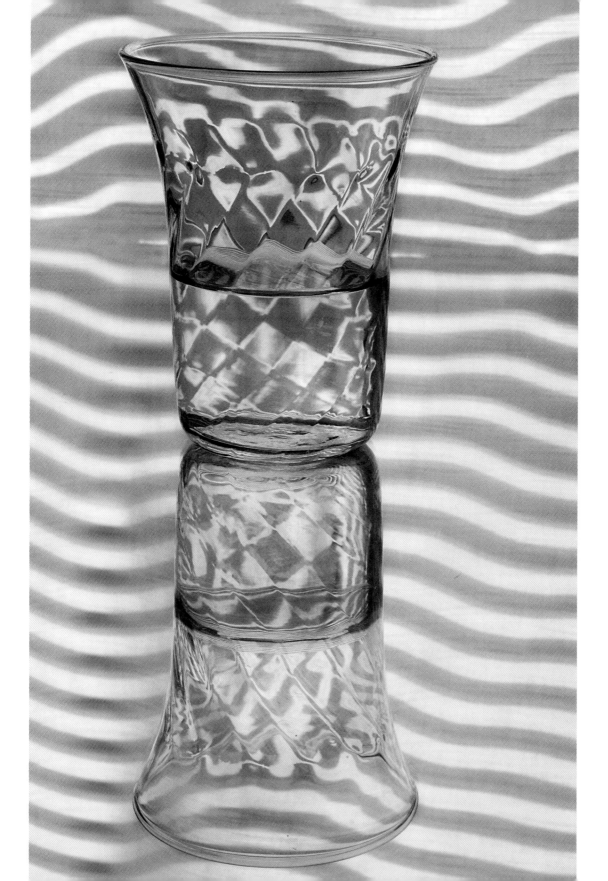

▼ I placed potatoes, rocks, and marbles—each in their own jar—on a white seamless background. I lit the setup with two lights: one bounced on the ceiling for the foreground and the other a bit more focused and covered with yellow tissue paper (except in the center) to create the spot effect seen in the background.

62mm, 4 seconds at f/32 and ISO 100, tripod mounted

▲ I saw these old bottles in a window in the historic ghost town of Bodie, California. Since the bottles were behind glass, I couldn't rearrange the composition. Getting down in the dirt of the road, I opened my tripod and positioned the camera to shoot this field still life. As I took the photo, I couldn't help but think how much more I could do with lighting and arrangement if I had these objects in my studio!

105mm macro, 1/25 of a second at f/36 and ISO 200, tripod mounted

Setting the Stage

All still life photographs are taken on a stage. Well, as Shakespeare put it in *As You Like It*, "All the world's a stage." But still life photographs are taken on a stage in a more specific sense than Shakespeare's general metaphor about life. So the more a still life photographer understands the importance of the stage, and how it is staged, the better the results.

To start, objects in a still life composition need to be placed *on* something—some kind of table or platform. Still life compositions can be found anywhere without the need to set up something, but the fun begins when you choose the stage yourself.

You can use interesting textured backgrounds like pieces of wood, but most of the time the platform will be "dressed" using background materials (see pages 200-205). It's pretty simple to create platforms that are dressed to create the illusion that the still life composition is floating on white or on black. And of course there are many other options.

So already, things are starting to get a little more stagey. There's a platform, which has been dressed to fit the aesthetics of the photo. The platform doesn't have to be fancy. I tend to use a portable folding table for smaller work, because it can be moved easily, and because I can position myself at any side of the table. For larger still life compositions, I use a wood slab on sawhorses.

For compositions that are extremely close-up, you don't have to worry about extending the platform dressing so it meets the background. But for many still lifes, a background will show as part of the photo. You need to consider the visual impact of your platform dressing. Do you want it to meet the background, or should your dressing and background actually be a single draped piece of fabric or paper? If the edge of the platform, where it meets the background, is too prominent, it can spoil the illusion of the universe you so carefully built.

To fully set the stage, you need to combine platform, dressing and background in a single construction. How do you hold these pieces together?

▶ Since the point of this photo is the shadow, and not the glass vase, I decided to emphasize the placement of the vase and shadow on a stage. To achieve this, I had to make sure the stage was not seamless, so the viewer could see the edges. A sheet of white paper served as part of the background, and the edges of the paper were clearly visible.

I pointed a single light from behind the vase, toward the camera. (See pages 212-215 for more details about lighting setups for capturing still life shadows.)

50mm macro, 0.3 of a second at f/32 and ISO 100, tripod mounted

One possibility: Light stands can be used to prop the dressing and background in position, and clamps will hold everything in place. (Clamps are shown to the right.) Strong tape is also useful. And none of this costs much.

So, yes, most studio still life work is best done on a small stage. But your small studio stage needs to be dressed and propped together, just like a larger one. The good news is that this is easy and fun, and it doesn't take much money.

▶ Clamps like these cost a few dollars each at a good hardware store, and they can be used to put together the stage for almost any still life setup.

To make this photo, I positioned these clamps on a white seamless background. I used a single 250-watt tungsten light bulb (purchased at a local hardware store, too).

I placed this bulb in an inexpensive metallic reflector and used a "brother" of one of the clamps shown in the photo to position the reflector on a light stand. I turned the reflector up to bounce off the ceiling and used pieces of white cardboard to lighten the metal surfaces of the clamps by reflecting light into these areas.

I shot this photo to show the inexpensive clamps I use to create the makeshift stages for my still life close-ups. But the image also shows that interesting still life compositions can be made from very humble objects.

50mm macro, 2 seconds at f/32 and ISO 500, tripod mounted

Backgrounds

Backgrounds can make or break a still life composition. My work and life takes place against a backdrop of considerable clutter. Perhaps this has something to do with the four young kids at home.

Unless your life is very different from mine, it's not likely that the natural backgrounds you find in your environment will be conducive to the Zen simplicity of still life compositions. In other words, it is up to you to decorate your stage with backgrounds that hide life's clutter.

Fortunately, there's no great difficulty or expense involved in coming up with a "library" of backgrounds for still life compositions. It's great to experiment with all your options!

I keep on hand three kinds of backgrounds:

- Seamless paper
- Fabrics
- Mirrors

Seamless paper comes in rolls that can be bought at photo or art supply stores. I have both black and white rolls on hand. Other colors can also make interesting backgrounds; and if you plan to photograph people in the studio, you should consider a gray seamless background.

Seamless is the classic studio background. It's extremely versatile and quite useful. The only downside is that it gets wrinkled and stained pretty easily, so you have to replace it often.

▶ I used a burlap background with relatively harsh and direct lighting to make the background itself an important element of this composition. The point of the photo is humorous: a pear resting on the burlap-decorated stage seems to be chatting with a pear in a glass Mason jar. Is this visiting hours in a fruit prison? The roughness of the burlap contrasts with the delicacy of the fruit, and this makes the humor of the photo more interesting.

95mm, 3 seconds at f/22 and ISO 100, tripod mounted

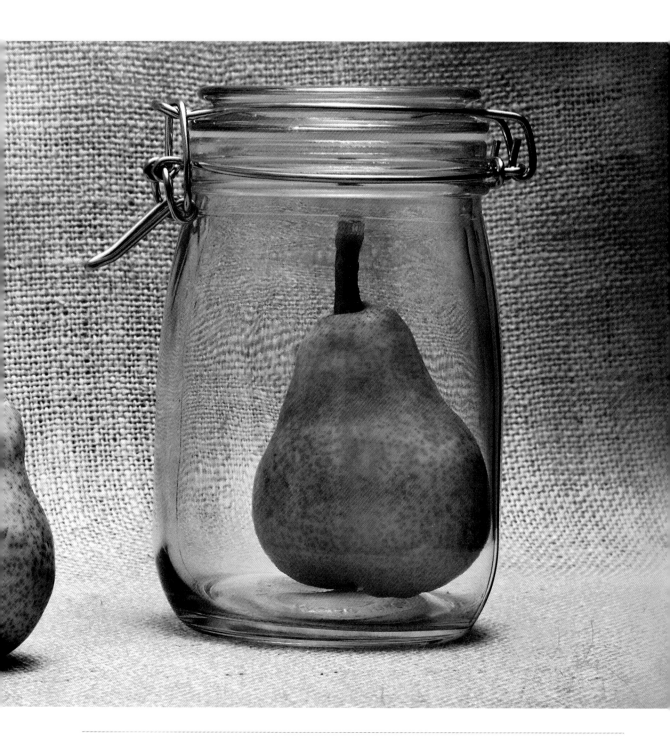

For my still life compositions, I buy a couple of yards each of black velvet, burlap and linen at a fabric store. You cannot possibly visit a fabric store without getting all kinds of wild and interesting ideas about other fabrics to use for still life backgrounds. So plan to be there for awhile, and let your mind wander!

If you take care of your fabric backgrounds by not spilling water on them and by storing them on a roll, you'll be able to use them for a long time. You may need to iron fabrics when you first get them to remove lines from storage, and repeat ironing may be needed to keep that "crisp" look in your compositions.

I often use mirrors beneath and behind the still life subjects to add depth and mystery. The best place to get mirrors for this purpose is a glass supplier, the kind that sells glass to replace broken windows. You don't need anything too big, probably no more than two feet in any dimension; but for best results, buy the thickest glass that is offered: likely a 1/2" thick.

Since mirrors reflect their background, it probably goes without saying that I use mirrors on my still life stages in conjunction with other background materials, such as seamless paper or fabric.

For still life photos that make their subjects seem transparent (see pages 106–111), I like to shoot down on the subject with a fluorescent-tube lightbox as the background. You'll find quite a few styles of lightboxes available from photo suppliers. The best ones to use have tubes that match the color temperature of daylight. Assuming you are using natural ambient light, there won't be a conflict between light sources with a different white balance.

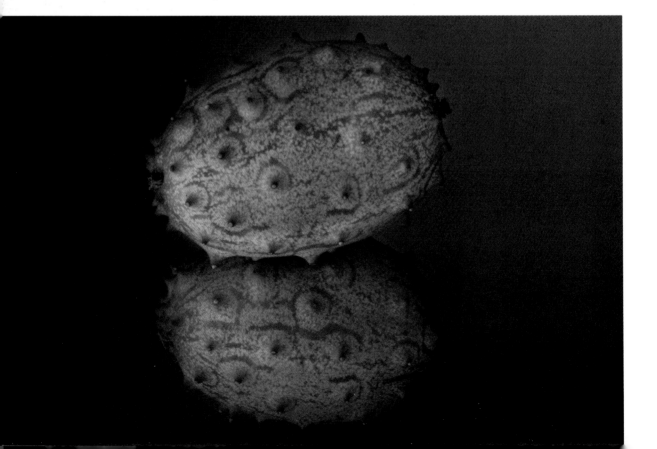

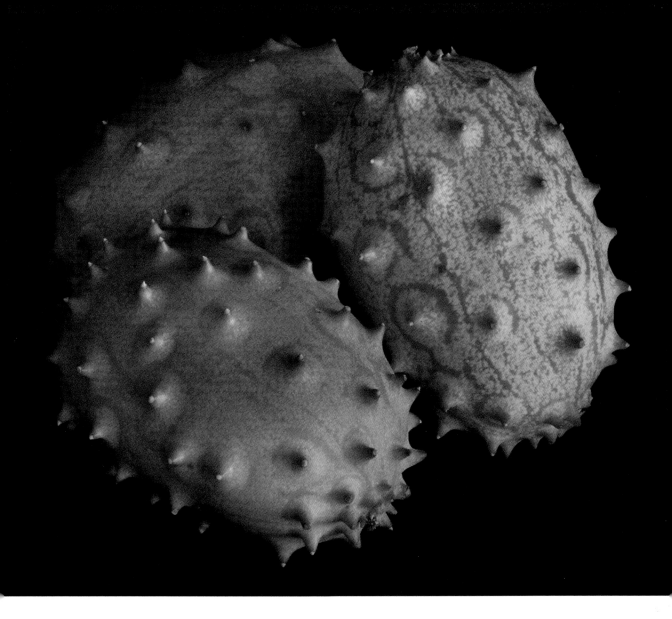

▲ I used a black velvet background to isolate these prickly melons from everything in the composition except each other. The idea of using a black background in this way is to create a sense of mystery. At the first take, the viewer of the image doesn't know exactly what they are looking at or what the objects in the composition are resting on.

130mm, 1 second at f/36 and ISO 100, tripod mounted

◀ Mirrors can be tricky as a background because they give you a limited field of view to capture... without revealing the world beyond your stage. If you try to make a composition with a wider view, you risk dragging in extraneous subject matter. For this photo, I was able to use the mirrored background to create a sense of mystery and humor around the subject. I think this prickly melon could almost be a submarine about to navigate the silent deep, but this required careful positioning of my camera angle.

85mm Perspective Correcting macro, 1 second at f/48 and ISO 100, tripod mounted

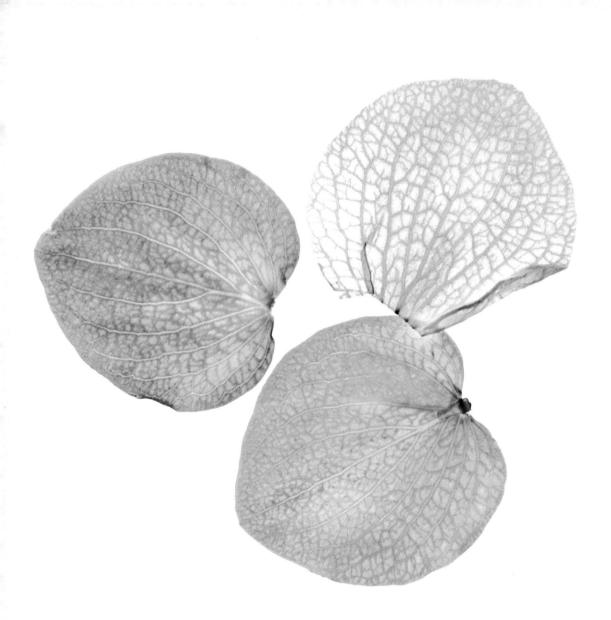

▲ I photographed these fresh, quarter-inch wide oregano leaves using a lightbox as a background. I made sure to overexpose the photo to increase "high key" feeling of the lighting effect and to make the tiny leaves seem even more transparent than they were.

200mm macro, 4 seconds at f/36 and ISO 100, tripod mounted

▶ In this still life composition, the sunflower is clearly resting in a bottle. I used a black seamless background to bring out the vibrant contrasting colors in the sunflower, because colors tend to seem richer when contrasted with black.

85mm Perspective Correcting macro, 2 seconds at f/45 and ISO 100, tripod mounted

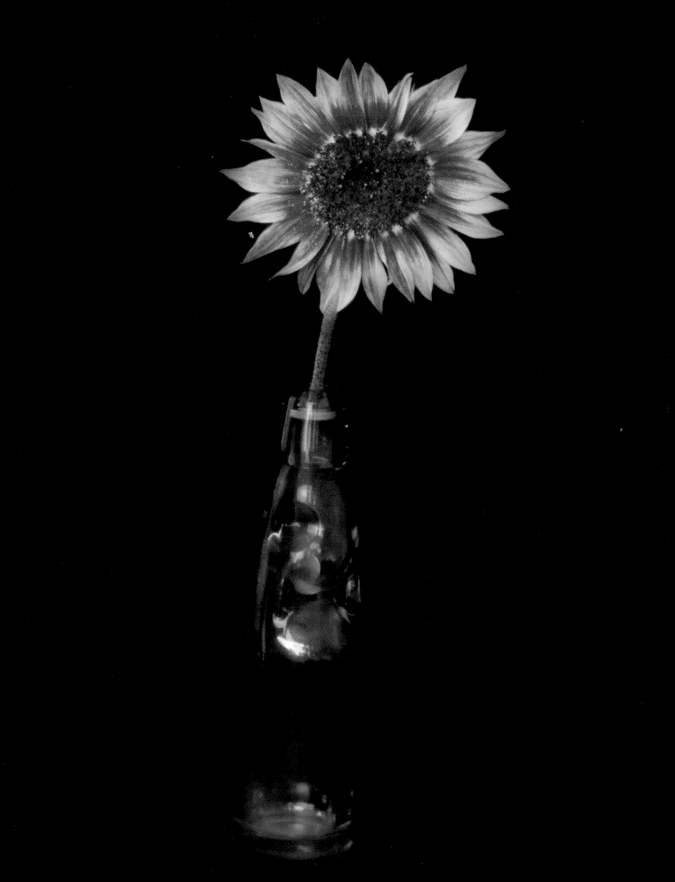

Lighting Still Life Compositions

▲ To photograph the "keypad" of this antique portable calculator manufactured by the Rapid Computer Company circa 1893, I knew I didn't want lighting that called attention to itself. The subject matter was enough without additional drama. So I bounced a single tungsten light off the white ceiling.

85mm Perspective Correcting macro, 6 seconds at f/24 and ISO 100, tripod mounted

So all you need is one light. Well, maybe two. I'll explain in a moment. But first let me return to a more important topic than the lighting fixtures you use. And that's learning to see light.

Ralph Hattersley, in his 1970s lighting technique classic, *Photographic Lighting: Learning to See* stated in regard to studio lighting that "learning to see is the most important step to take in the process of becoming a good photographer." (By the way, I highly recommend the exercises in Hattersley's book if you can find a used copy to study.)

As with lighting in the field (see pages 80–83), photographic light can be described in terms of direction, intensity and quality.

Direction of lighting is easy to understand because it refers simply to the direction from the light source to the subject. There are only a handful of possibilities. Backlighting comes from behind the subject and is usually facing the camera. Front lighting hits the front of the subject, usually from a light source located to the rear of the camera. Top, side and bottom lighting are clear enough as concepts, though in all cases, a given light source can hit the subject in several ways (e.g., top and side). The table on page 83 explains lighting directions in greater detail.

I discussed light intensity and quality in the context of the field on pages 80–83, and mostly the same concepts apply indoors. Light intensity results from the strength of the light source and its distance from the subject. You can more easily quantify studio lighting than ambient light outdoors, because you know the wattage of the light

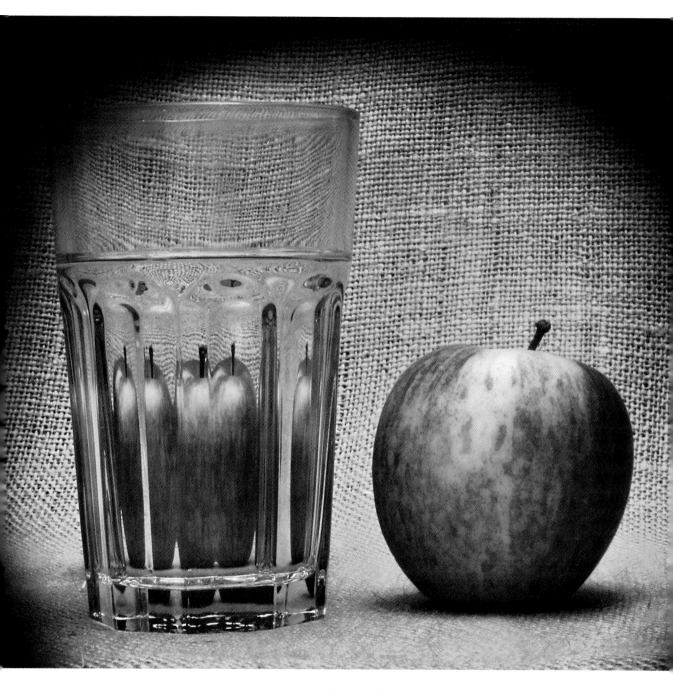

▲ I arranged this glass of water and apple on a rough burlap background. To emphasize the textural quality of the burlap, I used a light focused using a snoot—a dark tube placed on the front of the light—to create a spotlight effect. I also bounced light off the ceiling.

50mm macro, 8 seconds at f/32 and ISO 100, tripod mounted

bulbs you are using (if you are shooting tungsten), although fixtures and the amount of reflection also play a role.

The quality of light includes both its color temperature—something that can be measured and stated in degrees Kelvin—and various subjective aspects, especially whether the light is soft (bounced or diffused) or harsh (direct).

The first step in lighting a studio still life is to pre-visualize the lighting effect you'd like. Consider the composition you'd like to create and the way your setup looks on its stage. This becomes easier with experience, so don't worry if you aren't quite sure at first. Experiment!

Many still life compositions will work with an overall diffused light. This can usually be achieved by bouncing an incandescent tungsten light bulb in a reflector off a white ceiling. Place the light on a light stand some distance from the still life stage; put the light stand at a medium height; turn the light on, and see what the lighting looks like. If there are "hot spots" caused by the light, back it up and try moving its position slightly. If the light seems too harsh, tone it down by putting translucent material over the light (being careful not to start a fire!).

This kind of extremely simple setup works well for close-up details (such as the example on page 206) and when you don't want or need drama.

◄ I lit this egg from behind and then realized that the complete backlighting caused the front of the egg to appear quite gray (rather than white). So I added a second light, positioned in front and above the egg. The second light wasn't as intense as the primary backlighting, but it helped to balance the lighting.

200mm macro, 10 seconds at f/36 and ISO 100, tripod mounted

The same single lamp on a stand can be used to create backlighting as well as backlit shadow and other effects (see pages 212–215).

A second light comes in handy for balancing the primary light source. In a backlit scenario, you can use the second light to add some illumination to the front of the still life, as in the egg photo on page 208.

Another effective way to use two lights is to set both in front—one on the right and one on the left—facing toward the composition on the stage. Lights paired this way can be adjusted with great precision to get delicate lighting effects over all or part of a composition (see the example to the right).

When I'm creating a still life using this kind of setup, I'm looking for subtle lighting that doesn't call attention to itself but provides nuances with some variations across a composition. I complement the use of the lights with white cardboard (to reflect light into selected parts of the composition) and black board (to shield areas from light).

You also need some way to send very targeted light into compositions and their backgrounds. Essentially, this is a special effect (for example, see page 207). I use a Lowel Pro equipped with either barn doors or a snoot for this purpose, but you can make a hand-made snoot (a round tunnel placed in front of a light) by rolling dark cardboard and taping it to the front of a light (once again, taking care not to start a fire).

▶ I placed this chambered Nautilus shell on a black velvet background. To keep the light even across the shell, I used two lights. I placed a light at an angle to the shell on both sides, and bounced both lights off the white ceiling.

50mm macro, 8 seconds at f/32 and ISO 100, tripod mounted

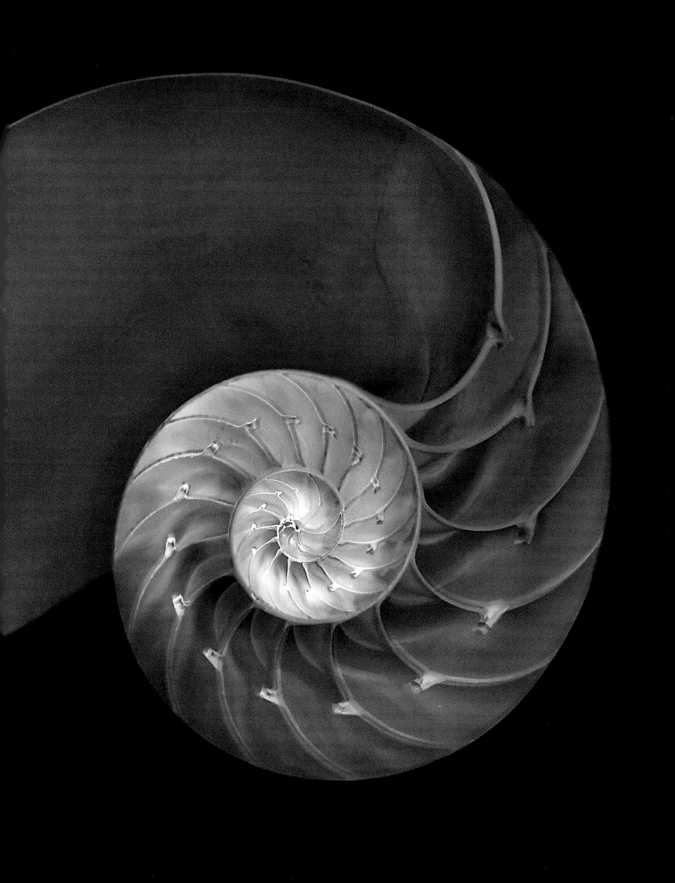

Shadows

Shadows are magical. C. S. Lewis, in many of his books, explored the shadow lands. To lose your shadow means, as Peter Pan found out, losing your soul. In photos, shadows evoke fear, excitement and—most of all—a world that is not normal.

Shadows often help make compositions interesting in field close-ups, but outdoor shadows are found objects. They are there or not there; you can alter the camera position or wait for different light, but you cannot make shadows from nothing.

In the studio, it's surprisingly easy to create shadows, although it can take much trial and error to get them right.

Shadows are such an important part of studio still life photography that it is a great exercise to create close-up photos that are primarily *about* the shadows the compositions contain, rather than the objects creating the shadow.

Since shadows are mostly about darks and lights, I tend to present photos that are about shadows in black and white.

To create controlled shadows, you need a dark room (otherwise the shadows don't show strongly) and a light source. One light will produce shadows that clearly progress in a single direction; if you use two lights, you'll get shadows that seem to move in several directions, and the shadows may not seem as strong.

A light behind a subject, backlighting it, will create shadows in front of the shadow-creating object (examples pages 213–215). A light behind the camera, front lighting the shadow-creating object, will produce a shadow behind the object (example page 230). Shadows in either direction can be interesting subjects.

A light that is positioned lower in relation to a subject will produce a longer shadow. Obviously, stronger light produces a more pronounced shadow, but you need light that is focused as well as intense. I use a tungsten halogen light equipped either with barn doors or a snoot for this purpose; but as I mentioned on page 210, it is easy to hand-make a snoot.

Generally, the further away from the object the light is, the sharper the edges of the shadow. But there's no substitute for trying many different light positions if you are going after a striking shadow effect.

▶ To make this photo, I placed the glasses on a table in a completely darkened room. I used my Lowel tungsten spot with barn doors on a light stand. The light was positioned opposite the camera and above the glasses, so these glasses are essentially backlit. I changed the angle and height of the light many times in order to get the composition exactly right…so the shadow of the ear pieces met the "actual" ear pieces.

85mm Perspective Correcting macro, 0.4 of a second at f/24 and ISO 100, tripod mounted

▲ I positioned the light above and to the left of a parfait glass. I underexposed the photo to let the glass go dark, because I thought the shadow of the glass was far more interesting than the glass itself.

50mm macro, 2 seconds at f/32 and ISO 100, tripod mounted

▶ I moved the light quite close to the parfait glass so I could capture the contrast between the white background and the dark shadow areas cast by the glass; the effect in this composition reminds me of a shadow shell.

85mm Perspective Correcting macro, 1/4 of a second at f/25 and ISO 100, tripod mounted

Staging the Set

Everything is ready. You have your still life objects for your close-up. A stage is in place. The stage is dressed with an attractive background that works well with your subject matter. You've put lights on stands, played with lighting effects, and you more or less understand how to light your subject. What's next?

Staging is the craft of attractively arranging objects together. This involves a visual and aesthetic component—getting the composition you want—as well as construction. The audience at a play in a theater cannot see behind the scenes to find out what holds the sets together. Likewise, when looking at a still life, you don't really know if it is held together with toothpicks, glue sticks, tape or one of the great secrets of still life staging: Clear Museum Gel.

Available at art supply stores, Museum Gel is removable, reusable, translucent and won't damage most surfaces. When you put little balls of the stuff between objects and

▶ It took a great deal of careful positioning of the apple, pear and glass to get the refractions shown in this photo to look good. For more on photographing refractions, see pages 168–179.

When photographing through glass, I try to experiment with shifting the angle of the glass. I also like to see what happens when I shift the focal length of the lens and aperture. For this photo, I originally tried working with a shorter focal length lens, and I was surprised at how much better the composition looked through my macro telephoto after I had the glass in position.

200mm macro, 10 seconds at f/32 and ISO 100, tripod mounted

wait half an hour or so, a secure and mostly invisible bond is formed.

In addition to the visual arrangement and physical sticking together, to make a good still life photo you'll need to consider the composition from the viewpoint of the camera.

This means experimenting with different lens choices and exposure settings, particularly aperture. Since aperture controls depth-of-field, changes in aperture can drive major changes in a still life composition.

In addition, minor shifts in camera position can create great changes in close-up compositions. Sometimes, these shifts reveal some of the "scaffolding" used to set the stage, which means you may be back to work, rearranging your set and gluing things back together so they will not show.

If you choose to try a different lens, this also can have a big impact on your composition. It, too, can make you to rearrange your staging because of the changes.

◀ The still life paintings of artists from the Renaissance through the Impressionist movement often show many objects arranged to relate to each other. It's fun to try to create this kind of assemblage for photography in the studio, but it's harder to pull off as a cohesive composition than you might expect.

This composition takes advantage of color contrasts between green and red objects to create an underlying sense of order, even though the pattern may not be apparent at first glance.

50mm macro, 10 seconds at f/32 and ISO 100, tripod mounted

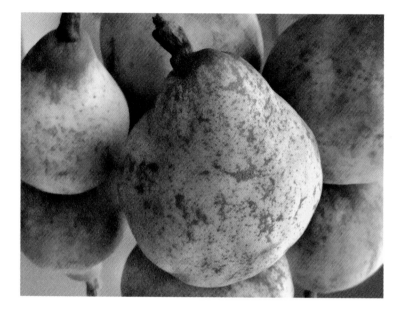

▲ I shot this image of pears from my garden on a mirror with a fixed-lens camera, using a high ISO (1600) for the specific purpose of creating a "noisy" still life. The noise gives the composition some added visual density and interest.

Canon G9 point-and-shoot, 14mm (approx. 70mm in 35mm equivalent terms), macro mode, f/8 at 1/100 of a second and ISO 1600, tripod mounted

▶ The Lensbaby allows you to set the area that is in focus (see pages 60–63); I used it here to create a more subjective image from the otherwise fairly conventional still life arrangement shown on page 218.

Lensbaby Composer, 1/160 of a second using f/5.6 aperture ring, ISO 500, hand held

Finding Subjects

How do you find subjects for still life close-ups? It's easy, often great fun and can lead to good photos if you round up the usual suspects: flowers, fruits, glassware and household items. These objects are probably listed in the order they are most frequently photographed in the studio.

In terms of gaining experience with studio close-up work, it probably doesn't matter much *what* you photograph. Lighting is lighting, and shapes are shapes.

To practice still life photography, it doesn't matter whether your subject is a stuffed animal, vegetable or mineral—although it makes sense to try out different colors, textures and levels of reflectivity.

To find interesting and unusual close-up subjects, try to pre-visualize what objects will look like when they've been staged and lit. Try to use your imagination and keep a sense of humor.

Pre-visualization lets me walk down the street, browse in the supermarket and generally enjoy life while keeping an eye out for objects that would be interesting to photograph—or make a good component of a still life.

My imagination helps me to see things such as a prickly melon masquerading as a submarine (see page 202) or a pear in prison (see page 201) while other people may see, well, a weird-looking melon and a pear. The same goes for my sense of humor. So cultivate both your imagination and your funny bone!

As you see, close-up subjects are found everywhere. Many mundane objects make great still life subjects. But, finely crafted objects such as ceramics and glassware also have their place in still life close-ups. Keep your eyes open, and start a collection of things both ordinary and special, and big and small, that you can use to create magical compositions on the small stage.

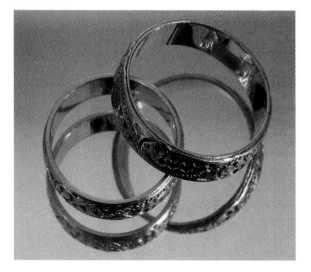

◄ I've already noted that you don't need fancy gear to shoot close-ups. This photo manages to be a close-up view of jewelry and a romantic statement at the same time, created with an older generation fixed-lens camera.

Canon PowerShot G3 point-and-shoot, 28.8mm (140mm in 35mm equivalent terms), macro mode, 0.8 of a second at f/8, tripod mounted

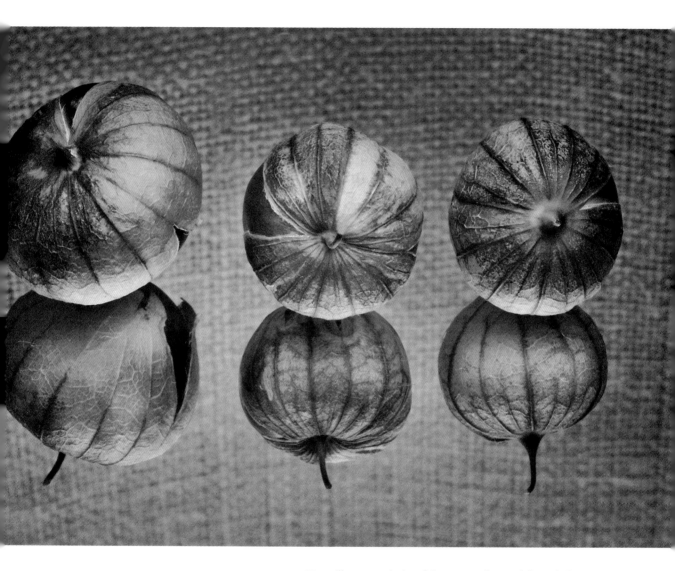

▲ Tomatillos are a relative of the tomato plant and the main ingredient in Latin American green sauces. At the supermarket, I was struck by the marvelous range of colors in these tomatillos and couldn't resist buying a handful to photograph.

85mm Perspective Correcting macro, 4 seconds at f/27 and ISO 100, tripod mounted

▲ My local supermarket is a great place for finding still life subjects—like this red pepper. The only problem is that I have to photograph this kind of subject quickly, before it becomes part of the family dinner.

I photographed this red pepper on a black velvet background using a single focused spotlight bounced against the ceiling. The low light levels that resulted from the indirect light and black background meant that this still life photo required a fairly long shutter speed. One of the exposures I used to make this image lasted a full three minutes.

85mm Perspective Correcting macro, five exposures combined in Photoshop at shutter speeds between 30 seconds and 3 minutes; each exposure at f/51 and ISO 100, tripod mounted

▶ This photo shows an old-fashioned egg yolk separator found in the back of one of my wife's kitchen drawers. I lit the egg yolk separator from behind using a single tungsten spotlight and carefully positioned both the light and the egg yolk separator to maximize the spiral shadow.

85mm Perspective Correcting macro, three exposures combined in Photoshop at shutter speeds between 2 and 8 seconds; each exposure at f/51 and ISO 100, tripod mounted

Photographing Jewelry

Photographing jewelry is much like other studio close-up work... with some added considerations:

- Often you must get extremely close to jewelry, so a macro lens is likely to be a requirement for this kind of shot.

- The point of most jewelry photography is to make the jewelry look good, and this is not the goal of all still life close-up work.

- Gold, silver and other reflective metals used in jewelry construction need to be treated with special care, photographically speaking.

The metal used in jewelry is reflective, meaning that it acts partially like a mirror, depending upon how polished it is. You need to understand that they way this metal appears in your photos will depend upon its surroundings and how you've set up lighting. The combination of the lighting and what the light reflects into the metal in the jewelry determines the warmth or coolness of the metal and whether the metals appears to radiate light or suck it in.

If you've set up a composition with jewelry and are happy with it generally, but not pleased with the specific color cast of the metal, it's time to trot out the secret weapon of jewelry photographers: boards. I keep a set of black, white, red and silver-coated boards that I can move into position to reflect light into my compositions that involve metal.

Of course, you need to position these boards precisely where you need them, and at an angle to do the most good. Once more, it is hardware store clamps to the rescue (see pages 196–199).

◀ To show this inexpensive trinket necklace in an unusual way, I placed it in a bowl of ice, and draped one of the hearts in the necklace over an ice cube formation that mimics the shape of the heart.

85mm Perspective Correcting macro, 8 seconds at f/64 and ISO 100, tripod mounted

▲ This a fairly standard photo of a watch, photographed on a black velvet background, with the hands of the watch positioned at ten minutes after ten, the standard position for professional watch photos. The watch itself is attractive and a little unusual because of the extent to which the watch works are visible.

To get an attractive color in the photo for the gold of the watch, I placed small pieces of white cardboard strategically around the edges of the watch, but out of view of the camera. These boards reflected light color into the gold, rather than the dull of the black velvet background.

85mm Perspective Correcting macro, 5 seconds at f/48 and ISO 100, tripod mounted

Photographing Glass

Like metal, glass is a polished surface that reflects lights and bright surrounding areas. These reflections can look intolerably bright, depending on how you light the glass. In addition, unless glass is photographed carefully, it can seem to disappear in your photograph. After all, glass is meant to be transparent.

There are a number of techniques that can be used to successfully photograph still life compositions that include glass. Perhaps the simplest approach is to make sure that your lights don't directly strike the glass. This can be done by bouncing one or two lights off a white ceiling or white board at a good distance from the glass.

Another approach is to use colored boards or lights to create your own reflections (example page 231). If the reflections you create are attractive, then this can create successful compositions. Although the glass in photos using this technique may look nothing like the actual glassware.

If you are creating a photo that requires strong light directed at something glass—for example, because you are interested in a shadow cast by the glass—you can partly cut down the harsh highlights caused by reflections from your light source by using black boards to selectively block light from hitting the glass (example page 230).

Taking this approach a bit further, you can construct a "black tent" made of black pieces of cardboard around glass objects. The black tent should have openings for the camera, and (depending upon your desired lighting direction) in the back. This arrangement absorbs the light that would otherwise create highlights in the glass.

Glass is one of the most difficult objects in a still life composition to successfully photograph close-up. This is partly because of the unattractive and harsh reflections that can result from light that is aimed directly at glass. Another issue is, as I have mentioned, the nature of glass. The best photographs of glass do not actually look like glass. Instead, successful photographs of glass create solid structures that we somehow interpret as looking like glass should look but don't include the natural transparency of glass.

Think of these difficulties as opportunity! Glass is a visual marvel, with its facets, reflections, refractions and fantastic shapes. The ability of a glass filled with water to refract light in never-ending variety means that to find an interesting subject for close-up work you never have to look further than your glassware cabinet and the kitchen sink.

▶ To photograph this glass vase filled with tomatillos, I placed the vase on its side between folds of linen. I used two lights bounced off the ceiling so that the glass wouldn't show any harsh reflections. The photo creates an illusion of looking straight down into the contents of the vase.

75mm, 6 seconds at f/32 and ISO 100, tripod mounted

If you light through ordinary glassware, sometimes you come up with an intriguing shadow. For this photo, I used a low light positioned in front of the glass and to the right of the camera. I placed a black board between the light and the glass to lessen the stark reflections on the glass. If you look at the top of the shadow toward the back, the shadow cast by the light passing through the glass may remind you of an arched bridge.

85mm Perspective Correcting macro, 1/4 of a second at f/17 and ISO 100, tripod mounted

To make this photo, I placed a stack of glasses on a mirror and positioned color light bulbs so they were reflected—but not visible—in the mirror. In post-processing in Photoshop, I enhanced the effect made by the reflected color lights by darkening the lines at the edges of the glasses and lightening clear portions of glass.

80mm, 10 seconds at f/32 and ISO 100, tripod mounted

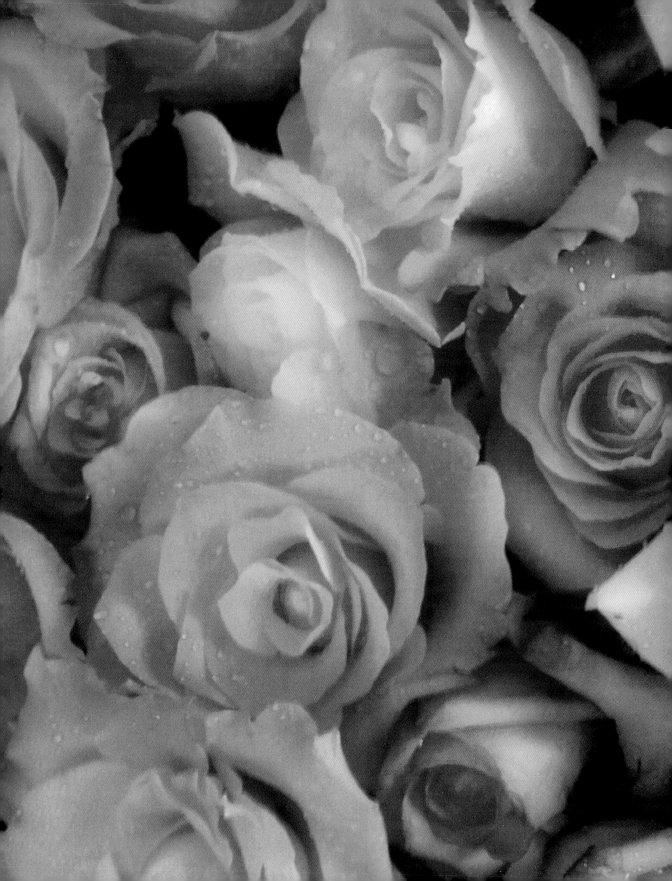

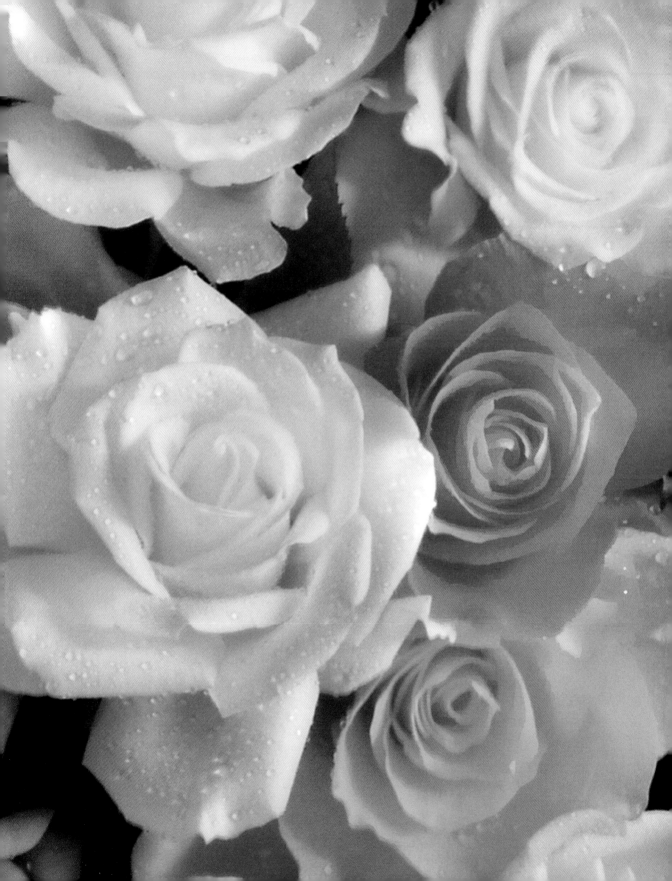

Resources and Further Reading

Extension tubes and close-up filters, page 52

Kenko extension tubes: www.thkphoto. com/products/kenko/slrc-04.html

B&W Schneider filters: www.schneider-optics.com/ecommerce/ CatalogSubCategoryDisplay.aspx?CID=57

Lensbaby, page 60

www.lensbaby.com

Tripods and Heads, pages 64–67

Gitzo: www.gitzo.com

Kirk Enterprises: www.kirkphoto.com

Manfrotto: www.manfrotto.com

Really Right Stuff: www.reallyrightstuff.com

Gorillapod: www.joby.com/products/ gorillapod

Composition and exposure, page 72

Creative Composition: Digital Photography Tips & Techniques (Harold Davis, Wiley, 2010)

Practical Artistry: Light & Exposure for Digital Photographers (Harold Davis, O'Reilly, 2008)

Botany and plant identification, pages 90–95

Botany for Gardeners (Brian Capon, Timber Press, revised edition 2005)

The Botany of Desire: A Plant's-Eye View of the World (Michael Pollan, Random House, 2002)

Plant Identification Terminology: An Illustrated Glossary (James G. Harris & Melinda Woolf Harris, Second Edition, Spring Lake Publishing, 2000)

High Dynamic Range (HDR), pages 112–119

The best software for automated High Dynamic Range processing is Photoshop, www.adobe.com, and Photomatix, www.hdrsoft.com (HDR processing is Photomatix's specialty).

To learn about hand HDR processing using layers and masking, see *The Photoshop Darkroom: Creative Digital Post-Processing* (Harold Davis, Focal Press, 2010).

Plant clamps, page 126

McClamp makes the McClamp stick, as well as more conventional plant clamps, www.fmphotography.us

Wimberly makes The Plamp, an effective plant clamp, www.tripodhead.com/ products/plamp-main.cfm

Digital painting and LAB color, pages 136–139

For more about my digital painting techniques and LAB color, see *The Photoshop Darkroom: Creative Digital Post-Processing* (Harold Davis, Focal Press, 2010).

Still Life Photography, pages 188–191

Masters of still life photography whose work I particularly admire include Irving Penn, Josef Sudek and Edward Weston. Of course, Penn, Sudek and Weston also created photos in other genres besides still life—and photographers known primarily for other kinds of work, such as Ansel Adams, created some fantastic still life imagery.

You can learn more about the still life work of Penn, Sudek and Weston in these books:

Still Life: Irving Penn Photographs, 1938–2000 (Irving Penn and John Szarkowski, Bulfinch, 2001)

Still Lifes (Joseph Sudek, Torst, 2008)

The Daybooks of Edward Weston (Beaumont Newhall and Edward Weston, Aperture, 2005)

Lighting, pages 202–211

Lowel, www.lowel.com, makes many lights and lighting systems, including the Lowel ViP Pro-Light that I use for some of my still life work.

Photographic Lighting (Ralph Hattersly, Prentice-Hall, 1970) is available inexpensively from many used-book sources.

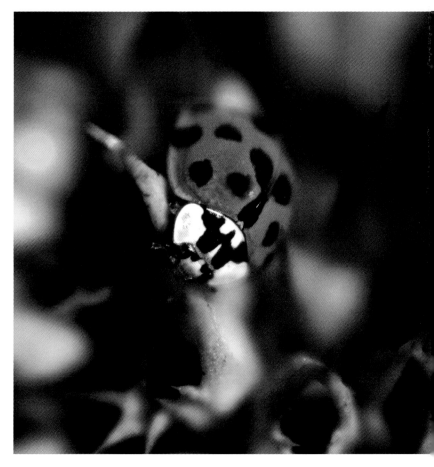

▲ Pages 232–233: I captured these roses on a black velvet background, using natural sunlight coming through semi-transparent shades. To make the image, I needed to get high enough above the flowers to shoot straight down. This was a bit tricky, because my tripod didn't extend far enough. I ended up putting each tripod leg on a chair and standing on a short ladder to compose the image.

50mm macro, three combined exposures at shutter speeds from 1.6 seconds to 4 seconds, all exposures at f/32 and ISO 100, tripod mounted

▶ I got up really close to this ladybug in the garden and used my Lensbaby with close-up filters to capture the insect with a blurred background.

Lensbaby, +14 close-up filters, 1/400 of a second at ISO 200, hand held

Glossary

Ambient light: The available, or existing, light that naturally surrounds a scene.

Aperture: The size of the opening in a lens. The larger the aperture, the more light that hits the sensor.

Barn doors: Blinder-type shutters that are placed on the front of studio lights to control intensity and direction of light.

Bellows: A bellows is a leather or cloth "tunnel" used for close-up work that fits between the lens and camera like an extension tube. A ratcheted rail system gives the bellows flexibility in how far it is extended.

Close-up filter: A piece of optical glass that screws into the front of a lens and provides magnification.

Composite: Multiple images that are combined to create a new composition.

Degrees Kelvin: see Kelvin.

Depth-of-field: The field in front of and behind a subject that is in focus.

Diffraction: Bending of light rays; unwanted diffraction can cause loss of optical sharpness at small apertures.

DSLR: Digital Single Lens Reflex, a camera in which photos are composed through the lens that will be used to take the actual image.

Dynamic range: The difference between the lightest tonal values and the darkest tonal values in a photo.

Effective aperture: The lens aperture, adjusted for the effects of magnification.

Exposure: The amount of light hitting the camera sensor. Also the camera settings used to capture this incoming light.

Exposure histogram: A bar graph displayed on a camera or computer that shows the distribution of lights and darks in a photo.

Extension tube: A hollow ring that fits between a lens and the DSLR, used to achieve closer focusing

f-number, f-stop: The size of the aperture, written f/n, where n is the f-number. The larger the f-number, the smaller the opening in the lens.

Focal length: The distance from the end of the lens to the sensor.

Focus stacking: Extending the field of focus beyond that possible in any single photo by combining multiple photos.

Focusing rail: A ratcheted rail that is attached to the camera and used for precision focusing by turning a knob to move the camera on the rail.

Hand HDR: The process of creating a HDR (High Dynamic Range) image from multiple photos at different exposures without using automatic software to combine the photos.

High Dynamic Range (HDR) image: Extending an image's dynamic range by combining more than one capture either using automated software or by hand.

Hyperfocal distance: The closest distance at which a lens at a given aperture can be focused while keeping objects at infinity in focus.

Image stabilization: Also called vibration reduction, this is a high-tech system in a lens or camera that attempts to compensate for, and reduce, camera motion.

Infinity: The distance from the camera that is far enough away so that any object at that distance or beyond will be in focus when the lens is set to infinity.

ISO: The linear scale used to set sensitivity.

JPEG: A compressed file format for photos that have been processed from an original RAW image.

Kelvin: The scale used to notate color temperature.

Lens reversal ring: Used to reverse a lens for close-up photography by attaching directly to a camera body or to the screw thread of a primary lens.

Lensbaby: A special purpose lens with a flexible barrel that allows you to adjust the "sweet spot" (area in focus).

Macro lens: A lens that is specially designed for close focusing; often a macro lens focuses close enough to enable a 1:1 magnification ratio.

Magnification ratio: The correspondence of an object and its actual size on the sensor.

Magnifying eyepiece: Attaches to the front of the viewfinder and magnifies what you see; useful for critical focusing.

Multi-RAW processing: Combining two or more different versions of the same RAW file.

Noise: Static in a digital image that appears as unexpected, and usually unwanted, pixels.

Open up, open wide: To open up a lens, or to set the lens wide open, means to set the aperture to a large opening, denoted with a small f-number.

Photo composite: *See composite.*

RAW: A digital RAW file is a complete record of the data captured by the sensor. The details of RAW file formats vary among camera manufacturers.

Right-angle finder: Attaches to the camera viewfinder; it can be tilted to adjust the angle at which you look through the viewfinder. It also usually provides magnification.

Reflection: Mirror image in which left and right are reversed.

Refraction: Curvatures and other distortions in reflections caused by the change in a light wave in relation to its speed, usually because the light has entered water.

Sensitivity: Set using an ISO number; determines the sensitivity of the sensor to light.

Shutter speed: The interval of time that the shutter is open.

Snoot: In studio lighting, a dark tunnel placed in front of a light to focus the light into a round spot.

Stop down: To stop down a lens means to set the aperture to a small opening; denoted with a large f-number.

Sweet spot: The area that is in focus when using a Lensbaby.

Tungsten light: Artificial incandescent light, created by sources including common household bulbs, photofloods and halogen bulbs.

Vibration reduction: See Image stabilization.

Wide open: *See Open up.*

Index

▼ Page 240: I photographed this still life of a lily in a vase on a black velvet background. I primarily lit the flower from the front using sunlight, and added a spot light covered with a diffuser to the right rear of the flower to add some highlights.

50mm macro, 1/2 second at f/32 and ISO 100, tripod mounted

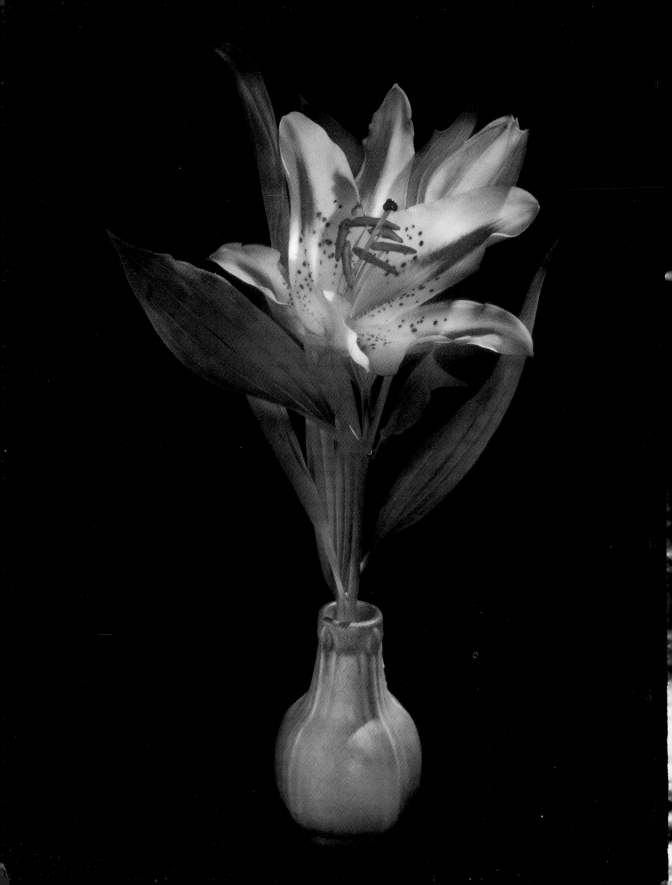